European Muses, *American Masters*

1870–1950

Portland Museum of Art

Portland, Maine

2004

This catalogue was produced in conjunction with the exhibition
Monet to Matisse, Homer to Hartley: American Masters and Their European Muses,
which was organized by the Portland Museum of Art and presented June 24 through October 17, 2004.

The Portland Museum of Art gratefully acknowledges Scott and Isabelle Black,
whose leadership and support have made this exhibition possible.

This exhibition has been generously sponsored by Peoples Heritage Bank. Media support
has been provided by WCSH 6 and the Portland Press Herald/Maine Sunday Telegram.

Edited by Fronia W. Simpson

Designed by Michael D. Ryus, MdR design

Printed by The Studley Press

Published by the Portland Museum of Art,
Seven Congress Square, Portland, ME 04101

Richard R. Brettell's essay was originally published in *Thomas Eakins and the Swimming Picture*,
ed. Doreen Bolger and Sarah Cash (Fort Worth: Amon Carter Museum, 1996), pp. 80–97.
Reprinted by permission of the publisher.

Library of Congress Control Number: 2004092081
ISBN: 0-916857-35-2

Cover:
Stuart Davis
New York–Paris, No. 2, 1931
oil on canvas
30 ¹/₄ x 40 ¹/₄ inches
Portland Museum of Art, Maine, Hamilton Easter Field Art Foundation Collection,
Gift of Barn Gallery Associates, Inc., Ogunquit, Maine, 1979.13.10
© Estate of Stuart Davis/Licensed by VAGA, New York, NY

Contents

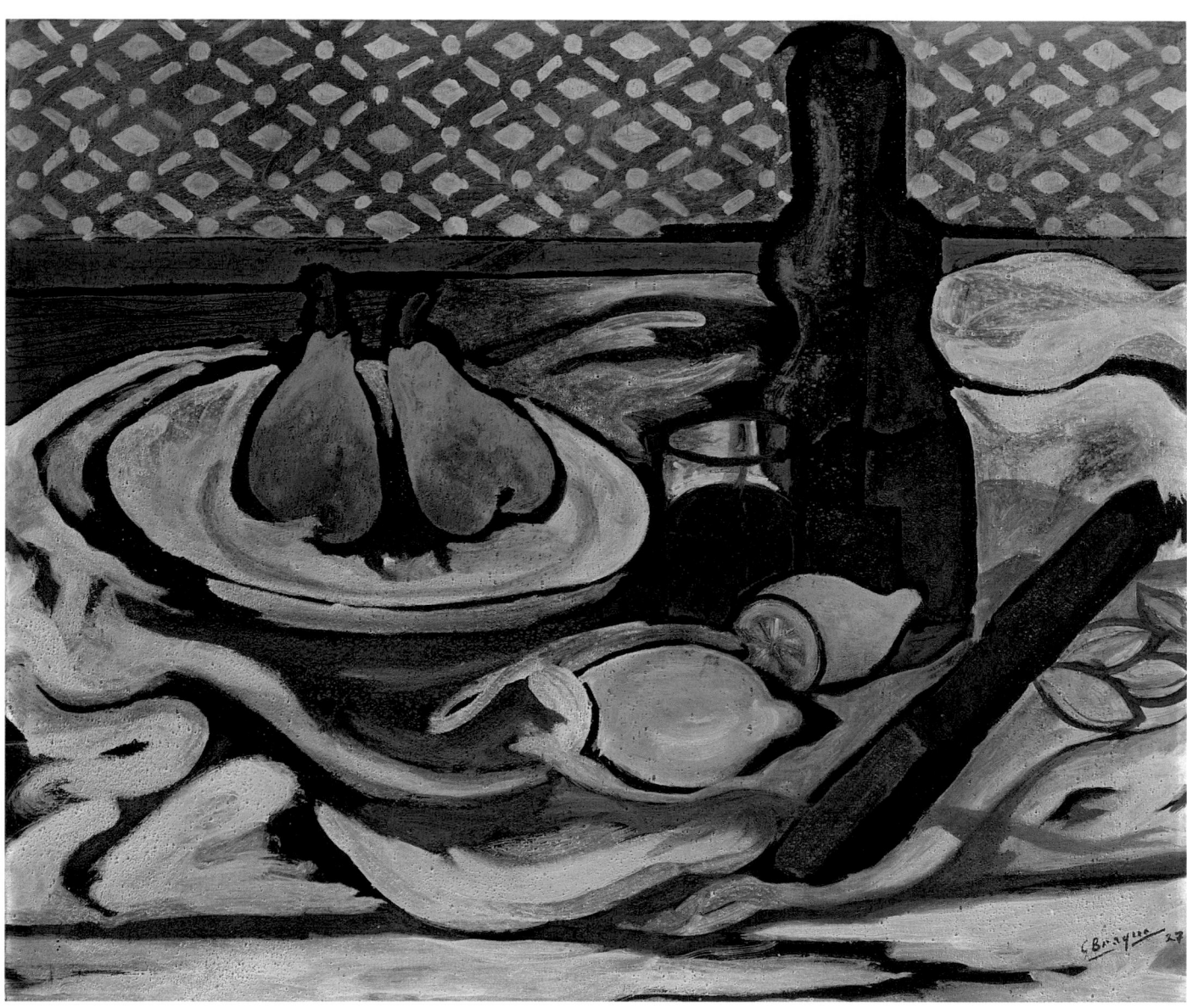

Georges Braque, *Nature Morte aux Poires, Citrons et Amandes (Still Life with Pears Lemons and Almonds*, 1927, oil on canvas, 19 $^7/_8$ x 24 inches. Scott M. Black Collection

Sponsor's Statement

Scott M. Black
April 14, 2004

My wife, Isabelle, and I are extremely pleased to be the major sponsors for this summer's exhibition entitled *Monet to Matisse, Homer to Hartley: American Masters and Their European Muses.* Nearly two years ago, on the completion of the Neo-Impressionist show, Daniel O'Leary, the director of the Portland Museum of Art, and I discussed potential artists for the upcoming summers of 2003 and 2004. We concurred that Fairfield Porter, who painted vigorously and competently in Maine, would be popular with visitors to the PMA, and our instincts proved correct. Additionally, I suggested to Dan that we organize a Toulouse-Lautrec retrospective comprising original oils and Lautrec's lithography. Given the relatively short lead time and the scarcity of oil paintings, we decided to seek an alternative course. After consultation with his curatorial staff, Dan proposed an exhibition showcasing the influence of European painters, including the School of Paris, on their American counterparts. Voilà, this summer's offering.

For those who have formally studied art history or who have frequented museums, the correlation seems apparent. Two notable Americans, James McNeill Whistler and Mary Cassatt, emigrated from the United States to Paris in the nineteenth century to imbibe the French culture and to pursue their métiers. Conversely, European modernists like Jacques Lipchitz and Yves Tanguy relocated permanently to the United States for religious and political freedom during World War II, furthering their sculptural and Surrealist endeavors, respectively. Some pairings are intuitively obvious: the landscapes of Monet and Hassam; the women of Renoir and Tarbell; the mountains of Cézanne and Hartley; the Cubism of Braque and Weber.

While *Monet to Matisse, Homer to Hartley: American Masters and Their European Muses* is intended to be an aesthetically pleasing exhibition, its main purpose is to highlight unusual links between European and American artists, to demonstrate the impact of European painters on their American cohorts, and to advance the body of scholarship in this important subject. Isabelle and I wish you an informative viewing and a wholly enjoyable summer in Maine.

Foreword

The Portland Museum of Art is pleased to present one of the most significant and exciting exhibitions in its history. Significant because it will capture the core of our Museum's mission, which is to reveal the character of American art as it evolved from European models and subsequently emerged as a powerful and independent force.

Daniel E. O'Leary
Director

The exhibition pairs carefully selected European and American objects to examine the rich exchange of ideas between Europe and America from 1870 to 1950, the years circumscribing the majority of the PMA's permanent collection. All the pairings, many of which include one object from the Museum's permanent collection, have been thoughtfully chosen to shed light on a particular aspect of the European/American dialogue—exploring ideas that were exchanged, the means of transmission, or how American artists adapted what they saw or read to fit their unique goals. Collectively these discussions will allow viewers to enrich their appreciation of works from both sides of the Atlantic.

Like the exhibition, the catalogue provides an opportunity to learn more about this complex dialogue, with each author considering a specific moment of exchange through focused discussions of selected artists. Carrie Haslett Bodzioney, Joan Whitney Payson Curator at the PMA, reflects on the intertwined concepts of influence and originality, citing various American artists' writings on the subject. In an essay originally published in 1996, Richard R. Brettell, Professor of Aesthetic Studies at the University of Texas at Dallas and Adjunct Senior Curator at The Meadows Museum, discusses Thomas Eakins's painting—*Swimming*—in the context of late-nineteenth-century French approaches to the male nude. Anne E. Dawson, Associate Professor of Art History at Eastern Connecticut State University, examines aspects of the legacy of French Impressionism on American art, which was profound, varied, and long lasting. Donna M. Cassidy, Director of American and New England Studies at the University of Southern Maine, explores the relationship between Post-Impressionist and early modernist aesthetics and the work of American artists who spent time in Maine developing ideas they first had encountered in Europe—including Marsden Hartley, John Marin, and Marguerite and William Zorach. And finally, Martica Sawin, critic, curator, and art historian, chronicles the rich history of the influx of European émigrés and art into America, beginning with exhibitions at Alfred Stieglitz's "291" gallery and the 1913 Armory Show and continuing through the 1940s.

The Museum wishes to thank Scott and Isabelle Black for their generosity in supporting this exhibition.

American Artists on European Muses

Carrie Haslett Bodzioney

In keeping with the goal of this exhibition, which is to explore the relationship between European and American art between the years 1870 and 1950, the essays in this catalogue point out some of the many avenues of engagement between American artists and European art during these years—travel abroad, publications, exhibitions, personal instruction—as well as particular instances of inspiration or influence, from matters of technique and style to more generalized aesthetic principles. In the exhibition itself, objects are paired to underscore this dynamic. Underpinning the curatorial enterprise of pairing objects and the essayists' discussions of objects in tandem with others lies the assumption that art itself can be a muse for artistic production.

But what is a muse? The *Oxford English Dictionary* tells us that, capitalized and as a noun, in Greek mythology it is "one of nine sister-goddesses . . . regarded as the inspirers of learning and the arts, esp. of poetry and music." It is also "the inspiring goddess of a particular poet. Hence, a poet's particular genius, the characters of his style and spirit." Definitions of the word as a verb include "To be absorbed in thought; to meditate continuously in silence; to ponder" and "to gaze meditatively; to look thoughtfully or intently."

All definitions except perhaps the first are useful in thinking about the nature of the "muse" for artists working between 1870 and 1950, an era in which artists actively sought out sources of artistic inspiration rather than passively accepting guidance from an external source, divine or otherwise. A number of circumstances made such an active search feasible for American artists working during this period. Travel to Europe and elsewhere was available and affordable, within the reach of anyone with the ambition to take advantage of it, not just the wealthy (William Zorach, for instance, worked as a lithographer's assistant to earn money for such a journey because he believed it vital to his artistic development); American museums and galleries opened that owned or exhibited European art; several art academies based on European models were well established in America; and European teachers came to America in increasing numbers. These artists looked not only to the established old masters—such as Raphael, Rembrandt, Frans Hals, and Diego Velázquez—but also to artists who were or would become giants of modern art, including Claude Monet, Paul Cézanne, Pablo Picasso, Wassily Kandinsky, and Piet Mondrian.

As a concept considered in relation to visual art and artists, "muse" amounts to a tantalizing complexity, and artists themselves are not always the best source for unraveling that tangle. Artists may be conscious or not of sources of inspiration and/or guidance, which can be

myriad (people, places, things, ideas, experiences, etc.) and related to art or not at all. If artists are conscious of any such sources, they may or may not acknowledge them verbally, or they may acknowledge sources that are arguably not really the most profound for their work. (One is not always blessed with self-awareness or honesty.) Most artists, of course, do not use words to credit inspiration for their work, and indeed, given this, one must rely on visual analyses to draw such conclusions. These analyses, in turn, of course, are themselves highly subjective.

Despite the challenges posed by artists' words, it is instructive to consider what at least some of the American artists represented in the exhibition have written on the general subject of looking at art by others in order to reflect further on the nature of art as "muse." Rather than tease apart the subtle distinctions among definitions of the word, I would like to ask, on a most basic level, why do artists look and to what end? Does looking affect artistic originality? And, given the topic of this exhibition, what are the implications for American art of American artists looking at European art? In the writings of even a few artists, several themes emerge that span several generations of American artists: an unquestioned assumption that there is such a thing as "great" art; the notion that such art is supported by universal principles (defined variously); and a belief in the value of looking at such art, especially European art, not so as to imitate or reproduce it wholesale, but as a means for developing one's personal expression. Tellingly, in these artists' writings, the model of European art is often spoken of in the same breath as the problem of defining an American art.

A number of the artists represented in this exhibition write eloquently of the necessity of looking at art. In *The Art Spirit*, published in 1923, American artist and longtime teacher Robert Henri (1865–1929) lays out many opinions on art, the making of art, the relationship between art and life, and life itself.[1] While adamantly asserting the importance of individualism and originality, he urges artists to "Know what the old masters did. Know how they composed their pictures, but do not fall into the conventions they established. They made their language. You make yours. They can help you. All the past can help you" (p. 16). Henri believed in the existence of an underlying universality to great art—from all the ages—which stems from the artist's ability to convey "truth" and "vitality," and he advises artists to "go to kindred spirits—others who have wanted to do that thing [you wish to do]—and study their ways and means, learn from their successes and failures and add your quota" (p. 55). For Henri, artistic originality is not something to "worry about," for "you could not get rid of it even if you wanted to" (p. 78).

In this same volume Henri offers countless instances of his observations of other artists' work, which collectively lend insight into the many sorts of inspiration and influence that art may offer. For instance, in the case of Titian, Henri admires his ability to organize and make use of "balances and rhythms"; with Rembrandt, "The beauty of the lines of the drawing rest in the fact that you do not realize them as lines, but are only conscious of what they state of the living person" (pp. 185, 110). He finds meaning in Édouard Manet's brushstroke, which "was ample, full, and flowed with a gracious continuity, was never flip or

1. Robert Henri, *The Art Spirit* (Philadelphia: J. P. Lippincott, 1923; reprint, New York: First Icon, Harper & Row, Publishers, 1984). Page numbers of quotations from this book will be given parenthetically in the text.

clever" (p. 76). From James McNeill Whistler he learns that "age need not destroy beauty," as seen in the portrait of Whistler's mother, wherein his "gesture manifests the inner life" (p. 123). He finds a near spiritual guide in Cézanne, whom Henri claims "correlated things never before correlated" (p. 269).

While urging artists to look at work by other artists, and recounting aspects of his own history of looking, Henri reminds them that "The wisdom and mistakes of the past are ours to build on, and the picture painted yesterday, now hanging on the wall, is already of the past and is part of our heritage" (p. 217). Art must be vital, he argues, an expression of the moment, as well as of one's individuality. In considering Henri's work over the years, one can glean what he means by this. Certain of his portraits, for instance *Village Girl (Lily Cow)* (page 103), recall the fresh, bold brushwork of Hals and Manet, and still others the ghostly atmospheric presence and tonal palette of Velázquez and Whistler; yet one would never mistake these portraits as being by anyone other than Henri—they are new in approach and effect, and they speak with the distinct voice of the artist.

Stuart Davis (1892–1964), also an artist represented in this exhibition, studied with Henri. Like his teacher, he believed that looking at art is an essential element in the development of one's individual art, not as something to imitate, but as a resource for discovering tools as well as personal sustenance. In a well-known letter to Henry McBride written in 1930, Davis takes the art critic to task for his assessment of Davis's work as being too influenced by French art:

2. Stuart Davis to Henry McBride, *Creative Art* (New York), 6, no. 2, supp. (February 1930): 34–35, reprinted in *Stuart Davis*, ed. Diane Kelder, in *Documentary Monographs in Modern Art* (New York: Praeger Publishers, Inc., 1971), p. 110.

3. Davis spent time in France, but clearly he did not believe an artist had to work in Paris to learn of developments there, and indeed, in 1931 he wrote of the benefits for him personally of working in New York rather than Paris; quoted in Wanda M. Corn, *The Great American Thing: Modern Art and National Identity, 1915–1935* (Berkeley and Los Angeles: University of California Press, 1999), p. 345.

I DID NOT SPRING INTO THE WORLD FULLY EQUIPPED TO PAINT THE KIND OF PICTURES I WANT TO PAINT. IT WAS THEREFORE NECESSARY TO ASK PEOPLE FOR ADVICE. . . . AFTER LEAVING THE DIRECT INFLUENCE OF MR. [ROBERT] HENRI I SOUGHT OTHER SOURCES OF INFORMATION AND AS THE ARTISTS WHOSE WORK I ADMIRED WERE NOT PERSONALLY AVAILABLE I TRIED TO FIND OUT WHAT THEY WERE THINKING ABOUT BY LOOKING AT THEIR PICTURES. CHIEF AMONG THOSE CONSULTED WERE AUBREY BEARDSLEY, TOULOUSE LAUTREC, FERNAND LÉGER AND PICASSO. THIS PROCESS OF LEARNING IS FROM MY OBSERVATION IDENTICAL WITH THAT FOLLOWED BY ALL ARTISTS. . . . [I CAN'T] UNDERSTAND HOW ONE IS SUPPOSED TO BE DEVOID OF INFLUENCE. I NEVER HEARD OF OR SAW ANYONE WHO WAS.

Moreover, he says, "While I admit the foreign influence I strongly deny speaking their language. If my work were an imitation I am sure it couldn't arouse in you that enthusiasm from which, you [McBride] state in your review, the bridles were almost removed."[2]

Davis believed the art of the early twentieth century to be international in scope, not so much because of any universal essence (as Henri saw it), but more for the dramatic developments in French painting:[3]

THE BEST PAINTING IN THE LAST SEVENTY-FIVE YEARS, THAT WORK WHICH HAS
ADDED SOMETHING NEW TO THE DEVELOPMENT OF ART, HAS UNQUESTIONABLY
BEEN DONE IN FRANCE. . . . SO WHEN WE SAY THAT GREAT PAINTING HAS BEEN
DONE IN FRANCE, IT IS A MATTER OF GREAT CONCERN TO ANYONE INTERESTED
IN ART. . . . AND WHEN FRENCHMEN MAKE GREAT ART IT IS NOT JUST AN
INTERESTING EXAMPLE OF FRENCH GENIUS. IT IS A REAL EVENT TO BE STUDIED
AND DEVELOPED BY ARTISTS IN OTHER COUNTRIES.[4]

In his autobiography, Davis gives an example of what he means by studying such art while
maintaining a sense of one's own individuality. He writes of feeling "enormously excited by
the [Armory] show, and respond[ing] particularly to [Paul] Gauguin, [Vincent] Van Gogh, and
[Henri] Matisse, because broad generalization of form and the non-imitative use of color were
already practices within my own experience. I also sensed an objective order in these works
which I felt was lacking in my own."[5] Here he was first drawn to approaches that were already
part of his vocabulary but then came to learn something new about "order." One sees this
developed in a work like *New York–Paris, No. 2* (front cover), a painting from 1931, with its
nonimitative use of color, broad outlines of form, and highly organized patterning and
construction of space.

Another important modernist artist, Marsden Hartley (1877–1943), spent many years
in Europe and also wrote extensively about art. He wrote in a variety of formats—from
catalogue forewords to magazine articles and essays about art—with topics ranging from the
nature and purpose of art to criticisms of a wide variety of individual artists past and present.
Fully assessing his notion of "muse" and the personal muses throughout his career requires
considerable attention, but a sampling of his writings is instructive and suffices for present
purposes.

Like his predecessors, Hartley devalues mere imitation while extolling learning from
others: "We derive our peculiar art psychology from definite sources, and it is in the
comprehension of these sources, and not in the imitation of them, that we gain the power
necessary for the kind of art we as moderns wish to create."[6] Hartley, like Henri, writes of a
generalized universality at the root of great works of art:

> UNDERLYING ALL SENSIBLE WORKS OF ART, THERE MUST BE SOMEWHERE IN
> EVIDENCE THE PARTICULAR PROBLEM UNDERSTOOD. IT WAS SO WITH THOSE
> ARTISTS OF THE GREAT PAST WHO HAD THE INTELLECTUAL KNOWLEDGE OF
> STRUCTURE UPON WHICH TO PLACE THEIR EMOTIONS. IT IS THIS STRUCTURAL
> BEAUTY THAT MAKES THE OLD PAINTING VALUABLE. . . . I BELIEVE THAT IT IS
> MORE SIGNIFICANT TO KEEP ONE'S PAINTING IN A CONDITION OF SEVERE
> EXPERIMENTALISM THAN TO BECOME A QUICK SUCCESS BY MEANS OF CHEAP
> REPETITION.

4. Davis, "Abstract Painting Today,"
1940, unpublished article
commissioned for *Art for the
Millions*, in Kelder, 1971, p. 120.

5. Davis, "Autobiography," 1945, in
Kelder, 1971, p. 23.

6. Marsden Hartley, "Dissertation
on Modern Painting" (1921), in
On Art by Marsden Hartley, ed. Gail
R. Scott (New York: Horizon Press,
1982), p. 69.

12

THE REAL ARTISTS HAVE ALWAYS BEEN INTERESTED IN THIS PROBLEM, AND YOU FELT IT STRONGLY IN THE WORK OF [LEONARDO] DA VINCI, PIERO DELLA FRANCESCA, [GUSTAVE] COURBET, [CAMILLE] PISSARRO, [GEORGES] SEURAT AND CÉZANNE.[7]

Elsewhere he speaks eloquently of an objective quality inherent to great art, and in looking at great art, he says, one can learn something about this quality and seek to develop it in one's own art:

FINE PICTURES ARE, AFTER ALL, . . . SOMETHING LIKE IMAGES OF THE TRUE ARCHITECTURE OF BEING, ELSE HOW COULD THEY RISE TO THE HEIGHTS THEY DO IN THE SAID "NIGHT WATCH," OR IN THE UNFINISHED "ADORATION OF THE MAGI" OF LEONARDO . . . , ALREADY SEEMING TO SING OF THE HARMONIES THAT HAVE NOT QUITE REACHED FRUITION THERE, REALITIES RISING ABOVE MERE THOUGHTS OR DIALECTIC ADHERENCES, INTO THE REALM WHERE EVERYTHING IS ALIVE BECAUSE IT LIVES OUT PERFECTLY THE DICTATIONS OF CLARIFIED HUMAN SENSE.[8]

In his autobiography published a year after his death, William Zorach (1887–1966) weighs in on these same subjects—the value of learning, originality, and a universality of great art. He writes:

A PERSON EVOLVES AND DEVELOPS HIS ART THROUGH CONTACTS AND INFLUENCES. . . . THOSE OF US WITH TALENT ARE BORN NAIVE DRAUGHTSMEN AND COLORISTS. . . . WE WOULD EACH HAVE A CERTAIN INNATE ORIGINALITY IN OUR SENSE OF COLOR AND HANDLING OF SPACE, BUT THE METHOD WOULD NOT VARY GREATLY OR THE RESULTS. BUT ONE CANNOT REMAIN ISOLATED IN AN AGE LIKE THIS. ONE HAS TO ABSORB INFLUENCES AND THROUGH THEM DEVELOP ONE'S OWN EXPRESSION. [FOR INSTANCE,] I COULD NOT ACCEPT MATISSE'S DISTORTION OR THE POSTER LOOK OF HIS PAINTINGS, BUT I FOUND HIS COLOR AND HIS FREEDOM EXCITING.[9]

7. Hartley, *Art—and the Personal Life*, 1928, quoted in Scott, 1982, p. 73.

8. Hartley to Aurelie Cheronne (never sent), 1936, quoted in Scott, 1982, pp. 109–10.

9. William Zorach, *Art Is My Life* (Cleveland: The World Publishing Company, 1967), pp. 32–33.

10. Zorach, 1967, pp. 74–75.

11. Zorach, 1967, p. 74.

Like the other artists, he adds that, in regard to the lessons to be learned from others: "You must listen and then make your own decisions as to what is right for you. . . . I have reached the point today where I have a great respect and interest in the past accomplishments of mankind. But you have to be able to discriminate between true values and the dead wood of tradition."[10] He also writes of how the artist must become "attuned to seeing with the inner eye the eternal" and work "until he gives back in permanent form that vision."[11] A painting such as Zorach's *Leo Ornstein–Piano Concert* (page 19) incorporates several of these lessons. The

artist has clearly looked to, and "absorbed," the work of Cubists and Futurists, using the principle of fractured space inherent in these approaches to convey in "permanent form" the fundamentally nonvisual, impermanent, "inner" experience of a live musical performance.

In the 1960s Will Barnet (b. 1911), part of a generation of artists that came after Zorach, would acknowledge:

> I STILL FEEL INDEBTED TO THE GREAT CLASSICAL TRADITION OF EUROPEAN PAINTING—ALSO TO BYZANTINE AND MEDIEVAL ART, MORE CONSCIOUSLY MAYBE THAN OTHERS BECAUSE LIVING IN A SMALL NEW ENGLAND TOWN, LEARNING ART IN BOSTON—WHERE THE TEACHING AND ART ACTIVITY WERE MUCH MORE ACADEMIC THAN ONE MIGHT SUPPOSE—I FOUND WHAT I CARED ABOUT IN BOOKS AND IN THE MUSEUM. . . . [M]Y GREAT HERO WAS [JOHANNES] VERMEER, AND MY GREAT DISCOVERY WAS THAT HE MADE THE CORNER OF A ROOM BECOME A WHOLE WORLD.[12]

In an interview from 1997 Barnet speaks of various other influences throughout his life, including artists of the early Renaissance, such as Giotto, as well as nineteenth-century masters such as Seurat, Cézanne, and Gauguin.[13] In a conversation with this author, Barnet spoke of admiring, in his early days, the "sculptural solidity" and "vitality of form" of [Amedeo] Modigliani, and even got into a "fist fight" with another artist over the merits of Cézanne.[14] The work by Barnet that is included in this exhibition, *Awakening*, from 1949 (page 21), was identified by the artist as a work particularly influenced by Picasso's paintings of the mid-1930s, such as *Femme lisant* (page 20), as well as by Native American pottery and Peruvian embroidery. The use of multiple and simultaneous points of view of the figures, the inclusion of masks, and the organization of space in broad bands could be seen to relate specifically to the work of Picasso.

While these artists ponder the importance and influence of European art, many are equally compelled to address the question "What is American art?"[15] My essay touches on a small handful of artists' writings, taken out of a larger historical context, most of which were written by American modernists who traveled to Europe and argued in favor of viewing modern art through a universal, rather than a national, lens. It should be noted, however, that many of these artists also made comments, at different points in their career, about a distinctly American art (notably Davis and Hartley). The former, universalist type of comment is most relevant to this exhibition, however, which looks at moments in the careers of American artists during which they embraced European art as a positive and essentially unproblematic influence. In the following remarks, these artists concur that the unifying principles underlying great art defy national boundaries and definitions. The belief in the importance of individual expression as well as a unifying essence permeating great art led Henri, for instance, to perceive the concept of nationalism as limiting: "Always we would try to tie down the great to

12. "Will Barnet—Statement for Lawrence Alloway," in *Will Barnet: A Timeless World* (Montclair, N.J.: The Montclair Art Museum, 2000), p. 124.

13. Emily Goldstein, "A Conversation with Will Barnet," in *Will Barnet: Early Works on Paper* (East Hampton, N.Y.: Glenn Horowitz Bookseller, 1997), p. 17.

14. Conversation with the author in Sebasco, Maine, August 14, 2003.

15. For an important scholarly study of the complex history related to the definition of a distinctly American art, see Corn, 1999. Corn discusses, among much else, not only artists who went abroad but "stay-at-homes," and in making this distinction, she identifies "one of the most pronounced tensions American modernists faced during the 1920s: the long-familiar lure of Europe in competition with the newly legitimate course of remaining at home and making New York the center of one's artistic universe" (p. xix).

our little nationalism; whereas every great artist is a man who has freed himself from his family, his nation, his race. Every man who has shown the world the way to beauty, to true culture, has been a rebel, a 'universal' without patriotism, without home"; elsewhere he writes, "The greatest American . . . will not be a 'typical' American at all, but will be heir to the world instead of a part of it" (pp. 146, 129). He states that his own "love of mankind is individual, not national. . . . And so I am 'patriotic' only about what I admire, and my devotion to humanity burns up as brightly for Europe and for America [and elsewhere]" (p. 143). In a spirit of internationalism and the belief in the spiritually elevating power of art, he also advocates for having "art in America . . . not to sit like a pack-rat on a pile of collected art of the past. It will be rather to build our own projection on the art of the past. . . . And to have art in America like this will mean a greater living, a greater humanity, a finer sense of relation through all things" (p. 132).

Another artist represented in this exhibition, Elizabeth Gardner Bouguereau (1837–1922)—who spent most of her life in France and who in 1896 married the well-known French academician William Bouguereau after a courtship of some twenty years—offers a similar sentiment, in regard to both the internationalism of her contemporary art world and the value of having European art in America. In a statement arguing against an American proposal to impose a duty on works of art by foreigners entering the country, she writes:

> [THE EUROPEAN] MASTERS, WITH PATERNAL DISINTERESTEDNESS, ENCOURAGE AND DIRECT OUR EARLY STUDIES, THEN ALLOW US FREE ACCESS TO THEIR ANNUAL SALONS, UNDER THE SAME CONDITIONS AS THEIR COMPATRIOTS, WITH EQUAL PARTICIPATION IN THE AWARDS OF COVETED MEDALS AND DECORATIONS. . . . HOWEVER THE PREPONDERANT PLEAS FOR FREE ART COMES, NOT FROM A DESIRE FOR JUSTICE ON THE PART OF A FEW SCORES OF AMERICAN ARTISTS WHO RESIDE ABROAD, BUT FROM THE NEEDS OF THOUSANDS WHO PURSUE THEIR STUDIES AT HOME. TO THESE, FACILITIES FOR CONSULTING THE WORKS OF FOREIGN MASTERS ARE AN ABSOLUTE NECESSITY.[16]

16. Elizabeth Gardner Bouguereau Papers, Archives of American Art, Smithsonian Institution, Washington, D.C., reel 3464, frames 973–74.

17. H. Barbara Weinberg, *The Lure of Paris: Nineteenth-Century American Painters and Their French Teachers* (New York: Abbeville Press, 1991), p. 253.

She, like Zorach, perceived the model of European art as indispensable to an American artist's education, and the life she lived attested to this belief. Gardner was the first American woman to pursue formal art study in Paris, traveling there in 1864.[17] Her work in this exhibition, *He Careth* (page 23), offers a clear parallel to works by her husband, such as *The Elder Sister* (page 22), showing her to be more of a conservative Parisian artist than an artist concerned with pioneering a modern and distinctly American art.

Stuart Davis, however, as noted earlier, considered France a particularly strong force in the early twentieth century precisely because it had added something "new to the development of art," and he elaborates on the general nature of the European–American dialogue in this letter dating to February 1930:

IN SPEAKING OF FRENCH ART AS OPPOSED TO AMERICAN THE ASSUMPTION IS
MADE THAT THERE IS AN AMERICAN ART. WHERE IS IT AND HOW DOES ONE
RECOGNIZE IT? HAS ANY AMERICAN ARTIST CREATED A STYLE WHICH WAS
UNIQUE IN PAINTING, COMPLETELY DIVORCED FROM EUROPEAN MODELS? . . .
SUPPOSE A SELECTED SHOW OF THE PAINTING OF EUROPE AND AMERICA FOR
THE LAST FOUR HUNDRED YEARS WERE HELD, WOULD THE AMERICAN CONTRI-
BUTION STAND ISOLATED AS A DISTINCT POINT OF VIEW, UNRELATED TO THE
EUROPEAN? . . . NO.

Davis defines himself as an American artist simply by virtue of having been born there; but he
also states that the term *American* could be applied to those who "live and paint" there.[18]

Writing just a month later, in March 1930, Marguerite Zorach (1887–1968) asks, in
response to derision of American art that was perceived to be too influenced by modern
European art: "What madness has come over the American art world? Are we so rich in artists
that we must eliminate? Are we so pure of blood that we must weed out our every foreign
strain?" And she points out that "There seems to be great excitement at present over what is
an American artist," yet "I have never heard of any similar excitement in Paris over what is a
French artist. Picasso hasn't been banished to Spain, [Constantin] Brancusi to Roumania [*sic*],
[Marc] Chagall to Russia, [Giorgio de] Chirico to Italy." Like Henri and Davis, she too
believes that "There is no isolation of ideas, or art, or peoples today." Finally, reflecting on the
notion of a national art, she writes:

ALL NATIONS PRODUCE ARTISTS BUT SOME NATIONS NEVER PRODUCE GREAT
ART. WE [AMERICA] MAY BE SUCH A NATION BUT I DO NOT BELIEVE IT. I THINK
SOME DAY WE WILL FIND THAT WE HAVE A GREAT ART AND GREAT ARTISTS. BUT
IT WILL NOT BE BECAUSE WE HAVE REMAINED PURE, ONE HUNDRED PER CENT
AMERICANS. IT WILL BE BECAUSE WE ALONE OF THE NATIONS OF THE WORLD
HAVE WELCOMED ALL PEOPLES. IN THE STIMULUS OF NEW SOIL AND OPPORTUNI-
TIES, NEW POSSIBILITIES DEVELOP.[19]

Acknowledging Davis's query of 1930 in the subject "Is there an American Art?"
Hartley opens his essay, written some eight years later but never published, by stating that this
"question is apt and provocative of serious consideration." He writes: "The western chauvinists
have shut their eyes to the polyglot aspects of art east of Chicago and with probably a fair
degree of reason, since art in New York alone is distinctly a Europeanized affair, since the
painters themselves are offshoots of recent strains, but that doesn't prevent them from being
respected as American artists in whatever degree their Americanism is expressed." But, he says,
"It can make no difference to American art itself, if there is such a thing, that the advertising
megaphone has been shifted to the corn belt." Moreover, the desire to create something

18. Davis to McBride, in Kelder,
1971, pp. 109, 110.

19. Marguerite Zorach, "When Is
an American Artist?" *Space* 1, no. 2
(March 1930), pp. 28, 30.

inherently American by not looking to non-American sources is like a writer "fool enough to localize his emotions to such an extent that he would refuse to read Shakespeare or Homer or Plato because it might injure his localism," and then, "Art itself is without a country in the strict sense. It is only localized when the artist has arisen in whatever locality, proving his unquestionable localism."[20]

Writing in 1944, Jackson Pollock (1912–1956) concurred: "The idea of an isolated American painting, so popular in this country during the thirties, seems absurd to me just as the idea of creating a purely American mathematics or physics would seem absurd. . . . An American is an American and his painting would naturally be qualified by that fact, whether he wills it or not. But the basic problems of contemporary painting are independent of any country." He, like Davis, accepted "the fact that the important painting of the last hundred years was done in France. American painters have generally missed the point of modern painting from beginning to end. . . . Thus the fact that good European moderns are now here is very important. . . . I am particularly impressed with their concept of the source of art being the Unconscious. This idea interests me more than these specific painters do, for the two artists I admire most, Picasso and Miro [sic], are still abroad."[21] *Untitled (7)*, an engraving and drypoint (page 139), very much demonstrates this particular moment in Pollock's career. Through its abstract biomorphic vocabulary, it recalls the automatic drawing of the Surrealists and, not coincidentally, dates to 1944, the year Pollock spent etching in Atelier 17, the printmaking workshop of the British abstract artist Stanley William Hayter, who had exhibited with the Surrealists in the 1930s.

These are comments by just a few artists, but their viewpoints are eye-opening, especially in regard to this exhibition. Through art history education and museum displays, one is prone to consider American art as fundamentally distinct from European art and that of other cultures, even as we are tangentially taught (through comparisons that are rarely fully developed) and visually reminded of a world of influence.[22] In their seeking out, looking at, admiring, copying, writing about, and learning from the art of others, these major forces in American art (at least) recall artists from any number of countries and centuries, while speaking specifically to decades of a profound relationship between art production in Europe and America. The universality of great art to which many of these artists allude seems to be paralleled by a universally voracious search by artists for muses—whether sources of inspiration or guidance—in regard to every aspect of their art making. Moreover, and equally enlightening, is the shared belief that looking at the art of others need not compromise one's originality—indeed, such looking and evaluating is considered an absolute requirement of artistic growth. Understanding the importance that these artists place on studying art helps to justify the premise of this exhibition and allows American art to be viewed not as derivative or any less original for having European antecedents, but rather as part of an age-old continuum of artistic change and development.

20. Marsden Hartley, unpublished essay, dated to circa 1938 by Scott, 1982, pp. 196, 197, 198–99, 198.

21. Excerpt from the artist's written answer to a questionnaire published in *Arts and Architecture* 61 (February 1944), quoted in *Theories of Modern Art: A Source Book by Artists and Critics*, ed. Herschel B. Chipp (Berkeley and Los Angeles: University of California Press, 1968), p. 546.

22. For the innumerable reasons why this was and continues to be so, see Corn, 1999, as well as Wanda M. Corn, "Coming of Age: Historical Scholarship in American Art," *Art Bulletin* 70, no. 2 (1988), pp. 188–207.

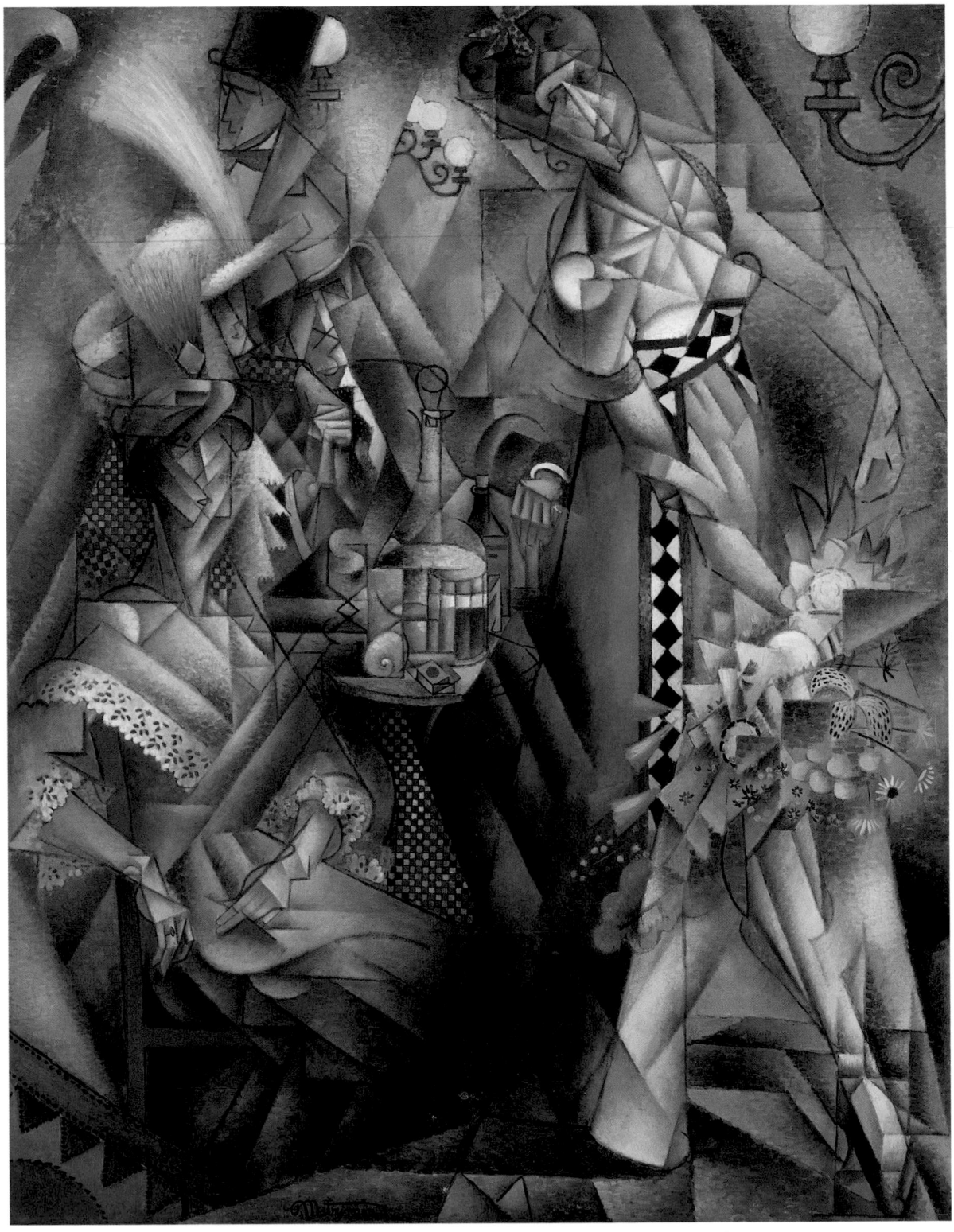

Jean Metzinger, *Dancer in a Café*, 1912, oil on canvas, 57 $\frac{1}{2}$ x 45 inches. Albright-Knox Art Gallery, Buffalo, New York, General Purchase Funds, 1957

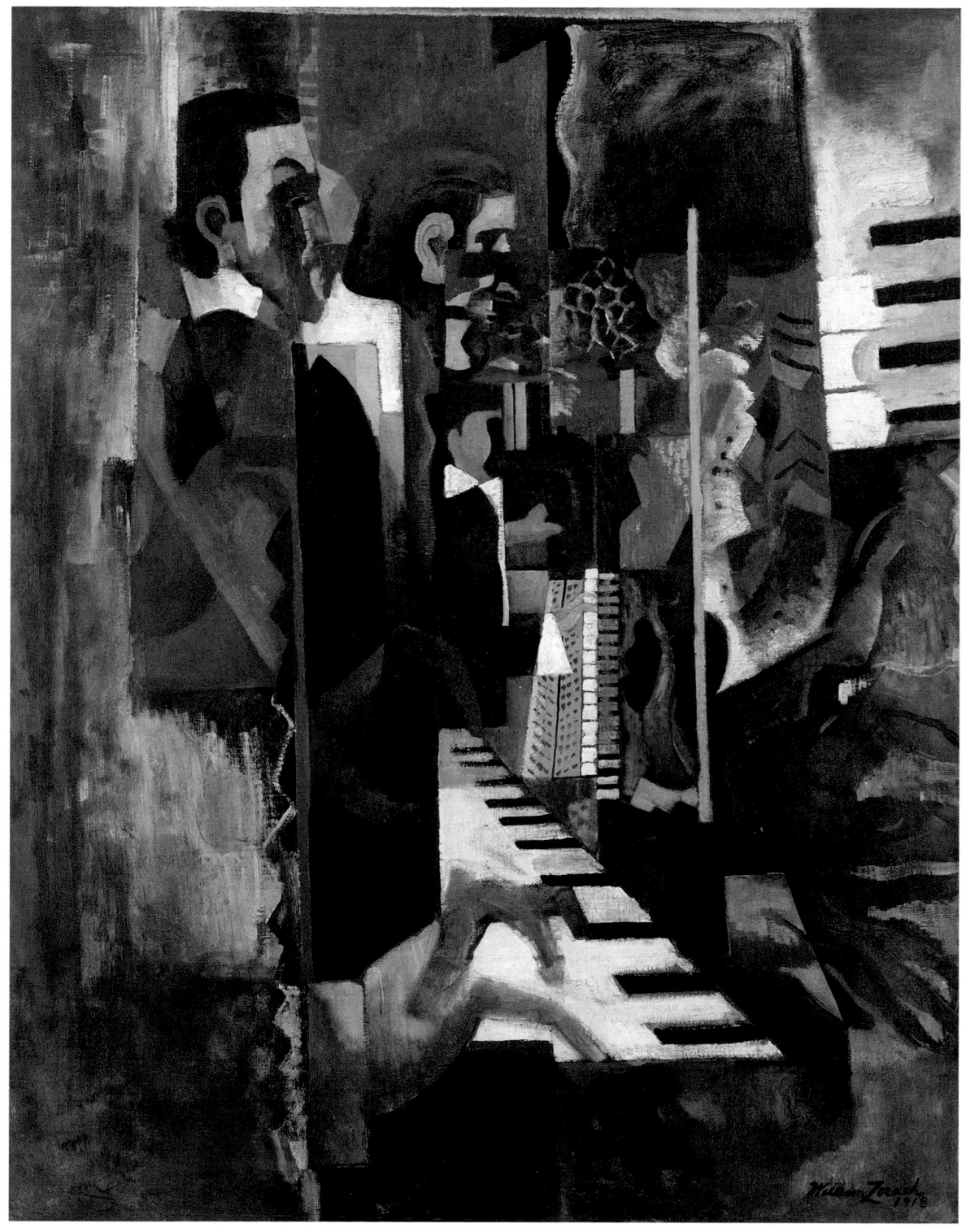

William Zorach, *Leo Ornstein–Piano Concert*, 1918, oil on canvas, 30 x 24 inches. Collection of Mr. and Mrs. William Bloom

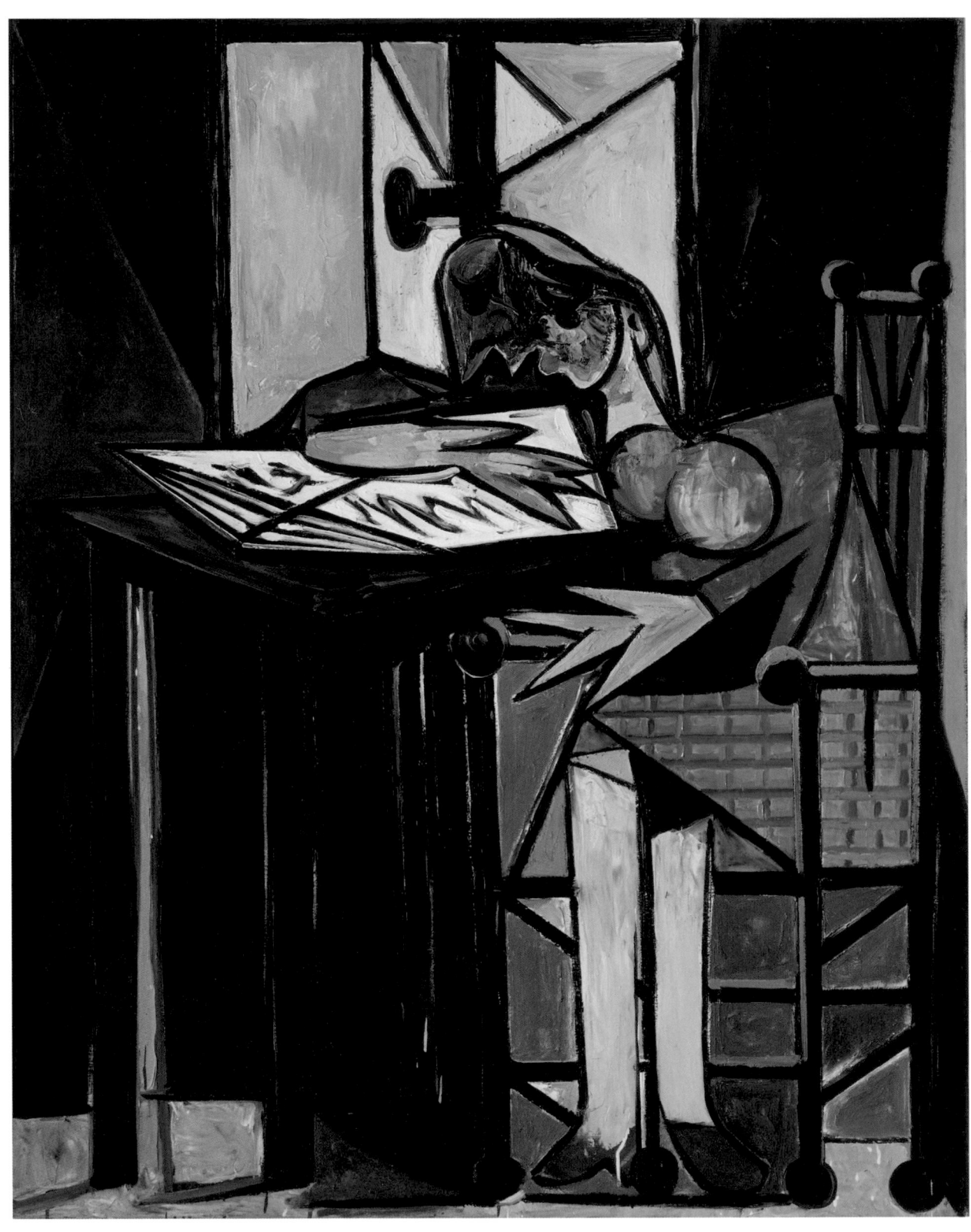

Pablo Picasso, *Femme lisant*, 1935, oil on canvas, 63 ³/₄ x 44 ¹/₂ inches, Musée Picasso, Paris, France

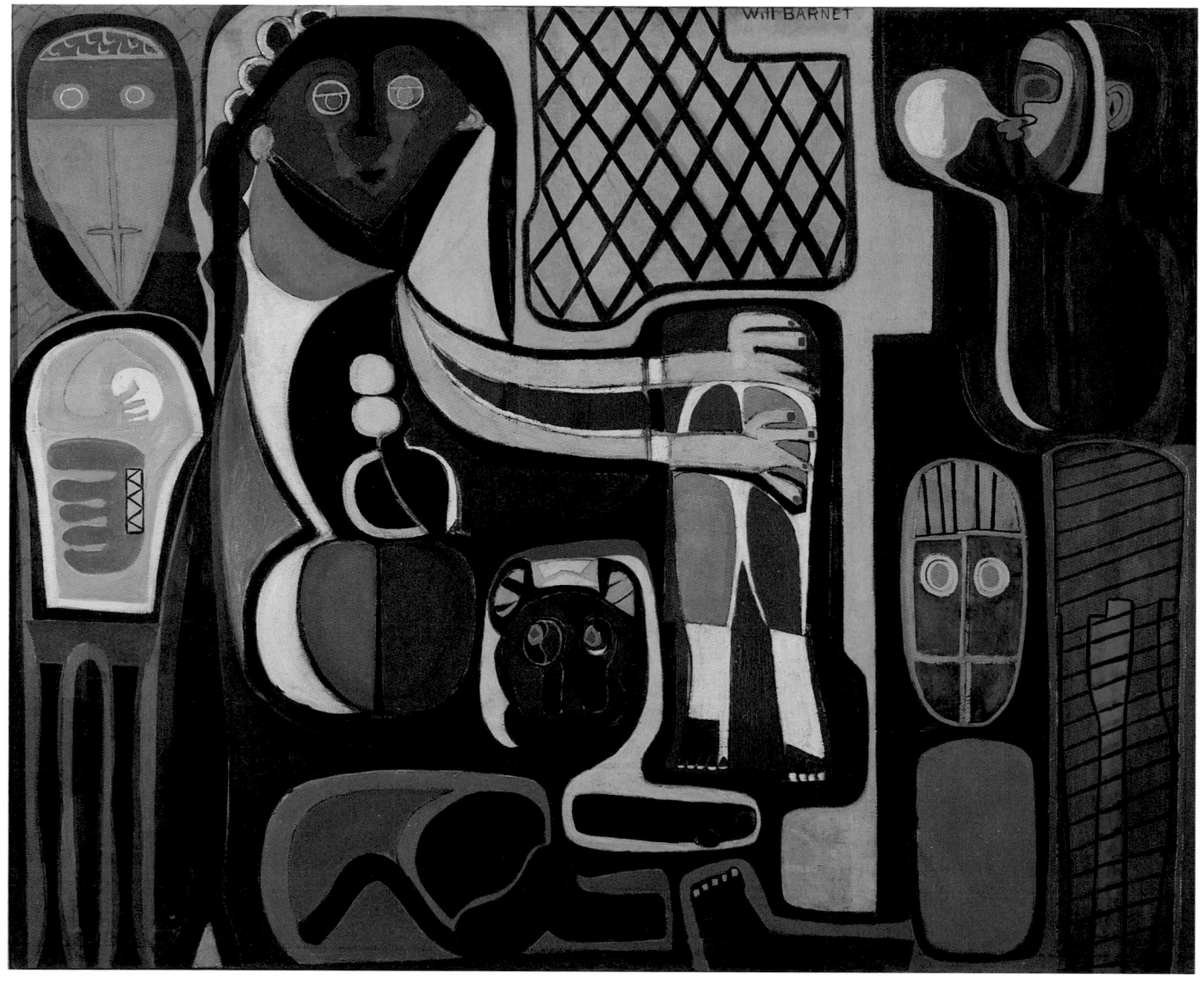

Will Barnet, *Awakening*, 1949, oil on canvas, 42 x 52 inches. Currier Museum of Art, Manchester, New Hampshire, Gift of Will and Elena Barnet, 1986.43

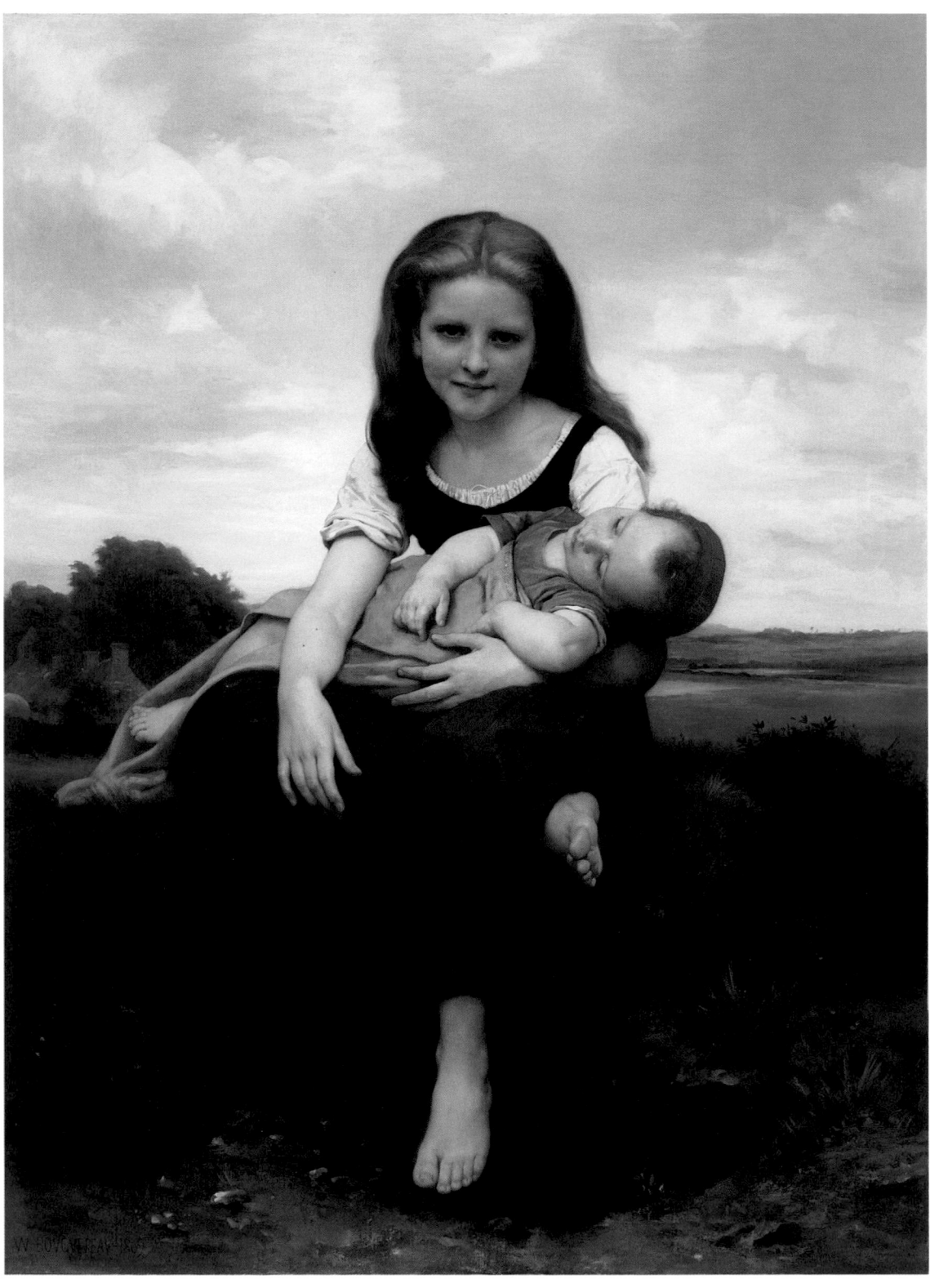

William Bouguereau, *The Elder Sister*, 1869, oil on canvas, 51 ¼ x 38 ¼ inches. The Museum of Fine Arts, Houston. Gift of an Anonymous Lady in memory of her Father, 1992

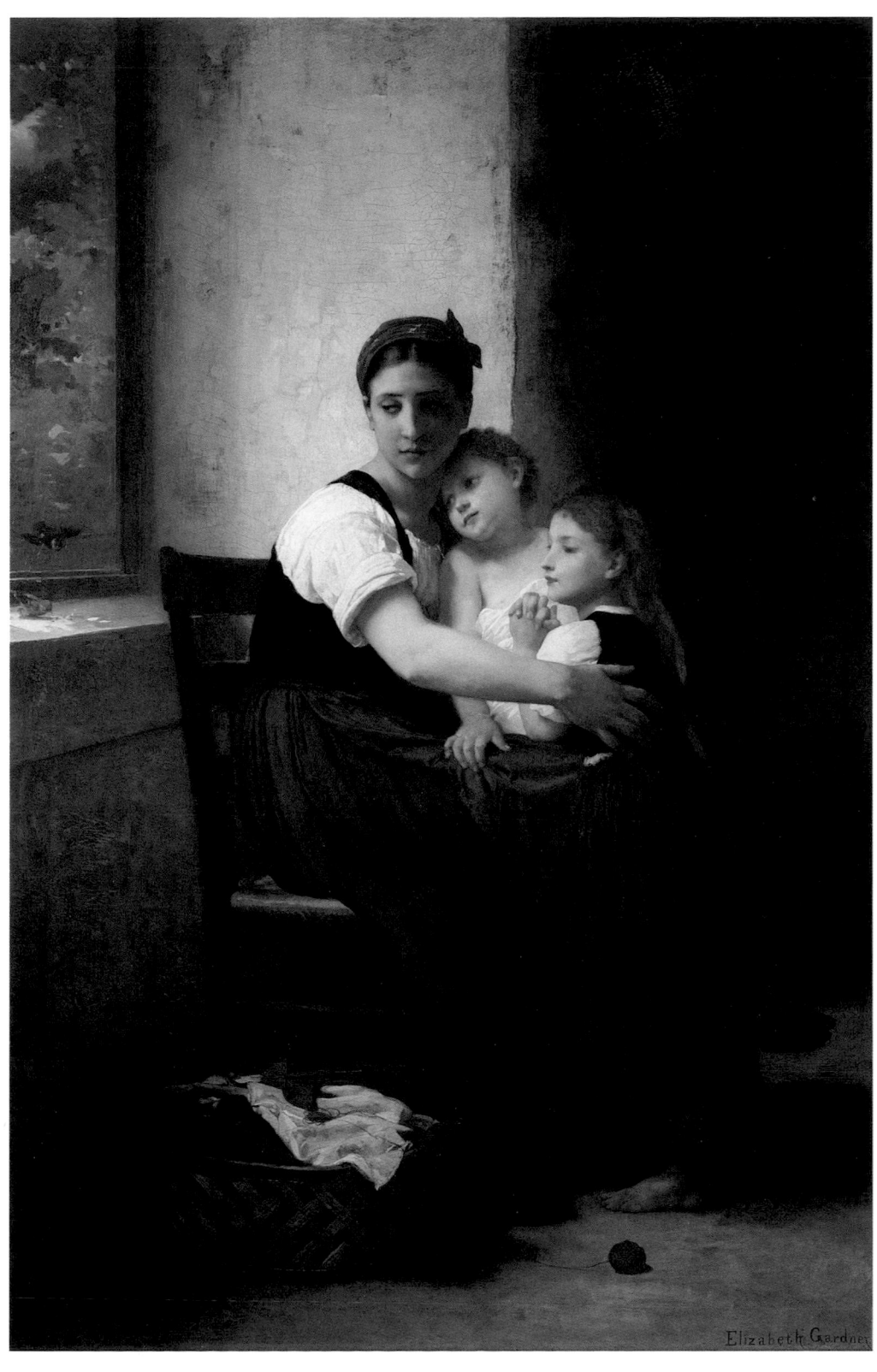

Elizabeth Jane Gardner Bouguereau, *He Careth*, circa 1883, oil on canvas, 48 x 32 inches, The Philbrook Museum of Art, Tulsa, Oklahoma, Gift of Laura A. Clubb, 1947.8.84

Eakins and the Male Nude in French Art, 1850–1890

Richard R. Brettell

Thomas Eakins ended a lengthy and seminal stay in France and on the Continent with a visit to the Salon of 1870.[1] While there, he almost certainly saw a revolutionary painting of male bathers by the young French artist Frédéric Bazille, who just months later was to be killed in a battle during the Franco-Prussian War. Eakins probably never met Bazille, who operated in very different—and more aesthetically advanced—circles than the American, but there is no doubt that Eakins was thoroughly prepared for Bazille's awkward but powerful work. Indeed, the brilliant American had already lamented contemporary representations of the nude by 1867, his first full year in France, in a letter written after he had seen the immense—and, from all accounts, immensely dull—exhibition of painting held in the International Exhibition of that year. "The French court has become very decent since Eugenie [the Spanish-born empress of France] had fig leaves put on all the statues in the Tuileries. When a man paints a naked woman he gives her less than poor nature did. I can conceive of few circumstances wherein I would have to paint a naked woman, but if I did, I would not mutilate her for double the money. She is the most beautiful thing there is—except a naked man, but I never saw a study of one exhibited—It would be a godsend to see a fine man painted in a studio with bare walls. . . . I hate affectation."[2]

It was the simple honesty of painted representation that appealed to Eakins, and surely that honesty must have struck him when he saw Bazille's *Summer Scene* (page 38). For both young artists, as for many of their generation trained in France, the quintessential subject of classical sculpture, the nude, presented a continuing challenge to the art of painting, and, in order to succeed as a painter, representational mastery over the human body was vital. Eakins's own greatest painting of male nudes, *Swimming* (page 39), was completed more than a decade later and has few stylistic relationships to Bazille's work. Yet each work struggles to define a role in painting for both the contemporary nude and the male nude.

The female nude dominates what we now call the discourse surrounding the origins of modern European paintings.[3] The history of modern art begins with Édouard Manet's female nudes of 1863, and discussions of class, sex (or, rather, sexism), commodification, sources, "style," and other issues that emerge from repeated analyses of *Le Déjeuner sur l'Herbe* and *Olympia* (both Musée d'Orsay, Paris) dominate our very idea of pictorial modernism.[4] The extraordinary advances made in feminist art history have centered on the interpretation of the female nude, and one can scarcely imagine the most trenchant work of Linda Nochlin, Griselda Pollock, Norma Broude, Tamar Garb, Kathleen Adler, and others without images of

1. Gordon Hendricks, *The Life and Work of Thomas Eakins* (New York: Grossman Publishers, 1974), p. 64. For more detailed treatment of Eakins in Paris, see Kathleen A. Foster, "Philadelphia and Paris: Thomas Eakins and the Beaux-Arts" (Master's thesis, Yale University, 1972).

2. Hendricks, 1974, p. 14.

3. The word *modern* is here used in the "old-fashioned" sense to connote vanguard or antiacademic painting from 1850 to 1940.

4. The most eloquent and difficult discussion of Manet's nudes can be found in T. J. Clark, *The Painting of Modern Life: Paris in the Art of Manet and His Followers* (New York: Alfred A. Knopf, 1984).

5. The most convenient collection of this enormously rich bibliography can be found in *The Expanding Discourse: Feminism and Art History*, ed. Norma Broude and Mary Garrard (New York: HarperCollins, 1992). Linda Nochlin's lectures and essays (see *Bathtime: Renoir, Cézanne, Daumier and the Practices of Bathing in Nineteenth-Century France* [Groningen: Gerson Lectures Foundation, 1991]) have rigorously analyzed the ubiquitous female bather in nineteenth-century French art, with its manifold social, psychological, and moral meanings. She has neglected nothing—scientific texts on bathing, hygiene, and athletics, as well as poetry, novels, and moral treatises—to create a verbal discourse for images that range from obscure and unphotographed academic paintings to well-known works by Monet and Renoir.

In most of this literature, men are scarcely mentioned, except reproachfully as the intended viewers for these supremely sexist works. Only Manet is spared the critical contempt of modern feminist critics, mostly because, through controlling the female gaze, he rendered the male viewer self-conscious to such an extraordinary degree that his intention must have been to instill guilt in his well-stuffed bourgeois viewers. Unfortunately, in the absence of Manet's words, we will never know the precise nature of his intentions.

6. This essay will concentrate on the part of that tradition that bears immediate comparative impact on an understanding of Thomas Eakins's *Swimming*. A full treatment of the subject is the proper subject of a dissertation and/or book.

7. To my knowledge, the only modern exhibition in which the subject of male bathing or the male nude in modern art has played any strong role was the *Cézanne Bathers* exhibition of 1988 in Basel.

female nudity.[5] "Sexism" and the sexuality of human discourse in art seems optimally inscribed on the nude (or naked) female body.

Yet, oddly enough, a good many of the most powerful and ambiguous vanguard paintings of the nude made in the 1860s, 1870s, and 1880s represent, not the female, but the male nude, and very few of these works have been subjected to the kind of rigorously critical analysis reserved for representations of women. Indeed, in a direct descent from Gustave Courbet's *Wrestlers* of 1853 (page 40), modern artists have created images of male nudes (or almost nudes) that should be analyzed in terms analogous to their better-known images of the female nude. One can immediately cite works by Camille Corot, Pierre Puvis de Chavannes, Edgar Degas, Thomas Couture, Pierre-Auguste Renoir, Bazille, Paul Cézanne, Gustave Caillebotte, Paul Gauguin, and Manet in French art alone—and examples from Max Liebermann to Hans von Marées or Edvard Munch outside the French national tradition.[6]

These works, however, must be considered a hidden tradition,[7] because many were neither exhibited nor published during the lifetimes of their artists, and others were greeted with such controversy, even in progressive circles, that their appearances were suppressed. Exemplifying the first approach are Degas's two large paintings *Young Spartans Exercising* (page 41 and a monochrome version in the Art Institute of Chicago).[8] These ambitious "history" paintings, the first in Degas's career, deal not with an elevated and specific historical subject but, rather, with a sort of classical genre scene. In his depiction of the training of young Spartan boys and girls, Degas represented some of both genders in the nude. Although all Degas scholars suggest that the paintings were begun circa 1860, only the larger of the two versions (page 41) was finished for exhibition in 1880, twenty years after its genesis; for reasons we shall never know, Degas failed to include it in the fifth Impressionist exhibition, although it is listed in the catalogue.[9] Was this the artist's own suppression of his work? Degas, who seems never to have exhibited a male nude, may have lost his nerve when it came time to show this powerful work that deals directly with the training and cultural significance of the body. Similarly, Renoir, whose only male nude is among the most apparently "perverse" paintings in the history of modern art, never exhibited his *Boy with a Cat* (page 45), and, in fact, the painting was not included in any exhibition until 1994 (*The Origins of Impressionism*, The Metropolitan Museum of Art, New York, and Musée d'Orsay, Paris).[10]

An example of the second sort of suppression is Gustave Caillebotte's masterful *Man at His Bath* of 1884 (page 42). This superb work, among the masterpieces of Caillebotte's short career, was sent in 1888 to the vanguard exhibition of Les XX in Brussels, where, in spite of the progressive aims of the organizers, it seems to have excited such controversy that it was moved to a closet or locked room outside the exhibition proper.[11] Clearly, the kind of ambivalence toward the male nude that continues to this day in photography and films was very much present in the nineteenth century, even among progressive artists. And, as all students of Eakins's career have shown, the controversy that swirled around the American master reached its zenith at the time he painted his only great representation of the male nude, *Swimming*.

How and why did this tradition develop when it did? It is a truism to say that the male nude is the central subject of Western sculpture and that, from the Greeks onward, nudity was considered more appropriate to male subjects than to female ones. There is, for example, no full-scale nude female in Greek sculpture of the sixth century B.C., despite the fact that there are literally hundreds of full-scale nude male figures. (Many art historians claim that the first female nude in Greek sculpture is the *Dying Naiad* of the late fifth century.) There are also comparatively few female nudes in later Greek and Roman sculpture and in Renaissance sculpture, in which male nudity abounds and female nudity, though not rare, is of lesser quantitative significance. However, by the late fifteenth and early sixteenth centuries, female nudity fully entered the realm of painting, sharing it equally with male nudes well into the seventeenth century, when male nudity in both painting and sculpture began a long, slow decline.

By the middle of the nineteenth century, male nudity was reserved for select scenes of classical history or for religious paintings of the death of Christ, St. Sebastian, and other martyrs. There were exceptions, but few, suggesting that, by 1800, male nudity signified the past in its variously classical guises. For French art, there is one powerful exception, Théodore Géricault's immense *Raft of the Medusa* of 1819 (Musée du Louvre, Paris). Because it represented a scene from contemporary history, included detailed descriptions of nude male (rather than female) bodies, and because it was then, as it is now, a famous work of art, the painting must be seen as the touchstone for all subsequent painters who made an attempt to represent the male nude.

The first major vanguard painting that dealt forcefully and officially with the male nude in a contemporary setting was Frédéric Bazille's *Summer Scene* (page 38).[12] Painted in 1869–70, it was accepted (to the surprise of its maker) in the Salon of 1870. Curiously, the painting was submitted with an equally large and ambitious Orientalist painting of a full-scale female nude, which was rejected by the jury.[13] *Summer Scene* can be read as Bazille's response to the larger *Wrestlers* of Courbet (page 40), whom Bazille had met by the spring of 1866 and with whom he remained on good terms throughout his life.[14] The "embedded tradition" of the male nude is pushed to America because Thomas Eakins probably saw Bazille's painting at the Salon of 1870.

For this reason, Eakins's American painting *Swimming*, of 1885, engages directly with a newly emerging European tradition that took on added force in the 1870s, when Cézanne began to paint male bathers almost obsessively. Few American paintings of the nineteenth century play important roles in sequences of major works of European art, and Eakins's *Swimming* is one of those few. It is the intention of this essay to place the work in a larger history of art rather than the American history to which it is most often relegated. The sequence of male nudes by Courbet, Bazille, and Eakins can be seen as a real sequence of works that demand to be interpreted both in regard to one another and as a cumulative response to a tradition of painting that gave privilege to the female nude as the carrier of

8. The liveliest recent discussion of this painting that includes all earlier interpretations is Norma Broude, "Edgar Degas and French Feminism, ca. 1880," in Broude and Garrard, 1992, pp. 269–80.

9. See Charles S. Moffett, "Disarray and Disappointment: The Fifth Exhibition, 1880," in Moffett et al., *The New Painting: Impressionism, 1874–1886* (San Francisco: The Fine Arts Museums of San Francisco, 1986), pp. 299–301.

10. This curious painting was recently purchased by the Musée d'Orsay in Paris. Interestingly, its first owner was Bazille's best friend, Edmond Maître.

11. The most recent discussion of this provocative painting can be found in Gloria Groom's entry in the exhibition catalogue *Gustave Caillebotte: Urban Impressionist* (New York: Abbeville, 1995), pp. 216–17. Interestingly, two feminist scholars have recently discussed the erotic—or homoerotic—content of this painting. Tamar Garb provoked an audience in a recent lecture at the Art Institute of Chicago, while Julia Bernard took such notions into print in a fascinating article, "Impressionism: Boys' Club," in *Text zur Kunst* 5, no. 17 (February 1995): 168–73.

12. The painting made its most recent appearance in Gary Tinterow and Henri Loyrette, *Origins of Impressionism* (New York: The Metropolitan Museum of Art, 1994), where it was discussed both in the lengthy essay on representations of the nude by Loyrette (pp. 95–123) and in an exemplary entry by Tinterow (pp. 334–35).

13. This canvas, *La Toilette*, is now in the Musée Fabre in Bazille's hometown of Montpellier.

14. The meeting is recorded in a letter Bazille wrote to his parents. Bazille's father was involved in the acceptance by the town of Montpellier of the gift of the Bruyas Collection in 1869. The Bruyas Collection was the single most important holding of Courbet's works then in private hands and was well known to the young painter. See *Frédéric Bazille: The Prophet of Impressionism* (Brooklyn: The Brooklyn Museum, 1992), p. 161.

15. The most accessible of the numerous discussions of the French art world before and after the Franco-Prussian War can be found in Paul Hayes Tucker, "The First Impressionist Exhibition in Context," in Moffett et al., 1986, pp. 93–117.

16. Unfortunately, only the titles of works in the catalogue can help us to identify other male nudes in the Salon exhibition in 1870, and these are notoriously unreliable as proof. However, due to the prominence of Bertall's caricature of Bazille's painting in *Le Journal Amusant*, we can safely assume that it was the most visibly controversial of these works. Others would have been representations of Christ, St. Sebastian, or one or more classical heroes in battle.

17. Zacharie Astruc, "Le Salon de 1870," *L'Echo des Beaux-Arts*, June 12, 1870, pp. 2–3; Edmond Duranty, "Salon de 1870," *Paris-Journal*, May 19, 1870, p. 2.

18. For an accessible reproduction of this cartoon, see the exhibition catalogue *Bazille: Prophet of Impressionism*, 1992, p. 50.

meaning for male artists and male viewers. Courbet, Bazille, and Eakins had the courage to confront issues relating to the body by using the male body. They also created powerful images of male bodies for public exhibitions at which members of both sexes and all ages could freely analyze these images. The wrestling men and all-male swimmers were wrenched from the complete privacy that they occupied in actual life and were liberated or opened to public scrutiny through representation. Was this maneuver any less radical—either aesthetically or socially—than Manet's liberation of the naked courtesan from her position of dominated privacy or from the corners of the bois de Boulogne to the Salon itself?

The answer, unfortunately, is yes. We know from counting column inches of criticism that Manet's confrontational courtesans were infinitely more shocking to French, European, and American viewers of the Salon des Refusés in 1863 and the Salon of 1865 than the (almost) nude men of Bazille were in the Salon of 1870. Perhaps because of this, they remain dominating today. Yet, it must be remembered that Eakins lost his job at the Pennsylvania Academy of the Fine Arts over issues of morality and freedom foreshadowed in *Swimming* and that Caillebotte's greatest male nude was actually censored from a major exhibition of vanguard art. Given this, we must ask an obvious question. Had Bazille's bathers in *Summer Scene* actually been nude, as he planned them to be, and had the painting been shown at a Salon when the French were less distracted by politics and economics than they were in the late spring and early summer of 1870, would the history of modern art have been differently written?[15] Sadly, we shall never know, because Bazille lost his nerve and covered what would have been the offending genitalia with trunks, and, within months, the French were at war with the Prussians, rendering issues that would have consumed all Paris in 1865 marginal in 1870. Indeed, Bazille himself was dead within five months of the exhibition of *Summer Scene*.

Given his oft-quoted comment about the ultimate beauty of the male body, Eakins must have been struck by the naturalism and utter frankness of Bazille's bathers. There were not many representations of the male nude that could compete with Bazille's in the Salon.[16] Eakins's command of French was excellent, but it is unlikely that he read the gushy but fascinating descriptive analysis of Bazille's painting by Manet's and Degas's friend Zacharie Astruc, or the more measured passage by Edmond Duranty, who would go on to champion the young Impressionists in his brilliant review of their 1876 exhibitions.[17] Eakins had too little time to keep up with the critics and probably was preoccupied with the arrangements for his own return to the United States after more than two years in Europe. Yet, perhaps he did see the widely circulated caricature of Bazille's painting by Bertall in *Le Journal Amusant*, which, in itself, raises fascinating issues about the representation of desire in works of art.[18]

During those two years and the decade that followed them, Eakins was intermittently faithful to the academic art practices and norms of his French master, Jean-Léon Gérôme (although the extent of this fidelity has been exaggerated by modern students of Eakins and Gérôme).[19] We have learned from students of French academic practice like Albert Boime and Gerald Ackerman and from Kathleen Foster and Barbara Weinberg, who studied the American

students of Gérôme and his compatriots, that Gérôme's attitudes toward art were completely opposed to those espoused by the young artists Claude Monet, Alfred Sisley, Renoir, and Camille Pissarro, with whom Bazille worked. Yet when Eakins himself turned to the subject of *Swimming*, he most likely did so with a clear memory of Bazille's work.

Few visitors to the 1870 Salon could have missed *Summer Scene* when it made its only nineteenth-century appearance. At once large and vividly colored, it must have virtually screamed from the walls of the Salon galleries. Its size was calculated for a favorable hanging— at once large enough to play a major role on a wall, square so that it would most likely have been centered on the wall, and small enough to prevent its being "skied," as were canvases of truly immense size. When we compare it with a highly successful, but slightly earlier, Salon painting dealing with male nudity by Henri Regnault, another young artist who was not to survive the Franco-Prussian War, the real originality—and the "naturalness"—of Bazille's seemingly contrived composition becomes clear. Regnault's *Automedon with the Horses of Achilles* (page 43) ensured the reputation of its young painter with its powerful figure, its extraordinary horses, and its post-Romantic swagger.[20] For Regnault, the male nude signified "classical history," and with the rippling muscles and gigantic horses derived from Leonardo da Vinci, Peter Paul Rubens, and Eugène Delacroix, Regnault's composition was so completely concocted as to be almost comic. Eakins also saw Regnault's "masterpiece," but, fortunately for his subsequent reputation, he was smart enough to take more cues from Bazille than from Regnault.

In painting *Summer Scene*, Bazille set himself a series of pictorial problems that would have made Regnault wince—the integration of eight separately observed male figures (one mostly immersed in the water) in a light-filled landscape that is itself as visually interesting and varied as the figures. As if in recognition of the difficulty of these "problems," Bazille worked harder and for a longer period at this painting than at any other Salon painting of his short career. Several letters allow us to understand its genesis. It was begun in April 1869 in Paris, where he made a series of figure drawings about which he wrote his father: "I am sketching in ahead of time the figures for the painting of male nudes I plan on doing in Méric."[21] In another letter, written from Méric to Paris, Bazille indicated that he would arrive in Paris with only one canvas, which he called "the nude men" and which was unfinished and unresolved. In neither of these letters does he refer to the painting in terms of bathing, stressing instead simply the nudity of the male figures.[22] This supports a reading of the painting as a study of male nudity in which the subject of bathing is largely a pretext for that nudity.

When considered in this light, the most remarkable aspect of the finished painting is that none of the figures is actually nude. Clearly, Bazille dithered over this. Of the seven figures in the most resolved of the compositional drawings (Musée du Louvre, Paris, Département des Arts Graphiques, R.F. 29731), only the largest in the foreground is wearing bathing trunks.[23] The others, whether wrestling, toweling themselves, or resting, are nude. Unfortunately, there are no surviving drawings from individually posed models, such as those to which Bazille

19. Gerald Ackerman's path-breaking essay, "Thomas Eakins and His Parisian Masters Gérôme and Bonnat," *Gazette des Beaux-Arts* 73 (April 1969): 235–56, first analyzed Eakins's French training and measured its subsequent effect on his career. Barbara Weinberg first elaborated on this trend in her important study of the American pupils of Gérôme, Bonnat, and Alexandre Cabanel (H. Barbara Weinberg, *The American Pupils of Jean-Léon Gérôme* [Fort Worth: Amon Carter Museum, 1984], pp. 35–47). Both of these works are excellent as far as they go, but their point of view assumes a greater degree of fidelity to teachers than is often the case in the best of students. They both also play down the relative importance of exhibitions, criticism, and the general artistic discourse at the time, preferring to concentrate on the classroom and studio instruction.

20. The Museum of Fine Arts, Boston, purchased this major painting by subscription in 1890. It has not been shown for more than a generation and thus plays a role as an academic male nude that, like its vanguard counterparts, has been suppressed by the modern museum and by scholarship. See Alexandra R. Murphy, *European Paintings in the Museum of Fine Arts, Boston: An Illustrated Summary Catalogue* (Boston: Museum of Fine Arts, 1985), p. 237. The museum also owns an oil sketch for the painting. [Since this essay was written, the Regnault has been conserved and handsomely installed in the museum's galleries, in its original frame.— ED.]

21. See J. Patrice Marandel, *Frédéric Bazille and Early Impressionism* (Chicago: The Art Institute of Chicago, 1978), no. 75, p. 180.

22. François Daulte, *Frédéric Bazille et son temps* (Geneva: Callier, 1952), pp. 76–77.

referred in the first letter about the painting. For this reason, we shall never know quite why Bazille decided to dress his figures in bathing costumes, as a close examination of the painting makes clear that he did. While it was common for academic artists of the nineteenth century to study posed figures in the nude and subsequently to represent them clothed in a finished painting, I know of no other cases in the oeuvres of other artists in which figures in a Salon painting were painted nude and then "clothed" in paint. Perhaps Bazille made such a prudish decision because his last painting of a male bather, *Fisherman with a Net* (page 44), had been completely nude and had been rejected by the Saion jury in 1869.

Fisherman with a Net contrasts fascinatingly with *Summer Scene*. It, too, was created as a pendant to a genre portrait of a woman.[24] In the earlier pairing, Bazille evidently intended that his two identically sized vertical canvases (the other, *View of the Village*, is in the Musée Fabre, Montpellier) would both be accepted by the Salon jury; perhaps he also hoped that, for reasons of their identical size and the reverse directionality of their compositions and imagery, they would be hung to the left and right of a central painting at the midlevel of the wall. The seated woman was much admired by members of the jury, but they rejected the male nude, and their reasons, though never stated, must surely have involved the ambiguously erotic nature of Bazille's representations.[25] Although posed as a fisherman in a manner familiar to students of classical sculpture and represented from the back, without offending genitalia and pubic hair, Bazille's figure is clearly an actual man, whose back, buttocks, and profile head were painted with a sensuousness that must have been too much for the jury. For that reason, the powerful binary tension between a standing nude man in an active pose and a seated, clothed woman in a passive pose—which Bazille surely intended in this pairing—was never realized in his lifetime.[26] What is surprising, even shocking, about the pairing is that the nude male is erotic and the seated female is chaste, thereby reversing the norm.

The overt eroticism of Bazille's *Fisherman with a Net* places the beholder of the painting in an awkward, ambiguous situation. We have no choice but to gaze at this centered and posed figure, and the placement of that figure in a real landscape with houses and an equally nude and equally inaccessible companion in the middle ground signify contemporary reality, adding further to the psychic confusion of the beholder. As viewers of paintings, we would have no such problems with an identically arranged male nude were he set in a classicizing landscape with Roman buildings. What is radical about *Fisherman with a Net* is that, while it retains classicism in the pose of its central figure, it jettisons precisely the aspect of the classical tradition—an archaeologically conceived setting—that allows the beholder to be distanced from the figure.

Measuring Bazille's intentions here is as difficult as deciphering those of Eakins in painting *Swimming*, and the inherent ambiguity of both pictures—their uneasy contemporaneous classicism—is their most compelling feature. Each denies the existence of the beholder because each describes a self-sufficient and internally closed world. At the same time, each painting possesses a real contemporaneity because of the temporal and, hence, physical prox-

23. The most accessible photographs of the surviving drawings related to *Summer Scene* can be found in *Bazille: Prophet of Impressionism*, 1992, pp. 116–17.

24. The fact that the two paintings are of virtually identical size and can, for that very reason, be interpreted as a pair has never been noted in the Bazille literature. It is perhaps because Bazille's evident gamble at having both pictures accepted failed, thereby forever separating them from paired consideration. From the point of view of sex roles and the sexuality of the body, joint analysis of the paintings is considerably more interesting than the isolated discussions that have filled the literature. Too often in the literature, paintings are discussed exclusively in terms of "like" paintings, thereby rendering many aspects of their comparative meanings irrelevant.

25. The most fanatic enemy of the circle of young artists around Bazille on the Salon jury of 1869 was none other than Eakins's teacher, Gérôme. Bazille himself wrote that Gérôme called them "madmen, and declared that he felt it was his duty to prevent our paintings from appearing" (*Bazille: Prophet of Impressionism*, 1992, p. 112). For that reason, it is highly likely that Eakins and the other students of Gérôme were actually warned *against* the work of these artists. I can think of no better instrument for piquing the curiosity of the young than the strong rejection by a senior authority figure!

26. The two paintings were shown together at the Bazille retrospective in 1910 and again in Montpellier, Brooklyn, and Memphis in 1992–93.

imity of the subject. Each also plays with notions of "the classical" in the posed quality of the figures and in the balance and coherence of the pictorial field. Bazille's painting contains perhaps a greater element of risk through its inclusion of domestic architecture in the middle ground, suggesting by this that the scene is not located in a physically remote setting. This, when one remembers that Bazille's painting was set in his native Provence, is proof that the painter made conscious links between classical civilization and its derivative in modern Provence. Surely Eakins had a similar intention in painting *Swimming*, with its clearly classical, even pedimental composition that also encourages viewers to leap from the world of the Mediterranean ancients to a successor civilization near Philadelphia, the cultural capital of the modern United States.

Yet, fascinating as the connections are between *Fisherman with a Net* and *Swimming*, there are no direct links between the paintings.[27] Instead, the actual visual history of Eakins's masterpiece is through Bazille's larger and more complex *Summer Scene* (page 38). The figures in Bazille's painting are arranged in three distinct planes that recede into space. Their setting, a meadow surrounded by birch trees and bordered by a pool, is placed within the agricultural landscape of western Provence, where the painter's family lived. In spite of the unity of the landscape setting, the figures are treated separately and placed in the setting in ways that emphasize their discontinuities. The full-scale figure in the left foreground has often been linked to figures of St. Sebastian, the male body that seems to be the site of the greatest homoerotic fantasizing in Christian art.[28] He leans against the scarred trunk of a birch tree, seeming to shrink from both the water and the sun, his eyes downturned and lost in thought. The strong shadows of the model's legs heighten our sense of his physicality, while the opened fingers of his hand resting on the tree clearly signify tactility. If he is "dry" and placed mostly in the sun, the other two bathers in the foreground are both immersed in the cool, shaded water of Bazille's pool, and their degrees of immersion clearly contrast. The central figure seems literally to have emerged from the water, and only his shoulders and head are in air. Of all the figures, he seems most like a boy or an adolescent, and his evident youth actually alters our reading of the painting. What at first appears to be a group of young male friends on an outing gradually becomes a group of young men, who may or may not be together, sharing the field and the pond with a boy. The very discontinuity among the figures strengthens an interpretation of shared rather than collective activity, and the fact that they are not nude, but wearing swimming trunks, gives the setting the quality of a quasi-public place.

The figure who emerges from the pool with the help of a partially clothed friend is the oddest and most disconcerting of the entire painting. This figural group seems to have been added to the composition during the summer months of 1869, after the compositional drawing was completed, and its effect on the composition is to activate it and to disperse its energies. The figure with one leg in the water is of an unparalleled awkwardness. No similar figure comes to mind in the entire history of Western art, and certainly not in the numerous representations of the Baptism of Christ that such a pairing of male figures might suggest.

27. We know from Bazille's letter quoted above that Eakins's teacher, Gérôme, was so upset by the work of certain young artists that he did everything possible to ensure that they were rejected from the Salon. Of the rejected paintings by Monet, Renoir, Bazille, and Pissarro, *Fisherman with a Net* had the most potentially shocking subject. Did Gérôme discuss it with his students?

28. Dianne Pitman points out that Bazille had already done a drawing of St. Sebastian. She also associates both the standing and the reclining figure on the left with specific sources: a *St. Sebastian* attributed to Jacopo Bassano at the Musée des Beaux-Arts, Dijon, and a *Landscape with a Shepherd Playing a Flute* by Laurent de la Hyre in Montpellier at the Musée Fabre (*Bazille: Prophet of Impressionism*, 1992, p. 119).

Only in some of the complex figural theatrics associated with various Descents from the Cross or in multifigural groupings of purgatory or hell can one find anything comparable, though not directly analogous.

Only one of the main figures in *Summer Scene* (the boy immersed in water) would, if unclothed, be as decorous as the central male figure in *Fisherman with a Net*. Every one of the seven remaining figures would have exposed genitalia, and, to make matters even more uncomfortable, most of the figures are placed in the immediate foreground of the composition, where their position with respect to the beholder does not allow for many forms of "distancing." Fortunately, Bazille helps us by clothing all of these figures in bathing trunks and by creating a situation in which none of them engages the beholder and only a few engage each other. This dispersal of gazes—both internally and externally—is one aspect of the painting's complex aesthetics. It is as if Bazille anxiously presents a summer scene of almost unparalleled physicality and immediacy and then, afraid of his very achievement, pulls the scene apart into various disconnected subscenes, each independent of the others. The mental and physical worlds of each figure or figural group are juxtaposed rather than unified, resulting in a work of art of perplexing discontinuity.

The very effect of this painting is to force the beholder to gaze separately at each figure and, thus, to do something in looking at the painting that one would not do in life—to gaze for some time at contemporary nude or partially clothed male figures. Indeed, young men who swim, wrestle, and sun together out of doors are permitted to touch each other only in forms of combat or support and are never encouraged actually to look at one another. In this painting, the beholder is placed in the awkward situation of being a voyeur of a scene that, through representation, raises challenging questions about the beauty of the actual male body. Even the earliest commentators about the painting noted certain quotations from old master painting, quotations that seem to have been cited to give a certain aesthetic validation to the scene. One source, as has been noted, was a religious image of a beautiful, young martyred saint. The adjacent reclining figure has been identified with the river god in Raphael's *Judgment of Paris*, engraved by Marcantonio Raimondi (the source for Manet's *Déjeuner sur l'Herbe*), and with a more compellingly similar figure in a landscape by Laurent de la Hyre, which Bazille saw in his hometown museum, the Musée Fabre in Montpellier.[29] The wrestling figures surely derive from a more immediate source, Courbet, who knew Bazille and had actually visited his studio. And the others seem not to have had sources in works of art or reproductions of them but were derived from observing—and then probably reposing—actual figures either in Paris or, in the case of the pair of figures on the right, in Provence.

The only scholar to confront directly the issue of homoeroticism and Bazille was Kermit Champa in his review of the 1978 Bazille exhibition at the Art Institute of Chicago. Although the more frankly erotic *Fisherman with a Net* was not then available for loan, Champa recognized *Summer Scene* as a signal to the world—perhaps an unconscious signal—of the painter's homosexual tendencies. His words bear quotation, not because he presents any

29. For a full quotation of the critical contemporary texts by Astruc and Duranty and for some additional discussions of figural sources, see Gary Tinterow's entry for the painting in *Origins of Impressionism*, 1994, pp. 334–35.

basis in written documents, but because they are among the few frank—and frankly sexual—interpretations of a major modern painting as homoerotic:

> LIKE COURBET, BAZILLE RESPONDS BOTH TO THE TITILLATING FACT OF PICTURED NUDITY AND THE SECONDARY VOYEURISTIC EXCITEMENT OF WATCHING PICTURED TITILLATION. SINCE BAZILLE'S PREFERENCES WERE PRETTY CLEARLY ORIENTED MORE TOWARD MEN THAN WOMEN, IT IS NOT SURPRISING THAT SUMMER SCENE IS MUCH RICHER IN INNUENDOES THAN TOILETTE [THE ORIENTALIST FEMALE NUDE REJECTED BY THE SALON JURY IN 1870]. FURTHER, IF ONE CAN IMAGINE THE IMAGE WITHOUT BATHING SUITS (AT LEAST SOME OF WHICH ARE LATER RE-TOUCHES, I CURRENTLY SUSPECT, PENDING X-RAYS OF THE CANVAS) THE RANGE OF INNUENDO BECOMES POSITIVELY ALARMING. BAZILLE . . . HAD IN SUMMER SCENE APPROACHED A CONCEPTUAL AND PSYCHOLOGICAL SHADOWY AREA, BORDERED ON ONE SIDE BY FACT AND ON THE OTHER BY PERSONAL FANTASY PURPORTING TO BE EXTERNAL FACT.[30]

Although this is certainly possible, one might even say likely, there is no actual evidence beyond the painting itself to support this view. And in an age in which verbal documentation is crucial to the establishment of art historical proof, this purely visual analysis is, perhaps, insufficient. Yet one suspects, given the pictorial context in which *Summer Scene* is set, that Champa is correct. Like most young artists in the nineteenth century, Bazille cut his teeth by representing the nude model, mostly male, and then turned to representing the nude woman. His first major painting of a nude, the full-scale *Sleeping Nude* of 1864 (Musée Fabre, Montpellier), is absolutely the opposite of Manet's realist nudes in its exploitation of the naked female. Because the woman appears to be sleeping, with her arm covering her nose and eyes, she has no individuality or character. She is simply a body, indecorously placed on the floor of a Parisian studio. How different she is from Renoir's or Manet's nudes, who are clearly actual women and who, in certain cases, aggressively engage the viewer in a kind of aesthetic dance by making eye contact. For Bazille, this was either an undesired aesthetic stance or, for deeper psychological reasons, impossible for him to picture. Indeed, all of his female characters are remote and inaccessible to the viewer, either in the company of other women or completely clothed. And, when one compares the female with the male nudes, it is clear that most of Bazille's erotic energy went into the fantasist rendering of the male.

Here, one confronts the central problem in interpreting Bazille's painting—and also the central reason why, despite the numerous stylistic differences between it and Eakins's *Swimming*, it is so clearly the prototype for Eakins's experiments in the mid-1880s. No earlier painting known to Eakins had the same combination of sublimated or fantasist homoeroticism and sheer realism as Bazille's oddly unsatisfying painting of 1869–70. Eakins was, in many senses, ready for Bazille's painting at the Salon of 1870, but in other, more profound, senses, he

30. See Champa's fascinating review in *The Arts*, no. 10 (June 1978): 109–10. Another cryptic, but brilliant, sentence also sheds light on Bazille's imagery: "It was Bazille's anxiousness to address realist painting's most compelling and difficult issues of imagery that allowed him to run so insensitively and with such pictorial persuasiveness through its evolving intricacies of form" (p. 110).

needed more than a decade before he could himself find a situation in which his life experiences, a commission, and his teaching could free him enough to represent the nude male in a contemporary setting.

In fact, the examples of Delacroix, Manet, and, more immediately, Léon Bonnat allowed Eakins first to represent the male nude as the crucified Christ (Philadelphia Museum of Art). This painting, one of a long series of representations of the nearly nude Christ, could not be shocking simply because of the nudity of the figure. The relative moral "safety" of this condition allowed Eakins to deal with the nude male subject in relative freedom. However, it was only with the commission of *Swimming* by Edward Hornor Coates, discussed so fully by Doreen Bolger,[31] and with his seemingly unassailable position with his students that Eakins found a situation in which he could treat the contemporary male nude in the manner of Bazille.

Many scholars have worried about the meanings of Eakins's male nudes, turning, as early as Gordon Hendricks in 1974, to a consideration of the painter's own sexuality as the possible explanation for the painting, but few students of European art have made similar efforts to explain the male nudes of Courbet, Degas, Bazille, Renoir, Cézanne, Caillebotte, and Gauguin. Of course, no one could even utter the word *homosexuality* in a discussion of Courbet, Renoir, or Gauguin, but, in point of fact, the sexual practices of none of the other artists are clearly established, and, as is evident from a close reading of Gauguin's texts, even this fabled heterosexual was not immune from homosexual impulses. We know from Whitney Davis's complex and sophisticated interpretation of the homoerotic—or rather, homosocial—content of Eakins's nudes of the 1880s that an artist's actual sexual practice and what Davis inelegantly calls the "discharge" of desire through picture making are two different things, and this might well be the case for other artists whose private lives remain private despite the invasive tactics of modern historians.[32]

There is, however, a wonderfully mysterious and powerful male nude that must enter the discussion at this point, Renoir's provocative *Boy with a Cat* (page 45). This seemingly shocking painting entered the Musée d'Orsay only in 1992, before which it was largely unknown and unreproduced. It made its public debut in the *Origins of Impressionism* exhibition in Paris and New York in 1994, and Henri Loyrette's entry in the catalogue made every effort to minimize the odd and ambiguous sexuality of the painting. Since *Boy with a Cat* was never exhibited in the nineteenth century, it has the status of a private painting. It represents a standing, nude adolescent boy, seen in a sort of vertical hermaphrodite pose, fondling a cat that sits on an altarlike table elaborately draped with floral printed satin. The entire painting is a pictorial apotheosis of the sense of touch, made all the more bizarre because the sexual object to be touched is a standing boy rather than the conventional reclining girl or woman. The picture would not be so relevant here were it not for the fact that its first—and only—French owner was Edmond Maître, Bazille's closest friend. This, together with the well-known link between Renoir and Bazille in the second half of the 1860s, suggests that the painting may

31. Doreen Bolger, "'Kindly Relations': Edward Hornor Coates and *Swimming*," in *Thomas Eakins and the Swimming Picture*, ed. Bolger and Sarah Cash (Fort Worth: Amon Carter Museum, 1996), pp. 36–48.

32. Whitney Davis's "Erotic Revision in Thomas Eakins's Narratives of Male Nudity," *Art History* 17, no. 3 (September 1994): 301–41, is among the most subtle and brilliant readings in what might be called "latent iconography" in the recent art historical literature. The only limitation of the essay is the narrowly circumscribed way in which Davis deals with Eakins's life and work, refusing to foray into analogous situations or images outside of Eakins. For a more satisfying reading of Eakins's painting, one must read Randall C. Griffin's stimulating essay, "Thomas Eakins' Construction of the Male Body, or 'Men Get to Know Each Other Across the Space of Time,'" *Oxford Art Journal* 18, no. 2 (fall 1995): 70–80.

even have resulted from a private commission on the part of Maître. We learn from Douglas Cooper, who came to know the family of Renoir's friends, the Le Coeurs, that the model was the son of the important architect Charles Le Coeur, a perfectly upstanding person who, in Loyrette's words, was "unlikely" to have "permitted such a portrait."[33]

If the father was ignorant of the painting's existence (hardly credible, given the age of the boy), and if the painter was unlikely to have created the conditions for this picture on his own, how does one explain a painting of a beautiful young boy, who looks coyly at the viewer while petting a cat? Perhaps the big question to ask here has to do with the origins of the picture's unconventionality. Does the painting reflect the ambiguous homoerotic yearnings of Renoir (unlikely) or does it tell us more about its first owner and possible patron? At this stage in our knowledge of Maître (whose marriage in 1869 left Bazille temporarily bereft), it is difficult to call the painting "patron driven," particularly because we do not know when Maître acquired the picture and, therefore, whether it was "commissioned."[34] Still, its very oddness in Renoir's oeuvre suggests that the painting emerged from discussions that involved Maître and possibly Bazille, both of whom may have urged Renoir to paint a male nude like *Boy with a Cat*. Indeed, the model has a startling similarity to the figure of the boy in the water in *Summer Scene*, suggesting that Bazille could have worked with Renoir in 1868–69. Bazille surely knew Renoir's *Boy with a Cat* and may even have arranged either the commission or the sale, and stylistic evidence suggests that it was painted at the same time as *Fisherman with a Net* and perhaps even the early stages of *Summer Scene.*

These encounters of Bazille, Renoir, and Maître, when combined with Bazille's personal knowledge of Courbet, created all the necessary conditions under which Bazille could actually conceive of and execute an ambitious, but ambiguous, Salon painting of male nudes. And, one must also remember that Bazille was close to Cézanne, who, although he had not yet painted any of his canvases of male bathers, had already begun to fantasize about his own youthful excursions with Émile Zola and others in the countryside around Aix.[35] The fact that these two young men—Bazille and Cézanne—were from Provence, wealthy, and struggling to define both their profession and their personal lives, all the while maintaining strong links with their families, created another bond that can, in many senses, explain just why Bazille decided to paint a Salon painting of male nudes and to pair it with what he expected to be a more socially acceptable painting of a female nude in an appropriately distanced Orientalist context. Although the entire canvas of *Summer Scene* is full of suppressed erotic tension, the only erotic twinge that one receives from *The Toilette* is of a racial sort, the superbly painted white hand of the central nude that rests complacently on the dark brown shoulder of a model of African origin. Not even Gauguin dealt so frankly with the sexuality of race, and no painting until Émile Bernard's failed multiracial pornographic machine of 1899 (*Les Trois Races*, Los Angeles County Museum of Art) matched this one in its hothouse lesbian atmosphere. As with Cézanne's mature oeuvre, no nude men are allowed by Bazille into a painting with women, and the converse is also true.

33. See Loyrette's entry for the painting in *Origins of Impressionism*, 1994, pp. 454–55.

34. For a full discussion of Bazille's friendship with Maître, see François Daulte, "A True Friendship: Edmond Maître and Frédéric Bazille," in *Bazille and Early Impressionism*, 1978, pp. 22–30.

35. There are many discussions of Cézanne's early "bathing" outings with Zola and Baptistin Baille. Perhaps the clearest, most recent, and most accessible is found in Lawrence Gowing's brilliant essay, "The Early Work of Paul Cézanne," in *Cézanne: The Early Years, 1859–1872* (Washington, D.C.: National Gallery of Art, 1988), pp. 4–7.

36. There are fascinating and fruitful comparisons with the Eakins in Russian and German painting of the nineteenth century, but these fall outside the scope of this essay. Perhaps the most uncanny visual parallels with *Swimming* in nineteenth-century European art can be found in a series of small paintings made in Italy circa 1840 by the Russian painter Alexandr Andreevich Ivanov. These represent young boys posing in the nude in vast, almost empty landscapes. The most curious among the group is *Youths on the Shore of the Bay of Naples* in the State Russian Museum, St. Petersburg. Another fascinatingly parallel painting, made in the mid-1870s in both Holland and France by the German artist Max Liebermann, is in the permanent collection of the Dallas Museum of Art. This work combines extensive quotations from classical sculpture and old master painting with up-to-date realist imagery, using the bodies of working-class boys as the carriers of these lofty associations. Its presence in Dallas helps to put Eakins's *Swimming* into the larger context of modern art, rather than in the purely American context created for the painting by the Amon Carter Museum's collection. [See *Dallas Museum of Art: A Guide to the Collections* (Dallas: Dallas Museum of Art, 1997), entry on the Liebermann by Dorothy Kosinski, p. 104.— ED.]

37. This painting has only recently been reproduced in color and discussed in terms of the immense modern literature about Cézanne. See the brilliant entry on it by Joseph J. Rishel in *Great French Paintings from The Barnes Foundation: Impressionist, Post-Modernist and Early Modern* (New York: Alfred A. Knopf, in association with Lincoln University Press, 1993), pp. 102–5, and notes, pp. 300–301.

38. Rishel, 1993.

After Bazille's premature death in the Franco-Prussian War, he became a minor hero for the avant-garde, but in little more than a year he was forgotten as the young men and women reconvened after the war and the Commune to form the group of independent artists known today as Impressionists. Yet, Bazille's last major painting had a long afterlife. Indeed, it can be argued that *Summer Scene* is the first of a group of paintings that includes not only Eakins's masterpiece of 1884–85 but also Cézanne's male bathers.[36] It is surely no accident that, when Cézanne participated in the third Impressionist exhibition in 1877, he chose to represent himself not merely with a group of wonderful landscapes and still lifes (which we would expect), but with a large, contrived classical painting he called *Bathers; Study, Project for a Painting*, now known as *Bathers at Rest* (page 46).[37] This work must have looked awkward and out of place in the same room with Renoir's *Moulin de la Galette* (1876, Musée d'Orsay) and Morisot's *Head of a Girl* (Lewyt Collection, New York). Whereas Renoir and Morisot treated the figure with a gentle lyricism and an easy, socially acceptable sensuality, Cézanne posed four intensely gawky figures in a vast Provençal landscape.

Painted with thick, viscous patches of color, Cézanne's earliest completed male bather composition has all the "southern" optical intensity of its prototype, Bazille's *Summer Scene*. Brilliant greens, yellows, and blues dominate the painting, and even the flesh is filled with colors—yellows, pinks, salmons, reds, lavenders. The figures share with those of Bazille a disconnected quality, as if each were separately observed, transcribed, and, finally, placed in the composition. In analyzing them, writers have tried to find prototypes in the history of art, with candidates for sources ranging from Michelangelo to Gérôme and including sculpture as well as painting.[38] Yet, in each case, Cézanne consumed the appropriated source so completely that its identity is lost in the final work. In this case, Cézanne's masterpiece differs from its major source, Bazille's *Summer Scene*. Indeed, the general sources of Bazille's figures—St. Sebastian, a reclining river god, Courbet's *Wrestlers*—are so obvious that a visually literate viewer recognizes them with no real effort. For Cézanne, as for Eakins after him, the sources for the poses are not nearly so apparent, and the fact that the painting seems to have had no clear sources is part of its stubborn originality. What is most surprising about this situation is that, while Bazille's figures wear their sources almost as forthrightly as they wear bathing costumes, his painting has a much more immediate contemporaneity than do the "classical" concoctions of either Cézanne or Eakins. In both cases, this classicism has two components— the first relates to the balanced and figurally oriented compositions of each work, and the second has to do with the relative absence in Cézanne and the absolute absence in Eakins of contemporary clothing.

It is clear that, for both Eakins and Cézanne, Bazille's *Summer Scene* had opened the door for their later—and independent—investigations of the male nude out of doors. Each of them brought different training, temperament, and psychology to the task of transcribing the contemporary male nude, but each clearly had a compelling need to do so. For Cézanne, that need continued throughout the remainder of his life, and there are at least thirty-three painted

compositions that deal with the male nude—alone and in various groups out of doors. These compositions are balanced by an equal number of female bather compositions, three of which are of very large scale. In fact, Cézanne's interest in the male bather seems to have remained steady from the mid-1870s, when he first turned to it, until his death in 1906. Conversely, his interest in the female bather increased in the years around 1900, when he worked on three very large works (now in the Barnes Collection, Merion, Pa., the Philadelphia Museum of Art, and the National Gallery, London) that have often been read as a kind of pictorial summation of his oeuvre. Interestingly, the most perfectly resolved, the largest, and the most ambitious of Cézanne's male bathers, *Bathers at Rest*, is among the first of the sequence, and, in recognition of its importance, the painting was acquired by Gustave Caillebotte, probably shortly after its appearance in the 1877 Impressionist exhibition.

Perhaps the closest parallel between Cézanne's *Bathers at Rest* and Eakins's *Swimming* is that each painting has been related in the literature to the respective artist's lives. Rather than being considered as "ideal" compositions with indirect relationships to contemporary reality, both paintings have consistently been discussed in biographical terms. In Eakins's case, the practice of collective nude activity out of doors was a well-known part of his teaching, and, although his motivations for engaging in these activities have been interpreted in a wide variety of ways, the facts of his practice never have. For Cézanne, there has been an equal reliance on biography in "explaining" his male bather compositions. Virtually every writer in the vast Cézanne bibliography alludes to the trips into the countryside around Aix-en-Provence taken with his friends, the future novelist Émile Zola and the future physicist Baptistin Baille. The importance of boyhood memories to Cézanne cannot be altogether ignored, particularly when it comes to the male bathers. Indeed, Cézanne's first datable work of art is a drawing of three young male swimmers under a vast tree, in a letter to Zola written in June 1859, when the painter was twenty, and his first painted nude was a large male nude executed circa 1860 (Chrysler Museum, Norfolk, Va.).[39] Zola himself referred to these naked encounters in his extraordinary—and cruel—autobiographical-biographical novel, *The Masterpiece*.[40] Yet, Cézanne's knowledge of classical literature was also great, as was his interest in the Arcadian compositions of Nicolas Poussin, suggesting that biography is only one strand in many that led to the creation of these works of art. We must remember that Cézanne was in his late thirties when he undertook these studio subjects as a kind of antidote to the rigorous kind of painting *en face de la motif* on which he, like his mentor and friend, Pissarro, insisted.

It would be fascinating to see Bazille's *Summer Scene* and Eakins's *Swimming* in one room—or even in one exhibition. Perhaps, then, we would understand Eakins's choice of a subject associated not with the art of his esteemed teacher, Gérôme, but with the artists that teacher most despised. The recognition of this choice would lead those of us who are Americans to understand the double ambivalence of Eakins as a painter. He was, at once, the first revolutionary force in American figure painting since John Singleton Copley and a painter who, perhaps because he was provincial, was able to respond only belatedly and instinctively to

39. Both of these works are reproduced and discussed in Lawrence Gowing's introductory essay to *Cézanne: The Early Years*, 1988, pp. 4–7.

40. His idealized memories of their experience are quoted often in the Cézanne literature. Perhaps the most curious—and the most telling—instance is in Sandra Orienti's inexpensive summary catalogue of Cézanne's complete work, *Cézanne, Classics of World Art* (New York: Rizzoli, 1972), p. 99.

the "bad" work of the most progressive artists in France. Unfortunately for our falsely national history of art, Eakins's supremely complex and difficult painting, *Swimming*, would pale if it hung next to its antisource, Bazille's *Summer Scene*. It is precisely because Eakins listened to—and understood—Gérôme that he was able to understand only the subject of Bazille's painting and was doomed forever to despise the forms, the brushstrokes, and the colors that made that subject truly revolutionary in Bazille's painting.

For Bazille and Cézanne, painting is a battleground in which subject and style—matter and manner—are pitted against each other until both either win or lose. Eakins, in spite of his much touted innovations in representing reflections or in deriving poses and pictorial situations from photographs, was less experimental as a painter than he was as a man and as a teacher. His use of a middle-tone ground against which to paint values, his carefully balanced and centered grouping of figures, his absolute avoidance of any strong color but the green of the trees—all of these decisions link his art inextricably to that of his own teacher, Gérôme, who did more than any other artist to make sure that vanguard paintings would not be in the Salon. When Gérôme lost in 1870, Eakins benefited enormously from the very sight of Bazille's bold—and aggressively unsatisfactory—painting. Unfortunately, when he himself turned to the same subject in *Swimming* in 1884 and 1885, he remembered only the subject and not the style of this important source.

Arthur Danto, our American philosopher of art, has recently written a provocative short essay about the parallels between Eakins's *Swimming* and Georges Seurat's *Bathers at Asnières* (page 47).[41] The comparison is far less real—and less interesting as a result—than that between the Eakins and the French paintings that were the actual sources—and antisources—of his work. Yet, in another way, Danto is correct: both Eakins and Seurat were equally "academic" in their conception of painting. Seurat's academic experience was as important for his art as was his well-known (but later than the *Bathers*) friendship with Cézanne and Paul Signac. Eakins, like Seurat, tried to have it both ways, and the entire history of modern art has taught us that one can never succeed by trying to have it both ways. Eakins thought that photography would free him from Gérôme as Seurat thought that color theory would free him from both the Impressionists and the academy, where he felt more at home. Both tried too hard to reconcile too much, and, as their respective bathers look forever sideways, parallel to the picture plane that is, for us, a barrier, we as viewers are reminded that we will never know just what it is that fascinates them. For each artist, the male bathers are contrived to gaze outside of the picture that frames them. What do they see?

41. Arthur Danto, "Men Bathing, 1883: Eakins and Seurat: Both Subverted What They Believed Was the Task of Art," *ARTNews* 94, no. 3 (March 1995): 95–96.

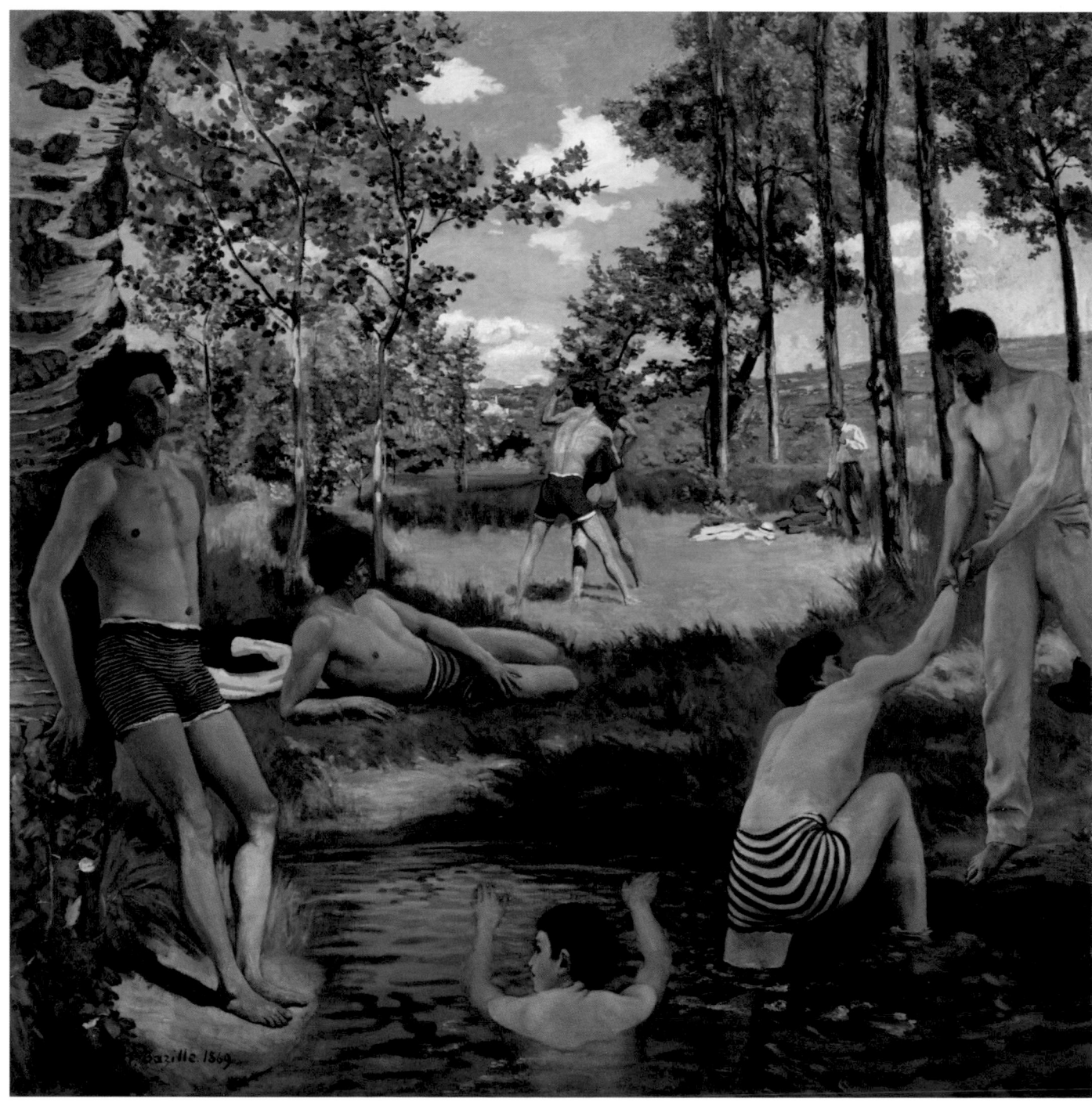

Frédéric Bazille, *Summer Scene*, 1869, oil on canvas, 62 x 62 $^3/_8$ inches. The Fogg Art Museum, Harvard University Art Museums, Gift of Mr. and Mrs. F. Meynier de Salinelles

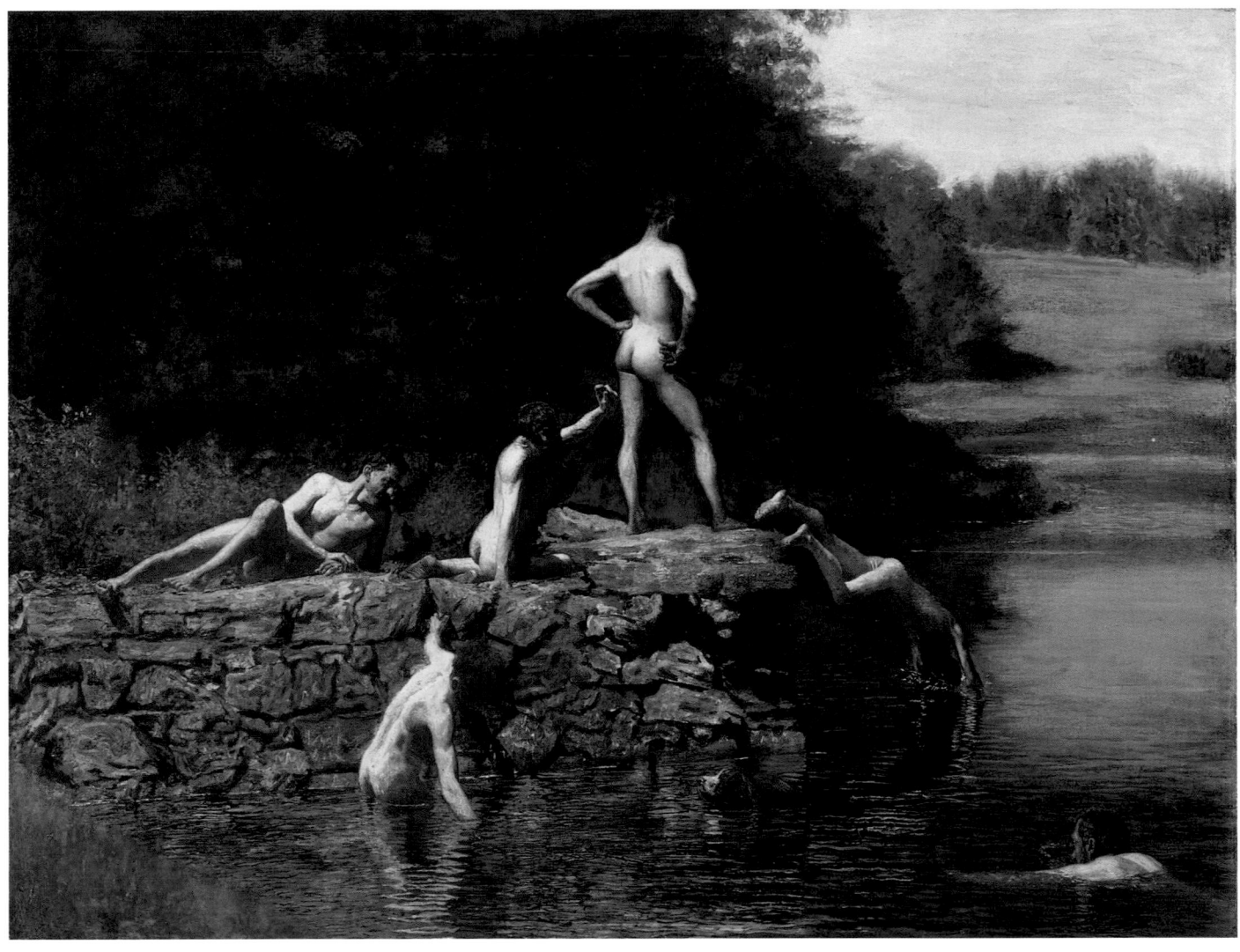

Thomas Eakins, *Swimming*, 1885, oil on canvas, 27 $^{5}/_{16}$ x 36 $^{5}/_{16}$ inches. Amon Carter Museum, Fort Worth, Texas, Purchased by the Friends of Art, Fort Worth Art Association, 1925; acquired by the Amon Carter Museum, 1990, from the Modern Art Museum of Fort Worth through grants and donations from the Amon G. Carter Foundation, the Sid W. Richardson Foundation, the Anne Burnett and Charles Tandy Foundation, Capital Cities/ABC Foundation, Fort Worth Star-Telegram, the R. D. and Joan Dale Hubbard Foundation, and the people of Fort Worth

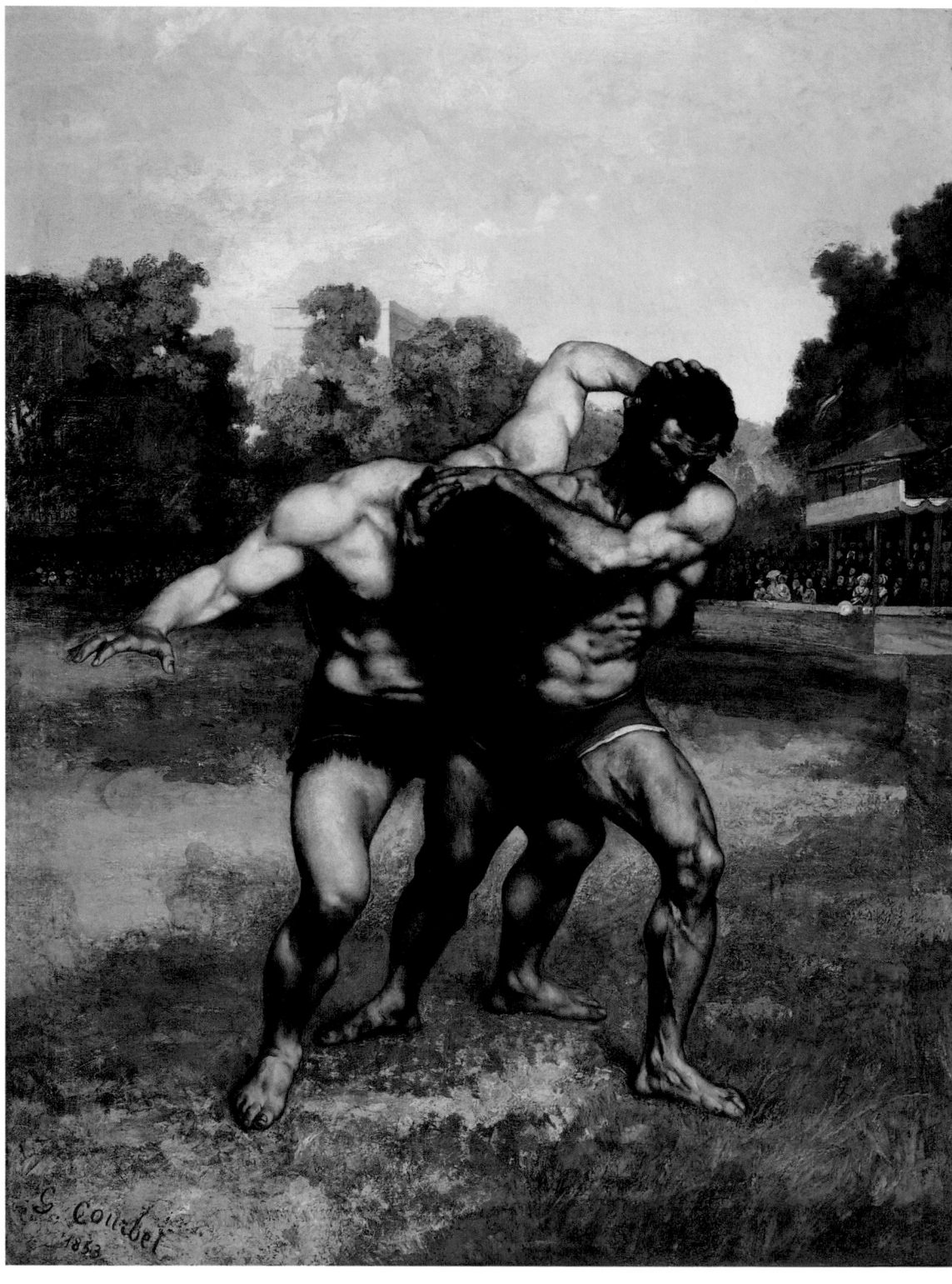

40

Gustave Courbet, *The Wrestlers*, 1853, oil on canvas, 98 $^{7}/_{8}$ x 77 $^{5}/_{8}$ inches. Szépmüvészeti Múzeum, Budapest

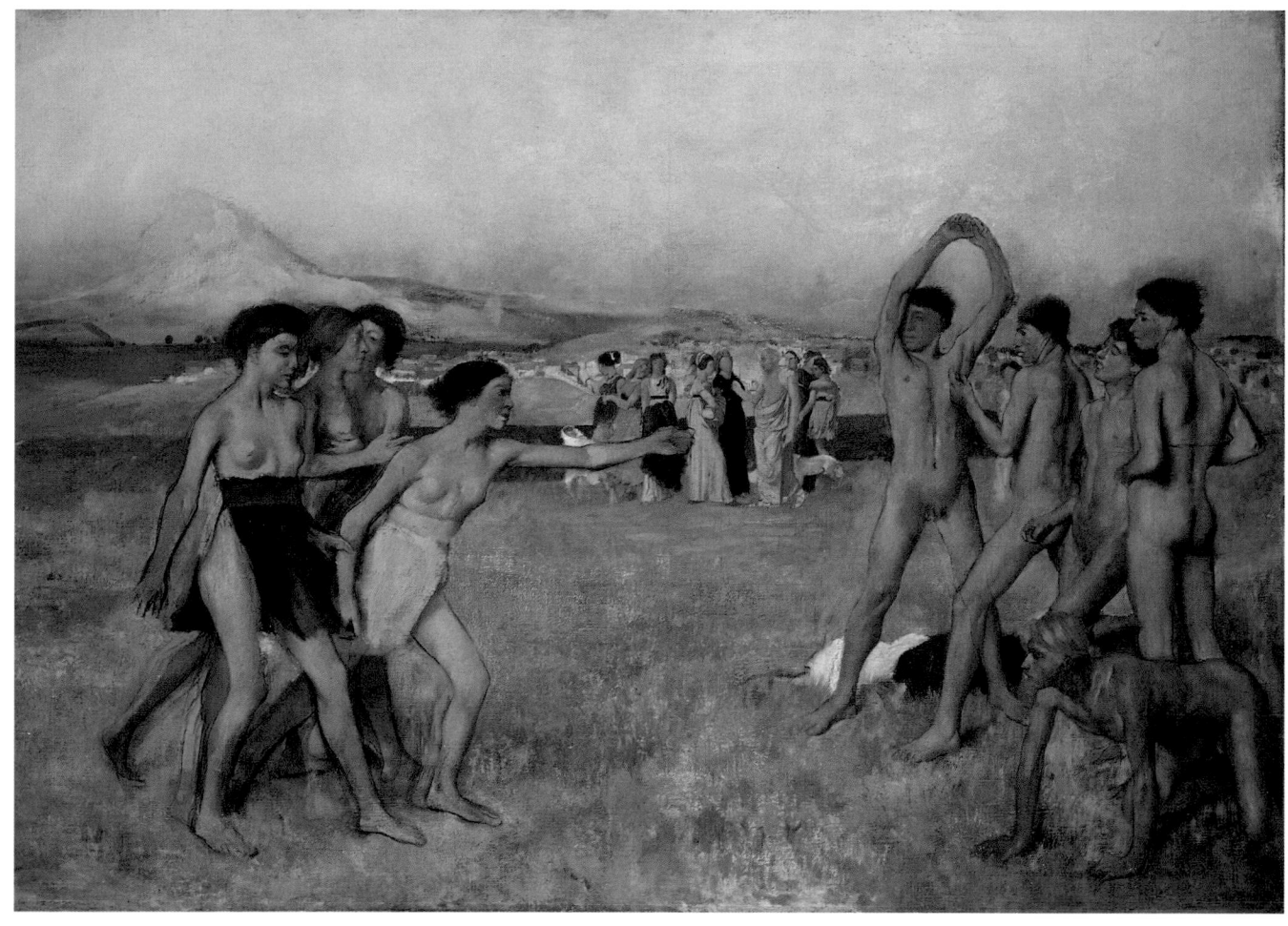

Edgar Degas, *Young Spartans Exercising*, circa 1860, oil on canvas, 42 $^7/_8$ x 60 $^1/_2$ inches. The National Gallery, London, NG 3860

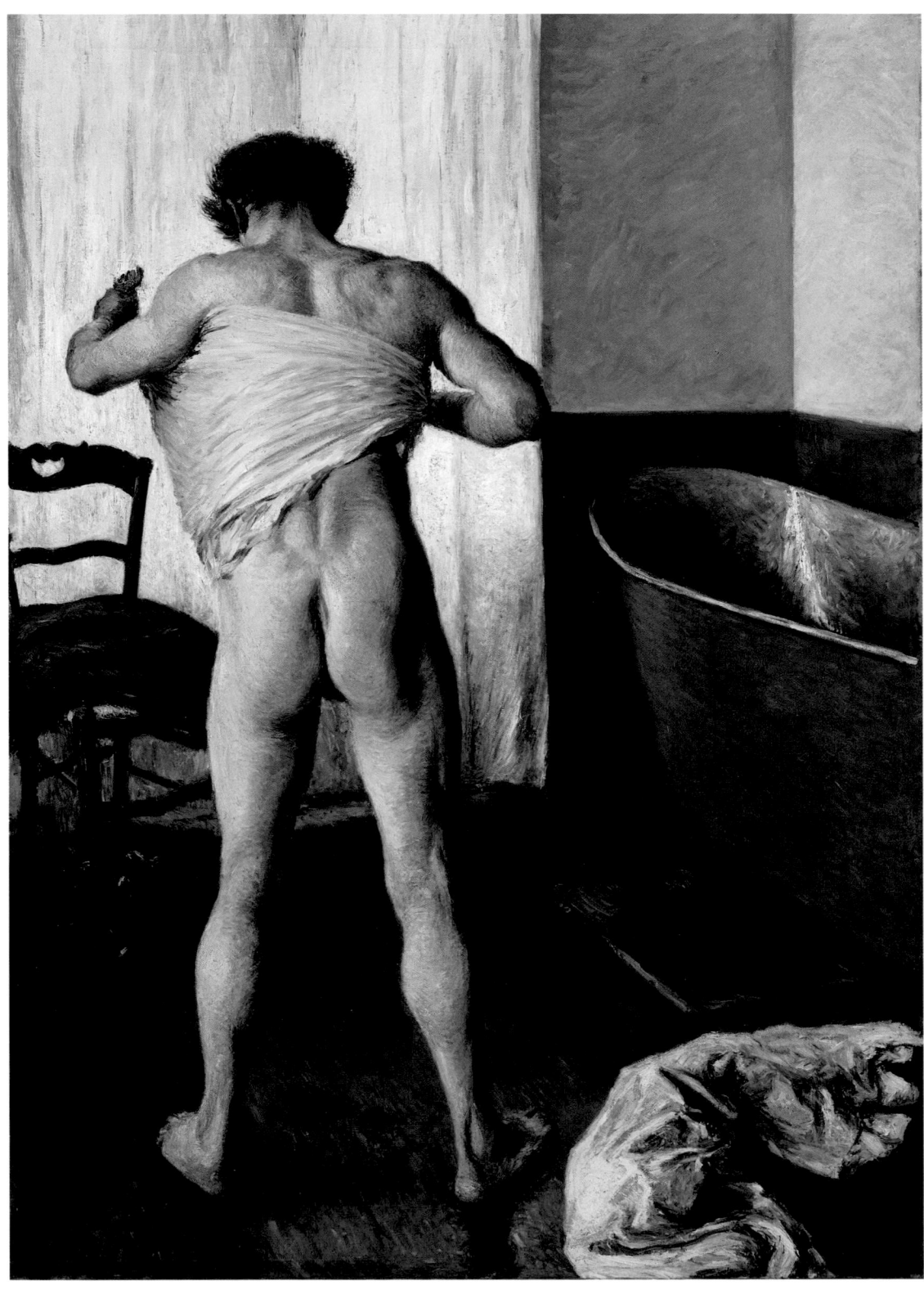

Gustave Caillebotte, *Man at His Bath*, 1884, oil on canvas, 67 $\frac{1}{4}$ x 49 $\frac{1}{4}$ inches. Private collection

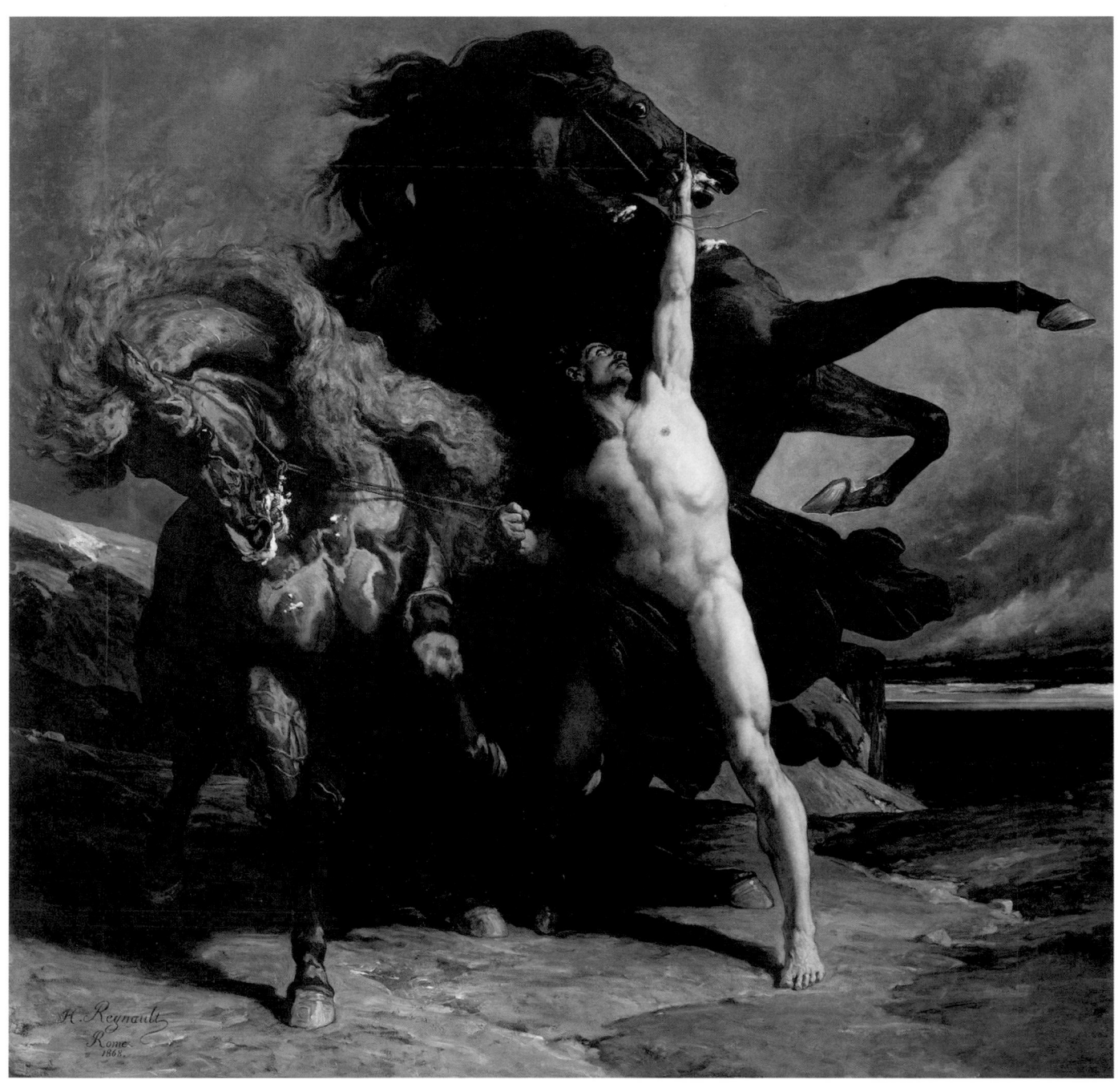

Henri-Alexandre-Georges Regnault, *Automedon with the Horses of Achilles*, 1868, oil on canvas, 124 x 129 ¹/₂ inches. Museum of Fine Arts, Boston, Gift by subscription, 90.152

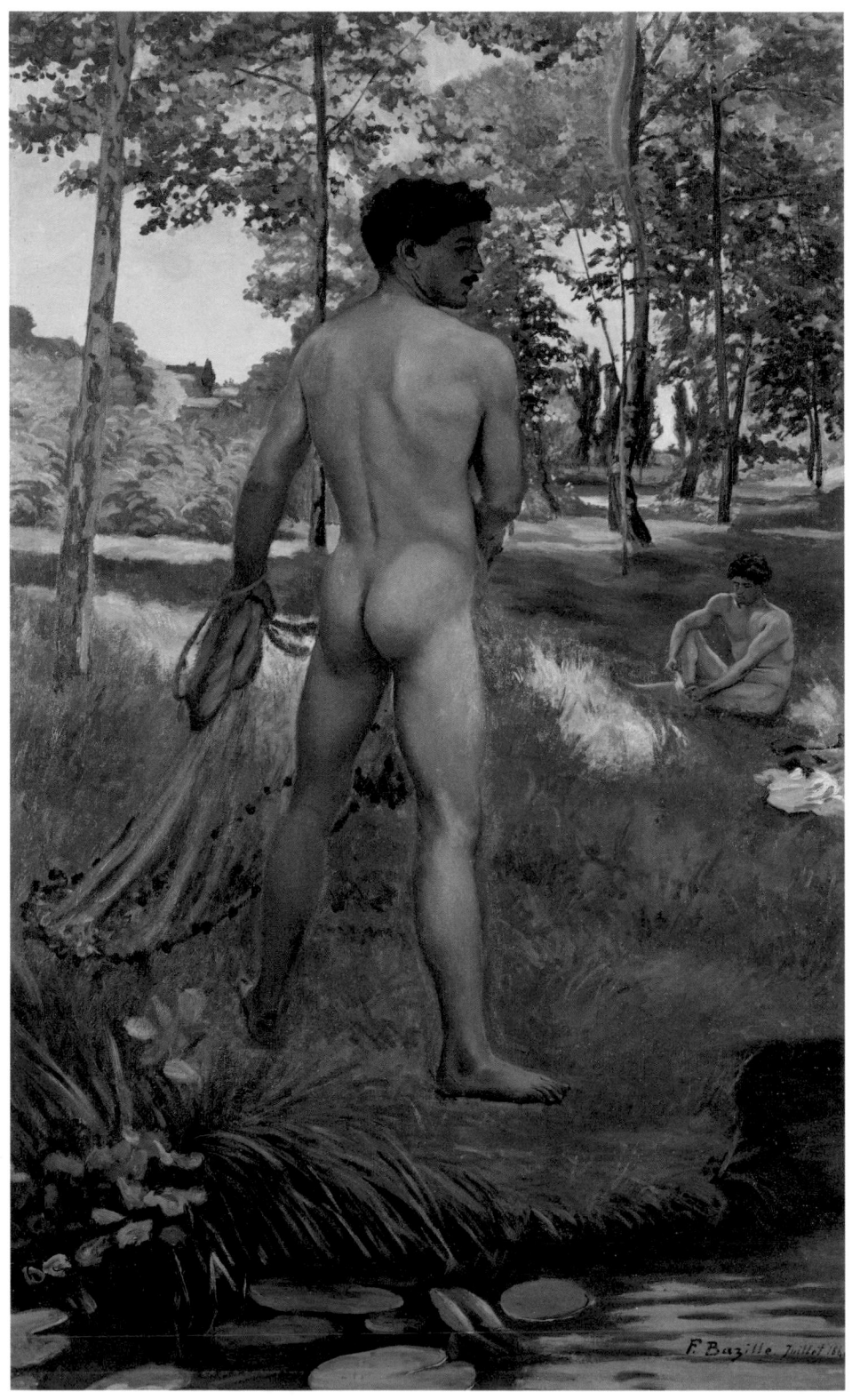

44

Frédéric Bazille, *Fisherman with a Net*, 1868, oil on canvas, 54 x 34 inches. Collection RAU – Fondation UNICEF, Cologne

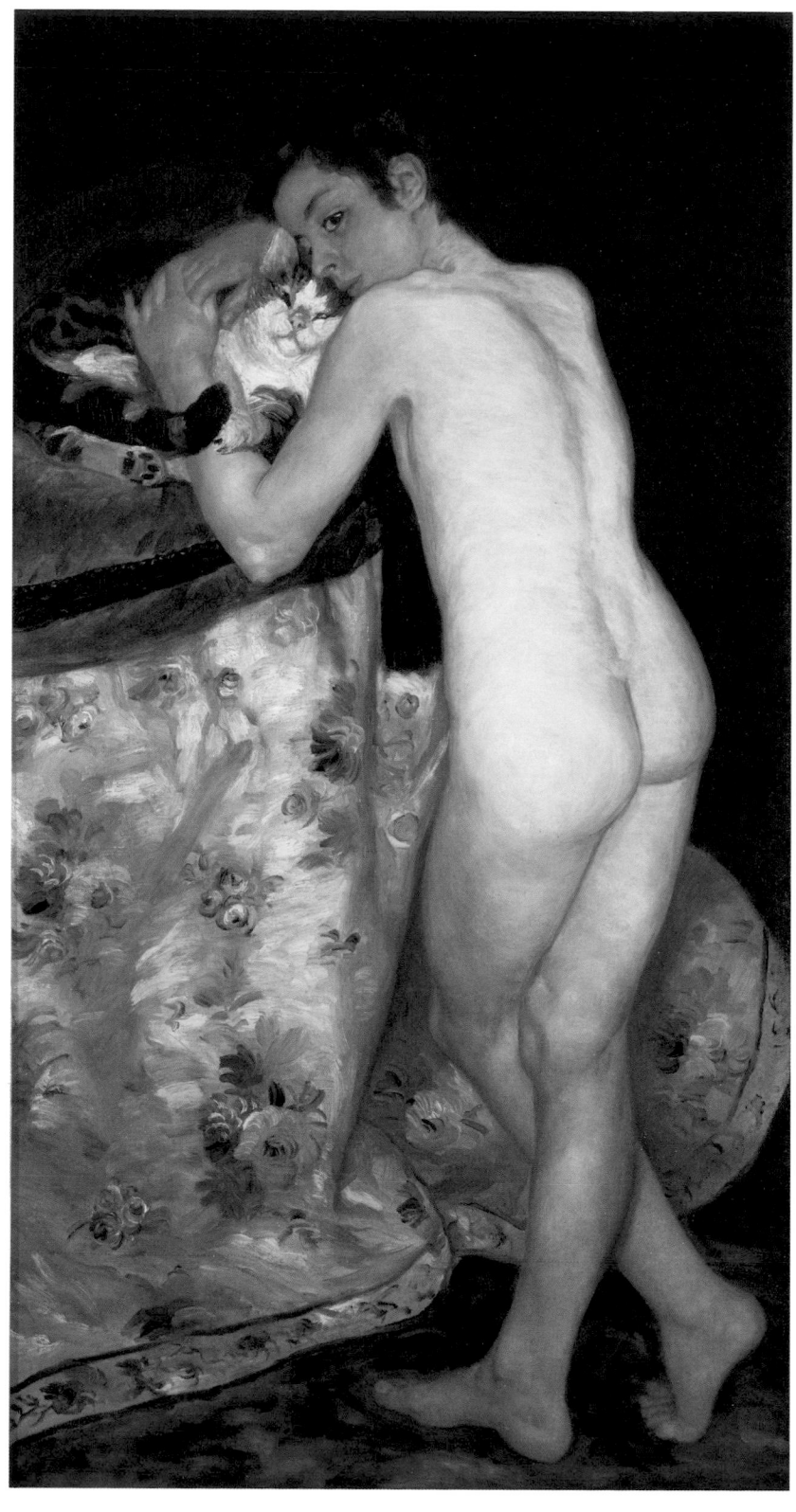

Pierre-Auguste Renior, *Boy with a Cat*, 1868–69, oil on canvas, 48 ⁵/₈ x 26 ¹/₄ inches. Musée d'Orsay, Paris, France

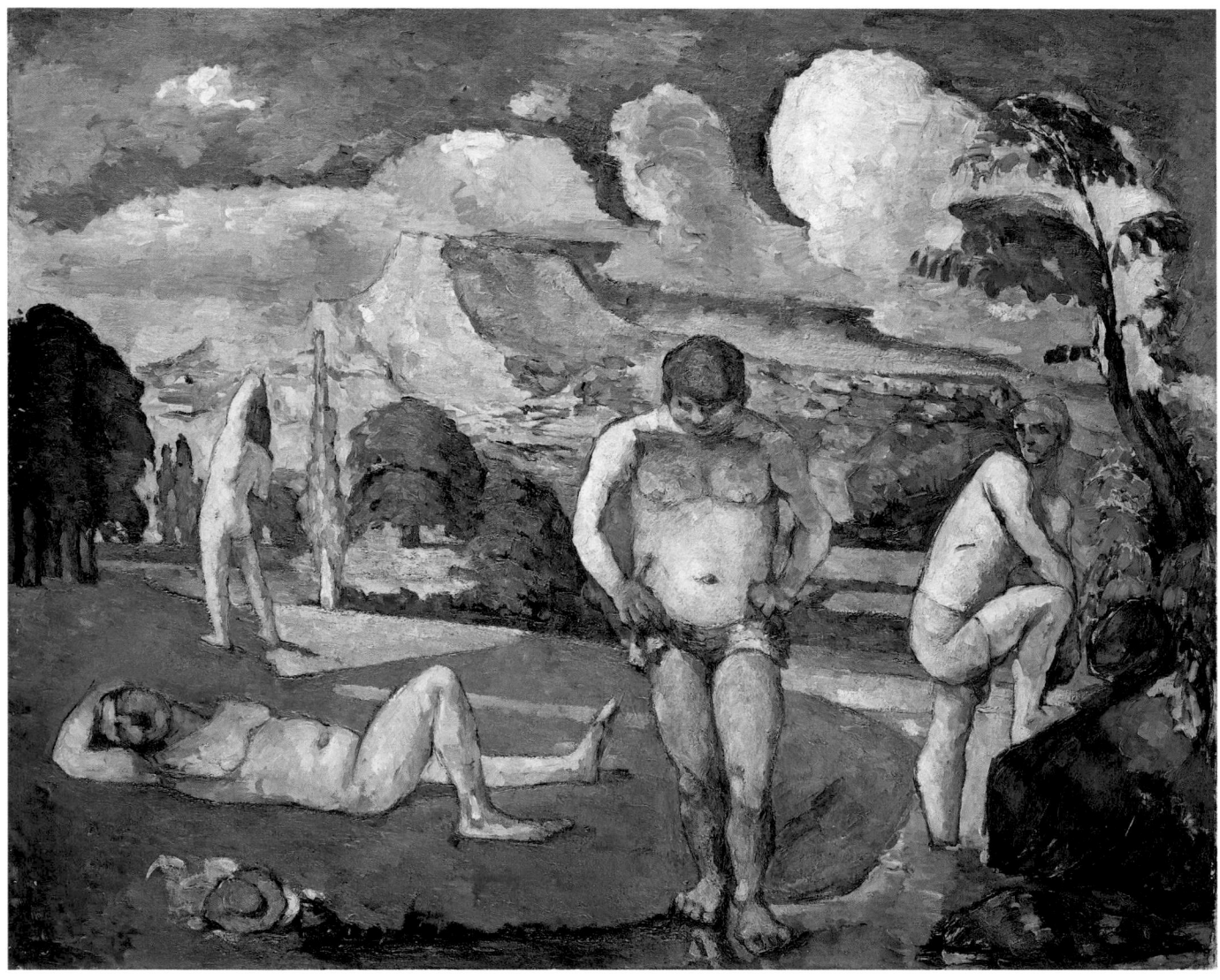

Paul Cézanne, *Bathers at Rest*, 1875–76, oil on canvas, 32 ¼ x 39 ⅞ inches, BF #906. The Barnes Foundation, Merion, Pennsylvania

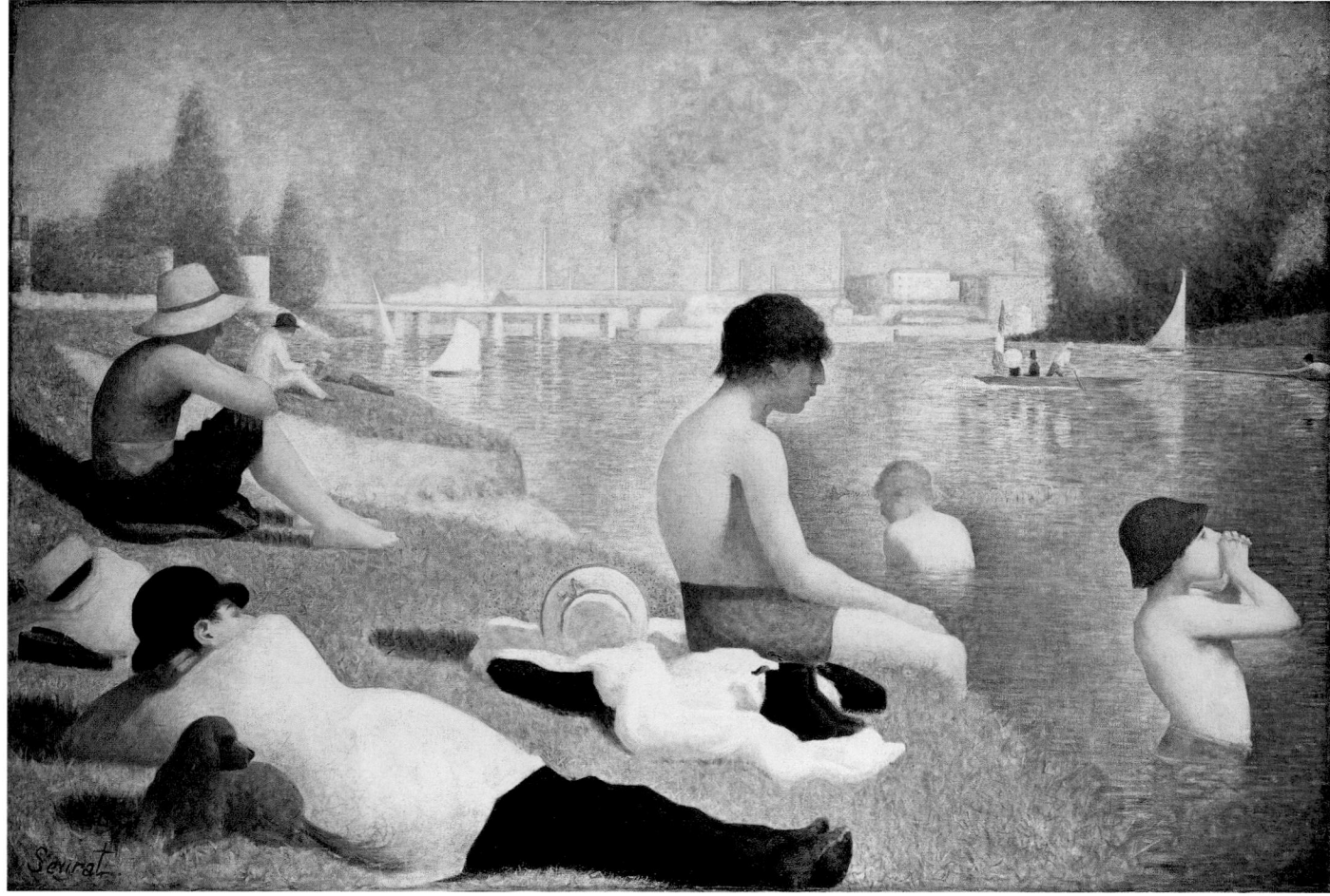

Georges Seurat, *The Bathers at Asnières*, 1882–83, oil on canvas, 78 $^1/_2$ x 117 $^3/_{16}$ inches. The National Gallery, London

William Glackens, *The Headlands, Rockport*, 1936, oil on canvas, 23 ¹/₂ x 32 inches. Kraushaar Galleries

American Painters and the French Impressionists

Anne E. Dawson

1. Frances Weizenhoffer, "The Earliest American Collectors of Monet," in *Aspects of Monet*, ed. John Rewald (New York: Harry N. Abrams, 1984), p. 74.

2. Frances Weizenhoffer, *The Havemeyers: Impressionism Comes to America* (New York: Harry N. Abrams, 1986), p. 21.

3. See Hans Huth, "Impressionism Comes to America," *Gazette des Beaux-Arts* 29 (April 1946): 225–52.

4. *Art Amateur* 9, no. 5 (October 1883): 91.

5. Huth concluded that the display sent by Durand-Ruel "was not only unsuccessful, but worse than that, the Impressionists were not even discussed, or as Pissarro had feared, were regarded as 'sick or mad.'" See Huth, 1946, p. 231. Although Huth's conclusions regarding responses to the *Foreign Exhibition* are incorrect, his article remains an important early source for documenting America's initial encounters with Impressionism.

6. *Daily Evening Traveller*, August 31, 1883, Charles Benjamin Norton Scrapbook, Rare Book and Manuscript Division, Boston Public Library, p. 3.

7. "Art at the Boston Exhibition," *Art Amateur* 9, no. 5 (October 1883): 90; "The Boston Exhibition," *Sun*, September 9, 1883.

Impressionism is one of the most popular, enduring, and complex of the French styles embraced by American painters at the end of the nineteenth and beginning of the twentieth centuries. American artists, among them Mary Cassatt, John Singer Sargent, Theodore Robinson, Childe Hassam, Mildred Burrage, William Glackens, and George Bellows, responded in diverse ways to French Impressionism, assimilating approaches to subject matter, compositional structure, light, color, paint application, and procedural methods. American painters' fascination with Impressionism is a consequence of their reliance on the art scene in Paris to further their professional training and opportunities. In Paris, American artists studied many styles simultaneously—traditional art, various forms of academic painting, the Barbizon style, and the realism of Gustave Courbet—in addition to the various modes that make up French Impressionism. It was not possible to study works by the French Impressionists in the United States until the mid-1880s, at least a decade after the style was well known in Paris. Exhibitions of French Impressionism in Boston and New York greatly expanded American artists' knowledge of and interest in the style. As a result, by the mid-1880s Impressionism became a strong current in American art. Relationships between American painting and French Impressionism are complicated. Stylistic affiliations are not always a matter of specific reactions to specific paintings but of accrued responses to seeing and studying many works over time, of adapting those experiences to American subjects, and of synthesizing the ideas of Impressionism with values obtained from a study of traditional art and contemporary Salon painting. Frequently, American painters assimilated what they learned from the French Impressionists so thoroughly that the generative influence is not discernible. These factors contribute to the intricacies that characterize the artistic affiliation between American painting and French Impressionism.

American painters' initial contacts with and enthusiasm for the French Impressionists and their works occurred gradually between the 1860s and the late 1880s. On the home front, opportunities to view Impressionist paintings were rare prior to 1886. One of the first Impressionist works to be seen in this country, a seascape by Claude Monet, was shown in New York and Boston as part of Alfred Cadart's exhibitions of the French Etching Club in 1866.[1] Twelve years later, Louisine Elder (Havemeyer) lent Degas's pastel *Rehearsal of the Ballet* (circa 1876, Nelson-Atkins Museum of Art, Kansas City) to the eleventh Annual Exhibition of the American Water Color Society. Elder (she did not marry Harry Havemeyer until 1883) had purchased the Degas in 1877 on the advice of her close friend Mary Cassatt, making Elder the

first American collector to own a work by that French artist.[2] In 1879 the French singer and friend of Édouard Manet, Madame Ambré, transported the painter's controversial canvas *The Execution of Maximilian* (Museum of Fine Arts, Boston) to Boston and New York, where it was made available to the public.[3] While these events are important historically, they did not substantially affect the progress of Impressionism in America.

It was not until the 1883 *Foreign Exhibition* in Boston that Americans had an opportunity, without traveling abroad, to view Impressionist works in a sizable grouping. To the *Foreign Exhibition*, a large international exposition of art and industry, the French dealer Paul Durand-Ruel sent seventeen works by Manet, Monet, Pierre-Auguste Renoir, Alfred Sisley, and Camille Pissarro. These canvases were equally divided between landscapes and figures. Paintings by Camille Corot (approximately six lent by American owners from Boston and Providence), Courbet, and Eugène Boudin were also included in the French art section.[4]

Although scholars have previously concluded that critics either ignored or condemned the Impressionist pictures on view at the *Foreign Exhibition*, in fact the Impressionist works attracted a great deal of critical attention, much, but not all, of it positive.[5] According to a writer for the *Daily Evening Traveller*, "The Impressionists will offer a new revelation in art to Boston. It is the finest and most complete representation of this school that has ever before been brought to America, and gives opportunities for a fair and discriminating judgment of its relative merits with other schools."[6] A reviewer for the *Art Amateur* found that "the modern pictures in the art gallery form the best part of the exhibition," while the *Sun* described them as "the most interesting" section of the art gallery.[7] A writer for the *St. Louis Spectator* declared sympathetically that the Impressionist pictures, "like olives," "need an acquired taste," and that "once you do like them, you like them awfully."[8] As was typical of early responses to Impressionism, a few critics combined admiration for the Impressionists with outrage at their apparent disregard for the values of traditional painting.[9] Although one reviewer found Pissarro's *Shepherd and the Washerwoman* "the most objectionable Impressionist canvas in the gallery," it was Manet's *Entombment of Christ* (now called *Dead Christ with Angels*, The Metropolitan Museum of Art, New York) that constituted for the majority of critics the most offensive Impressionist work.[10] On the other hand, critics responded most enthusiastically to Renoir, especially his *Boatmen Breakfasting at Bougival* (now called *Luncheon of the Boating Party*, The Phillips Collection, Washington, D.C.), while they virtually ignored Monet and Sisley.[11] Critics were put off by the pessimism and ugliness of Manet's work, while they appreciated the optimism and beauty of Renoir's. Reviewers also valued Renoir's paintings as more academically inspired than the other Impressionist works on view.[12]

In addition to receiving the most attention and enthusiasm among critics, two of Renoir's paintings were illustrated in publications pertaining to the exhibition. *The Artist* reproduced Henry Bacon's sketch after Renoir's *At the Concert* (1880, now called *A Box at the Theatre*, Sterling and Francine Clark Art Institute, Williamstown, Mass.) in its special *Foreign Exhibition* edition, while a copy of Renoir's *Boatmen Breakfasting at Bougival* was included in

8. "The Foreign Exhibition at Boston," *St. Louis Spectator*, September 29, 1883, Charles Benjamin Norton Scrapbook, Rare Book and Manuscript Division, Boston Public Library, p. 117.

9. See "The Fine Arts: The Picture Galleries of the Foreign and Institute Fairs," *Boston Journal*, September 8, 1883, Charles Benjamin Norton Scrapbook, Rare Book and Manuscript Division, Boston Public Library, p. 45; "The Fine Arts: The Picture Galleries of the Foreign Exhibition," *Boston Advertiser*, September 3, 1883; "Exhibition Art: The Collection to Be Seen at the Foreign Exhibition," *Boston Daily Globe*, September 16, 1883, all Charles Benjamin Norton Scrapbook, Rare Book and Manuscript Division, Boston Public Library, p. 69.

10. A writer for the *Boston Advertiser* described Manet's *Entombment* as "a dream of horror. It depicts the ugliness of death and ignores its beauty. Good taste protests against this brutality of realism. . . . The face of the corpse is distorted, the features pinched, the flesh discolored; the expression is that of a dead idiot." "The Fine Arts: The Picture Galleries of the Foreign Exhibition," *Boston Advertiser*, September 3, 1883. *The Boston Journal* judged Manet's painting to be "ghastly and putrescent" and "so repulsive to every instinct and taste and decency," concluding that "in its brutal treatment of a subject, which most men regard as at least in some sense sacred," it "nullifies the respect which his other work might inspire." "The Fine Arts: The Picture Galleries of the Foreign and Institute Fairs," *Boston Journal*, September 8, 1883. For a detailed analysis of Americans' earliest responses to Manet and their association of Manet and the writer Émile Zola, see Laura L. Meixner, *French Realist Painting and the Critique of American Society, 1865–1900* (Cambridge: Cambridge University Press, 1995).

11. A writer for the *Daily Evening Traveller* characterized *Boatmen Breakfasting* as "full of life," color, and vitality, proclaiming that it represents the "best example of the best qualities" of the Impressionist school. "Painting and Sculpture at the Foreign Exhibition," *Daily Evening Traveller*, September 12, 1883, Charles Benjamin Norton Scrapbook, Rare Book and Manuscript Division, Boston Public Library, p. 61. See also "Exhibition Art: The Collection to Be Seen at the Foreign Exhibition," *Boston Daily Globe*, September 16, 1883; "Pictures at the Foreign Fair," *Republican*, September 24, 1883, Charles Benjamin Norton Scrapbook, Rare Book and Manuscript Division, Boston Public Library, p. 93; "Art at the Foreign Exhibition," *Artist*, November 22, 1883, p. 108.

12. For example, "'A Box at the Opera', with two pretty young ladies, fulfills all the usual Academic requirements, is finished enough, good in tone, and remarkable only for the uncommon liveliness of expression of the two precocious little girls. This picture proves that M. Renoir can be original without being incomplete or outlandish." "The Boston Exhibition," *Sun*, September 9, 1883. For discussions of the diverse cultural meanings inherent in American responses to French Impressionism, see Meixner, 1995, and Kathleen Pyne, *Art and the Higher Life: Painting and Evolutionary Thought in Late Nineteenth-Century America* (Austin: University of Texas Press, 1996).

13. *Artist,* November 22, 1883, p. 111. The anonymous reviewer concluded that "the impressionists are the most conspicuously represented," and declared that Renoir's *Boatmen Breakfasting* "is a picture to excite discussion, as are also Pissarro's curiously tinted canvases." Manet's *Entombment* was reproduced in the 1883 *Illustrated Catalogue, American Exhibition of Foreign Products, Arts and Manufactures, Art Department.*

the *Album of the Most Celebrated Works of Art and Industry from the Boston Foreign Exhibition* published in 1885, for which the painter Edmund Tarbell produced several line drawings.[13] Although Tarbell thus knew Renoir's *Boatmen Breakfasting at Bougival* intimately in 1883, the impact of this experience did not manifest itself until he painted *Three Sisters: A Study in June Sunlight* in 1890 (Milwaukee Art Museum) and *In the Orchard* in 1891 (Terra Museum of American Art, Chicago). Considering the amount of attention the Impressionist works garnered at the *Foreign Exhibition*, and the fact that at least two American artists made copies of selected Impressionist works, it is likely that other American painters, especially the close-knit art community in Boston, went to see this important early display of Impressionist pictures.

The year 1886 marks a turning point in the exposure of American painters to Impressionism at home. That year Durand-Ruel, in response to an invitation by James F. Sutton, president of the American Art Association, organized a major exhibition of Impressionist art for New York. Including approximately three hundred works, the Durand-Ruel exhibition was larger than any of the independent Impressionist exhibitions held in Paris between 1874 and 1886, and decisively increased appreciation for Impressionism among American painters, critics, and collectors.[14] Many American painters, especially those who later formed the Impressionist group identified as the Ten, began to reconsider their stylistic approaches after the 1886 show.[15] While critics in 1883 favored Renoir's figurative works, those responding to the 1886 show favored Monet and landscape Impressionism. After the 1886 exhibition, Monet became the most admired French Impressionist among American critics, painters, and collectors, a trend that lasted for the next eighteen years.[16] From 1886 on, exhibitions of French Impressionism in America occurred with increasing frequency and American painters began to be associated with their French predecessors. In 1893 works by the American Impressionists J. Alden Weir and John Twachtman were exhibited at the American Art Association together with works by Monet and Albert Besnard. The following year, Durand-Ruel opened a gallery on Fifth Avenue, where the Ten American painters exhibited from 1898 to 1904.[17] These events exemplify the strong links—through joint exhibitions and by virtue of their being promoted by the same dealer—that existed between American Impressionism and French Impressionism in the United States.

At the same time that these events were taking place at home, American painters residing in Paris began coming into contact with members of the French Impressionists. In addition to James McNeill Whistler, who participated directly in avant-garde events in Paris beginning in the late 1850s, Daniel Ridgway Knight, Joseph R. Woodwell, and Mark Fisher are among the first American artists to encounter the French Impressionists in France. Knight became friends with Renoir and Sisley sometime before 1863 at the studio of the academic painter Charles Gleyre.[18] Woodwell, a painter from Pittsburgh, met Renoir, Monet, Sisley, and Pissarro while visiting France during the mid-1860s, while Fisher worked in the company of Renoir, Monet, and Sisley in Paris sometime before 1870.[19] Another American, the Impressionist painter John Joseph Enneking, associated with Renoir, Manet, Monet, and Pissarro

during the early 1870s. In 1874 Enneking sketched Camille Monet and her son at Argenteuil in the company of Manet and Renoir.[20] These events demonstrate that Americans were actually close to the Impressionist art scene well before the style became dominant in America.

Mary Cassatt is the only American painter to become an integral member of the French Impressionists' circle. After several European sojourns that included travel in France, Italy, and Spain, Cassatt settled permanently in France in 1874, the same year the Impressionists organized their first independent exhibition.[21] By 1876 she was working in an Impressionist manner, as seen in *Mrs. Duffee Seated on a Striped Sofa, Reading* (Museum of Fine Arts, Boston), with its bright palette and broken brushwork. The subject of Cassatt's work also mirrors recent Impressionist painting, such as Renoir's *Camille Monet Reading* (circa 1873, Sterling and Francine Clark Art Institute, Williamstown, Mass.), as well as paintings by traditional artists such as Jean-Honoré Fragonard.[22] After Cassatt met Degas sometime in 1877, he invited her to exhibit with the Impressionists. Cassatt contributed works to four of the Impressionist exhibitions, in 1879, 1880, 1881, and 1886, and became close friends with many of the Impressionists, including Monet, Berthe Morisot, Pissarro, Renoir, and especially Degas.

At various moments in her career Cassatt was inspired by the example of Manet, Renoir, and Degas. Cassatt's understanding of Manet's broad, flat brushwork can be seen in her *Woman Reading* (1878–79, Joslyn Art Museum, Omaha), while her knowledge of Renoir's delicate brushwork and rich color harmonies is manifested in works such as *On a Balcony* (1877–79, The Art Institute of Chicago) and *Woman in a Loge* (1878–79, Philadelphia Museum of Art). Cassatt's drypoint *Nursing* of circa 1890 has been compared with Renoir's *Child at the Breast* from 1886 (private collection).[23] In several pastels from the 1890s, such as *Girl with a Banjo* (1893–94, private collection, Los Angeles), Cassatt incorporated loose brushwork and warm tonality similar to Renoir's paintings from the time. In 1893 the French critic Alfred de Lostalot noted a relationship between Cassatt's and Renoir's color and brushwork.[24] Cassatt visited Renoir often between 1912 and 1914, and although she criticized the hot color of Renoir's late nudes, her pastel *Mother and Child* of 1913–14 (The Metropolitan Museum of Art) recalls the intense warmth and looseness of paint handling found in Renoir's late works.[25]

However, it was Degas with whom Cassatt formed the most intense artistic exchanges.[26] After meeting in 1877, the two artists maintained a close friendship until Degas's death in 1917. While Degas may have mentored Cassatt initially, their respect for each other's creative work was mutual and their artistic exchanges often collaborative. They collected each other's works, shared professional sentiments that led them both to refuse to submit works to the 1882 Impressionist exhibition, and developed etchings for a journal they hoped to produce. Cassatt acted as a model for Degas on a number of occasions. She also encouraged American collectors, among them her brother and her close friends the Havemeyers, to purchase Degas's work.[27]

The pairing of Cassatt's *Simone in a Plumed Hat* (circa 1903, page 59) and Degas's *Seated Dancer* (1894, page 58) in the present exhibition exemplifies both exchanges and

14. See Huth, 1946; Richard J. Boyle, *American Impressionism* (Boston: New York Graphic Society, 1974); William H. Gerdts, *American Impressionism* (New York: Cross River Press, 1984); Weitzenhoffer, 1984; and Ulrich W. Hiesinger, *Impressionism in America: The Ten American Painters* (Munich: Prestel-Verlag, 1991).

15. Hiesinger, 1991, p. 97.

16. See Anne E. Dawson, *Idol of the Moderns: Pierre-Auguste Renoir and American Painting* (San Diego, Calif.: San Diego Museum of Art, 2002), pp. 12–17. For a discussion of Americans' renewed interest in Monet during the 1950s, see Michael Leja, "The Monet Revival and New York School Abstraction," in *Monet in the 20th Century*, by Paul Hayes Tucker (New Haven: Yale University Press, 1998), pp. 98–108.

17. Hiesinger, 1991, p. 86.

18. Peter Bermingham, "Daniel Ridgway Knight," in *Master Paintings from the Butler Institute of American Art*, ed. Irene S. Sweetkind (New York: Harry N. Abrams, in association with the Butler Institute of American Art, 1994), p. 153.

19. Diana Strazdes, *American Painting and Sculpture to 1945 in the Carnegie Museum of Art* (New York: Carnegie Museum of Art, 1992), pp. 484ff. Patricia Jobe Pierce and Rolf H. Kristiansen, *John Joseph Enneking: Amerian Impressionist Painter* (North Abington, Mass.: Pierce Galleries, 1972), p. 97.

20. Pierce and Kristiansen, 1972, pp. 62–66. Enneking associated with and learned from many contemporary artists in addition to the Impressionists, including Léon Bonnat and Charles-François Daubigny.

21. On Cassatt's career before 1874, see Andrew J. Walker, "Mary Cassatt's Modern Education: The United States, France, Italy, and Spain, 1860–73," in *Mary Cassatt: Modern Woman* (Chicago: The Art Institute of Chicago, in association with Harry N. Abrams, 1999), and Nancy Mowll Mathews, *Mary Cassatt: A Life* (New York: Villard Books, 1994).

22. See Judith A. Barter, "Mary Cassatt: Themes, Sources, and the Modern Woman," in *Mary Cassatt: Modern Woman*, 1999, p. 61.

23. See George T. M. Shackelford, "Pas de deux: Mary Cassatt and Edgar Degas," in *Mary Cassatt: Modern Woman*, 1999, pp. 130–31.

24. Alfred de Lostalot, "Exposition des oeuvres de Miss Mary Cassatt," *La Chronique des Arts et de la Curiosité*, December 9, 1893, cited in Griselda Pollock, *Mary Cassatt: Painter of Modern Women* (London: Thames and Hudson, 1998), p. 65.

25. In a letter dated January 11, 1913, Cassatt states, "He is doing the most awful pictures or rather studies of enormously fat red women with very small heads." A year later, in a letter of February 17, 1914, Cassatt commented, "I saw Renoir this afternoon, very well and painting and with pretty color, no more red." Nancy Mowll Mathews, ed., *Cassatt and Her Circle: Selected Letters* (New York: Abbeville Press, 1984), pp. 308 and 315. See also Mathews, 1994, pp. 299–301.

26. On Cassatt's relationship with Degas, see Shackelford, 1999.

27. See George T. M. Shackelford and Erica E. Hirshler, "Helping 'Fine Things Across the Atlantic': Mary Cassatt and Art Collecting in the United States," in *Mary Cassatt: Modern Woman*, 1999.

28. See Shackelford, 1999.

divergences between these two painters. Cassatt's prevalent use of pastel throughout her career parallels her admiration for Degas's work in the medium. In a 1915 letter Cassatt designated her first viewing of Degas's works, which happened to be pastels, as a turning point in her career. And, at the Impressionist exhibition in 1879, she exhibited pastels for the first time. The works she and Degas included in that show have in common not only medium but also color, application of pigment, and use of brightly colored frames.[28] *Simone in a Plumed Hat* demonstrates the type of application of pigment Cassatt developed alongside Degas, characterized by a combination of graphic edges operating as structured elements with soft, free, overlapping brushes of bright color. At the same time, the works included here exemplify Degas's preference for dancers as subjects and Cassatt's fondness for depicting children, a theme that began to dominate her oeuvre about 1886.[29] Cassatt's participation in the Impressionist movement, close friendships with the French Impressionists, and permanent residency in France make her a signature example of the close connections that existed between American and French painters throughout the late nineteenth and early twentieth century.

John Singer Sargent settled in Paris in 1874. Although he visited the first Impressionist exhibition held that year as well as the second Impressionist exhibition in 1876, he produced only a few Impressionist-inspired works initially, *In the Luxembourg Gardens* of 1879 (Philadelphia Museum of Art) and *The Daughters of Edward Darley Boit* of 1882 (Museum of Fine Arts, Boston), concentrating instead on developing his skills at portraiture.[30] Sargent's *Ellen Archer Eveleth Smith* (page 61), painted in 1883, demonstrates his commitment to the painterly academic tradition that he developed under the guidance of the successful French Salon painter Carolus-Duran. Sargent began studying with Carolus-Duran in 1874 after admiring his works at the Salon and because "he is considered one of the great French artists."[31] Carolus-Duran favored painterly artists from the past, especially Titian, Anthony van Dyck, and Diego Velázquez, as well as his contemporaries Courbet and Manet. He encouraged his students to apply paint to the canvas directly and freely, rather than first sketching the composition in pencil. Carolus-Duran's painterly academic approach can be seen in *Portrait of a Woman* (page 60). Carolus composes the figure simply, depicting her at a little more than bust length and excluding her hands. She looks gently, but directly, at the viewer. Carolus-Duran uses light to guide the viewer's attention to the sitter's face and the exquisitely and freely painted lace bodice. Sargent's portrait follows a similar format, except that his figure gazes to the side. Like that of his teacher, Sargent's virtuoso brushwork around the collar adds elegance to this simple but striking portrait. Sargent maintained his interest in portraiture for a long time.

Sargent began to experiment consistently with Impressionism only after his move to London in 1885. That same year he made the first of several visits to Monet in Giverny, which helped initiate a close friendship between the two artists. During this visit, Sargent began to work outdoors and to experiment with Impressionist techniques as seen in his *Claude Monet Painting at the Edge of a Wood* (1885, Tate Britain, London). During the spring of 1885, Sargent

53

and Monet exhibited works together at the gallery of Georges Petit. Sargent also made the first of four purchases of Monet's works that year.[32] In 1888 Sargent painted *A Morning Walk* (private collection), a work that has been described as "Sargent's quintessential Impressionist painting, his salute to Monet."[33] Although Sargent learned a great deal from both Carolus-Duran and Monet, he developed a style and flair uniquely his own.

Theodore Robinson also established a close friendship with Monet. Although Robinson visited Giverny as early as 1885, his first extended visit dates to the summer of 1887. Monet and his works directly influenced Robinson. Robinson helped further American interest in Monet by writing an article on the painter for the September 1892 issue of *Century Magazine*.[34] In addition to landscapes, Robinson painted many figurative works while living in Giverny. His *Val d'Aconville* painted in Giverny in 1887–89 (The Art Institute of Chicago) employs the same theme, a woman reading in the landscape, and muted tonality as Monet's *La Prairie* (1874, Nationalgalerie, Staatliche Museen Preussischer Kulturbesitz, Berlin). In both paintings priority is given to the landscape over the figure. Another work by Robinson, *The Lane* (page 63), painted in the United States circa 1893, is closer in spirit to Renoir's treatment of this popular Impressionist theme. Robinson's *The Lane* and Renoir's *Confidences* (circa 1873, page 62) depict figures reading quietly in a wooded setting, with greater emphasis placed on the figure. Both paintings include dappled light filtering through foliage, a device especially favored by Renoir in the 1870s, and both contain analogous brushwork. Robinson is known to have seen works by Renoir in private collections, galleries, and at Monet's home in Giverny.

Although Childe Hassam traveled to Europe for the first time in 1883, on a grand tour that included visits to England, France, Italy, the Netherlands, Spain, and Switzerland, he did not turn to an Impressionist aesthetic until settling in Paris between 1886 and 1889.[35] Hassam began his painting career in Boston, where he absorbed the lessons of the Barbizon style from local painters who were former students of William Morris Hunt.[36] In Boston, Hassam began working outdoors and painting the type of urban scenes that became a favored theme throughout his life. For his earliest cityscapes, such as *Boston Common at Twilight* (1885–86, Museum of Fine Arts, Boston), Hassam relied on the soft brushwork and subdued tonalities characteristic of the Barbizon style.

During his three-year stay in Paris, Hassam studied academic figure drawing at the Académie Julian and painted on his own, developing the Impressionist technique that would dominate his style for the rest of his career. In 1890 Hassam painted *Rainy Late Afternoon, Union Square* (page 65) in New York, where he settled after leaving France. This painting exhibits the lightened palette and Impressionist paint application Hassam acquired while in Paris. The work also demonstrates the dramatic diagonal shift from spacious foreground to depth that Hassam adopted by 1885. This compositional structure is found in many Impressionist works, such as Gustave Caillebotte's *Étude pour "Le Pont de l'Europe"* of 1876 (page 64). Hassam's time in Paris likely strengthened his preference for this theme and composition.[37]

29. Shackelford, 1999, suggests that Cassatt made a conscious decision to focus on the theme of mothers and children as a way to differentiate her art from that of Degas.

30. Warren Adelson, "In the Modernist Camp," in *Sargent Abroad: Figures and Landscapes* (New York: Abbeville Press, 1997), p. 11.

31. Quoted in H. Barbara Weinberg, "Sargent and Carolus-Duran," in Marc Simpson, *Uncanny Spectacle: The Public Career of the Young John Singer Sargent* (New Haven: Yale University Press, 1997), p. 6.

32. William H. Gerdts, *Monet's Giverny: An Impressionist Colony* (New York: Abbeville Press, 1993), pp. 21–23.

33. See Adelson, 1997, p. 22.

34. Theodore Robinson, "Claude Monet," *Century Magazine*, September 1892, pp. 696–701.

35. Ulrich W. Hiesinger, *Childe Hassam: American Impressionist* (Munich: Prestel-Verlag, 1994), p. 70.

36. Hunt, the most famous painter in Boston from the 1860s until his death in 1879, studied in France with Jean-François Millet and other French Barbizon painters.

37. Warren Adelson and William Gerdts cite Jean Bérard, James Tissot, and Giuseppe de Nittis as likely sources for the cityscapes Hassam developed in Boston in 1885. See Warren Adelson, Jay E. Cantor, and William H. Gerdts, *Childe Hassam: Impressionist* (New York: Abbeville Press, 1999).

Among the Impressionists Hassam drew inspiration most frequently from Monet. In fact, early-twentieth-century critics commonly referred to Hassam as the "American Monet."[38] Hassam preferred to be recognized as an American artist and therefore often denied the relationship of his works to those of the French Impressionists.[39] A strong connection to Monet can be discerned in Hassam's scenes of rock, land, and sea off the coast of New Hampshire, another of the painter's favorite subjects. Hassam's *Isles of Shoals* (1915, page 67) recalls Monet's *The Customs House* of 1882 (page 66). The paintings include a similar composition—a lushly vegetated hillside stretching from lower right to upper left balanced against a calm sea and sky—bright palette, and intricate brushwork.

Monet's paintings inspired many American artists who visited Giverny, including Mildred Burrage, a painter from Maine. Burrage traveled to Giverny in June 1909 with Mary Wheeler, the principal of a girls' school in Providence, Rhode Island, who owned a home near Monet's. In 1911 Burrage authored an account of the American art colony at Giverny. She reported that "M. Monet joins not at all in the life of the colony about him . . . apparently oblivious to everything but the production of more 'Monets.'"[40] Burrage's *A November Day* (page 69) echoes the monochromism and compositional structure of Monet's *Springtime in Argenteuil* of 1872 (page 68). Both landscapes are composed using a horizontal format with two-thirds devoted to sky and a strong vertical patterning, established by tree trunks and branches, that unites the surface.

Although American painters, such as Hassam and Burrage, continued to be inspired by Monet during the early decades of the twentieth century, a new generation of American painters working in styles that were intended to move American art past Impressionism increasingly came to draw inspiration from Renoir, whom they began to revere as the most innovative and influential of the French Impressionists. Renoir's oeuvre was seen to confirm the aesthetic principles not only of Impressionism but also of Post-Impressionism. Americans valued Renoir's late works as significant contributions to Post-Impressionism because of their synthesis of musical expression, three-dimensional form, and advanced formal virtuosity. Monet continued to be understood solely as the inventor of Impressionism, a style that was beginning to be considered old-fashioned.[41]

Robert Henri, William Glackens, and George Bellows, members of the group of American realists known as the Eight, were among the early-twentieth-century American painters who turned to Renoir for inspiration. As a teacher, Henri encouraged his students to study Renoir's paintings as precedents for successful expression of human character and emotion and use of intricate color and brushwork. Above all, Henri and other early American modernists admired Renoir's ability to maintain a relationship to tradition while successfully contributing to innovative modernism.

William Glackens's admiration for Renoir's color and brushwork emerged about 1910 in paintings such as *Nude with Apple* (Brooklyn Museum of Art) and *Family Group* (1910–11, National Gallery of Art, Washington, D.C.) and lasted until his death in 1938. In

55

38. On Hassam's relationship to Monet, see David Park Curry, *Childe Hassam: An Island Garden Revisited* (New York: W. W. Norton and Company, in association with the Denver Art Museum, 1990).

39. Hiesinger, 1994, p. 9.

40. Mildred Giddings Burrage, "Arts and Artists at Giverny," *World To-Day* 20 (March 1911): 344–51.

41. See Dawson, 2002.

fact, Glackens so admired Renoir that he became known as the "American Renoir." Glackens drew inspiration from Renoir for choice of subject matter as well as color and paint application. Both Renoir and Glackens concentrated on still life, landscape, the female nude, people enjoying outdoor leisure, and depictions of family and friends. Glackens's *The Headlands, Rockport* (1936, page 48) recalls Renoir's *L'Estaque* (circa 1882, Portland Museum of Art) in color range and composition. Glackens's fluid and blended paint application, however, derives from the latest phase of Renoir's oeuvre, most often admired by Americans during the early decades of the twentieth century.

Glackens's friend and colleague George Bellows was also affected by Renoir's works. Like Glackens's *Family Group*, Bellows's portrait *Emma and Her Children* (Museum of Fine Arts, Boston) recalls the composition of Renoir's *Madame Charpentier and Her Children*. This portrait was well known among American artists from the time it entered the collection of the Metropolitan Museum of Art in 1907. A wide range of the French painter's works were readily available to be seen by American artists beginning in 1908, the year that Durand-Ruel held Renoir's first one-artist exhibition in America. Bellows's *Emma in the Black Print* (1919, page 71) recalls Renoir's *Woman in a Chantilly Lace Blouse* (1869, page 70) in conception, lighting, and tonality. Other works by Bellows that reveal a debt to Renoir include his *Tennis at Newport* (private collection) and *Gramercy Park* (private collection), which integrate patchy light effects similar to Renoir's works from the mid-1870s. Bellows's *Nude with Hexagonal Quilt* (1924, National Gallery of Art, Washington, D.C.) reveals the complex color and brushwork of Renoir as well as his interest in the female nude conceived as a modern subject. George Luks and John Sloan, other members of the Eight, were also inspired by Renoir's example, as were such early-twentieth-century modernists as Marsden Hartley, Kenneth Hayes Miller, Isabel Bishop, Andrew Dasburg, and Henry Lee McFee, among others.[42] These artists, like the American Impressionist painters who preceded them, believed that innovation was best achieved through a synthesis of new concepts and the lessons of traditional and modern masters.

An essay of this scope can only touch lightly on such a broad and complex topic as the impact of French Impressionism on American painting. American painters' fascination with Impressionism was a consequence of their esteem for the cultural achievements of France and their profound commitment to professional success and to expanding international recognition for American art. In many ways the American and French Impressionists were not separate entities but closely intertwined artistic communities. American painters met and worked beside French Impressionists as early as the 1860s. In the mid-1870s Mary Cassatt became an integral member of the French Impressionist circle, participating in their independent exhibitions, their marketing strategies, and their social gatherings. By the mid-1880s American Impressionism was an established style and enjoyed favor well into the early twentieth century. American artists as diverse as John Singer Sargent and George Bellows found rich sources of inspiration in the diverse styles of French Impressionism. The stylistic variety and

42. Dawson, 2002.

complexity of French Impressionism provided generative material for American artists for more than sixty years. Viewed from this broad perspective French Impressionism emerges as a major catalyst for developments in late-nineteenth- and early-twentieth-century American art. American painters' profound interest in Impressionism is a fascinating episode of the rich and complex cultural exchanges that have existed between America and France.[43]

43. For a study of the exchanges between Old World Paris and New World New York that proliferated in modernist circles during the late 1910s, 1920s, and 1930s, see Wanda M. Corn, *The Great American Thing: Modern Art and National Identity, 1915–1935* (Berkeley and Los Angeles: University of California Press, 1999).

Edgar Degas, *Danseuse Assise (Seated Dancer)*, 1894, pastel on joined paper mounted on board, 22 ³/₄ x 17 ³/₄ inches. Scott M. Black Collection

Mary Cassatt, *Simone in a Plumed Hat*, circa 1903, pastel over counterproof, 24 ¹/₈ x 19 ⁵/₈ inches. Scott M. Black Collection

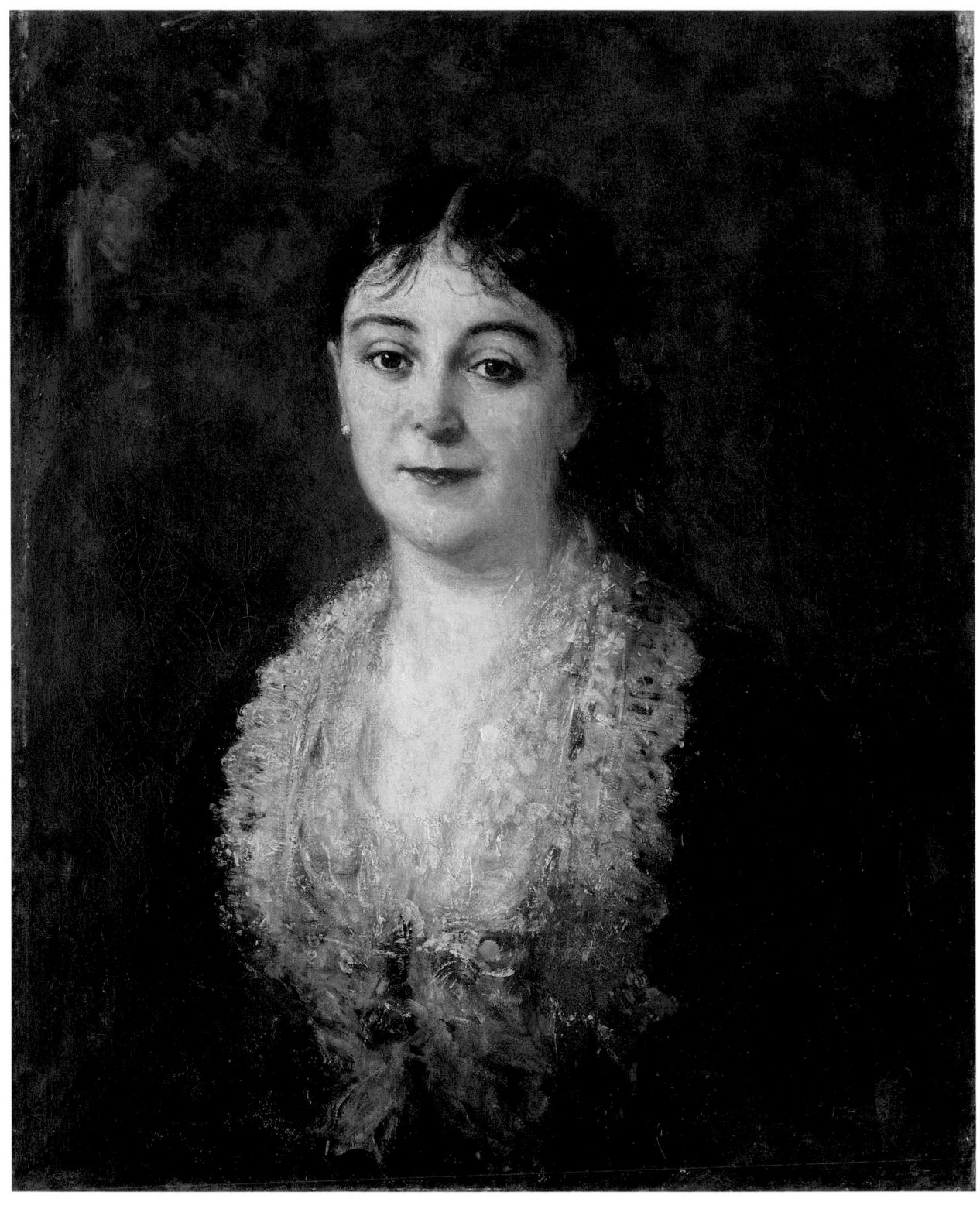

Charles-Émile-Auguste Carolus-Duran, *Portrait of a Woman*, n.d., oil on canvas, 28 ³/₄ x 23 ³/₄ inches. The Metropolitan Museum of Art, Gift of Mr. and Mrs. Oscar Kolin, 1981 (1981.366)

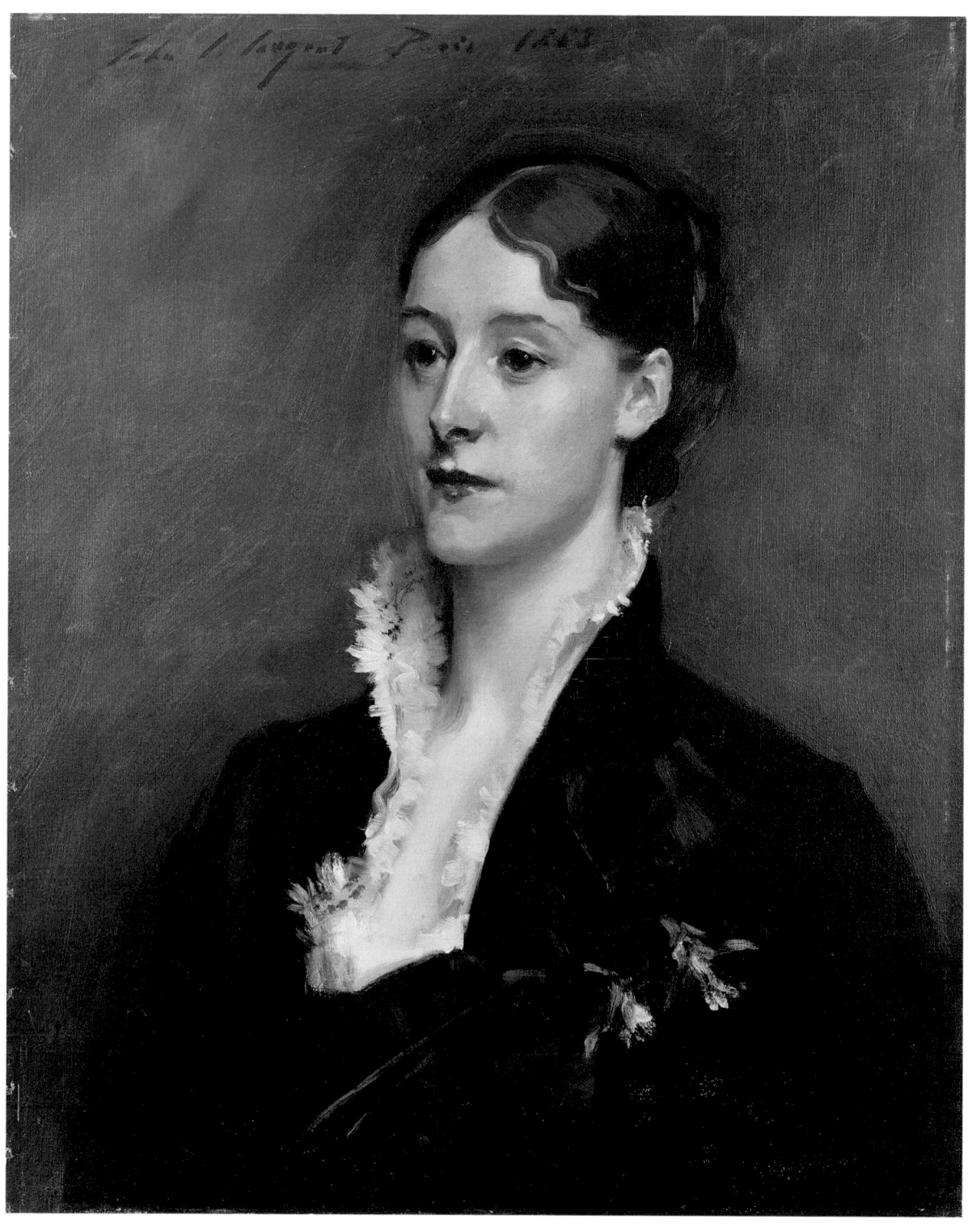

John Singer Sargent, *Portrait of Ellen Archer Eveleth Smith (1856–1925) (Mrs. Henry St. John Smith)*, 1883, oil on canvas, 25 5/16 x 20 7/16 inches.
Portland Museum of Art, Maine, Gift of Dr. and Mrs. Henry St. John Smith and their children, 1986.65

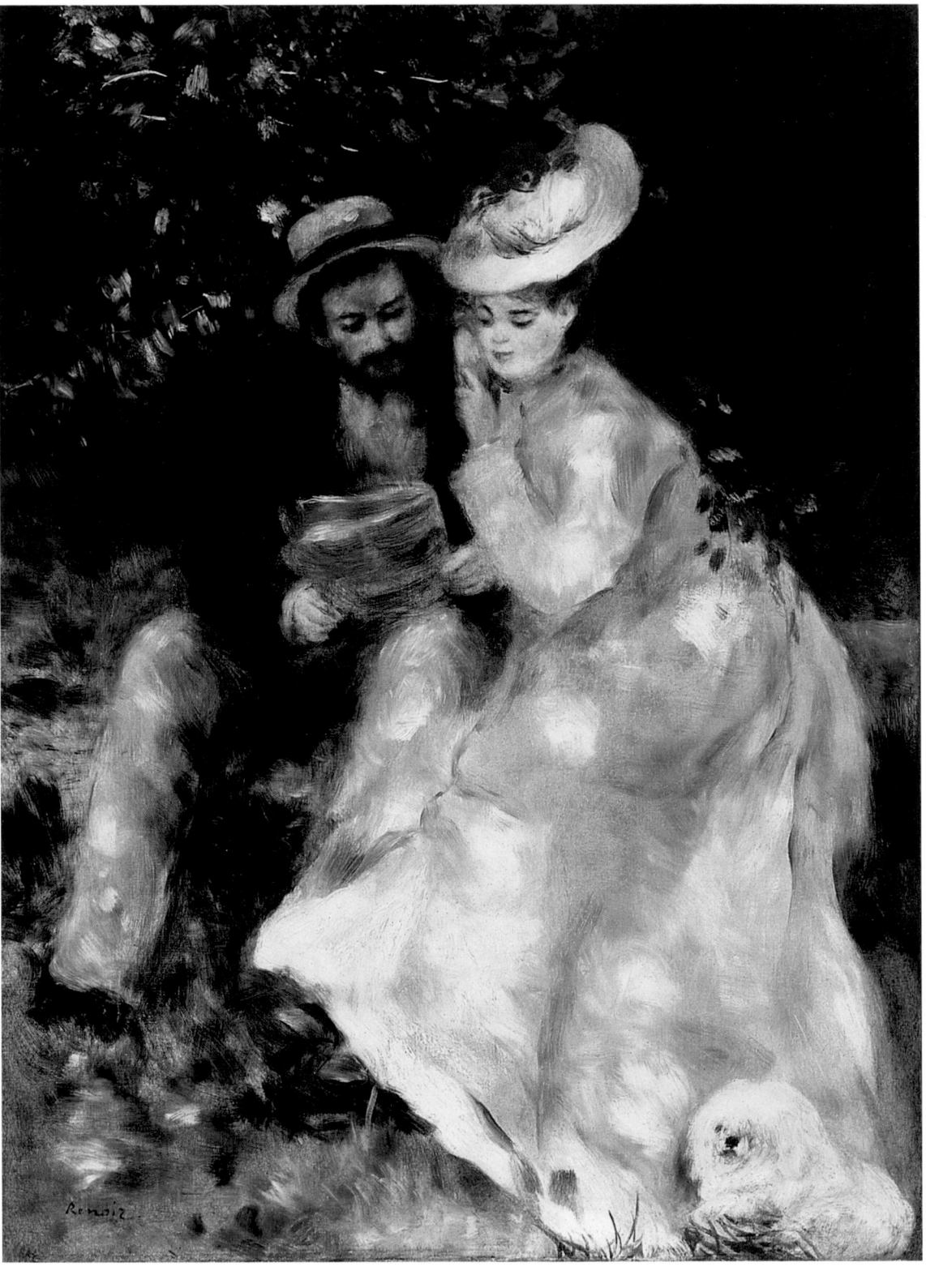

Pierre-Auguste Renoir, *Confidences*, circa 1873, oil on canvas, 32 x 23 ¾ inches. The Joan Whitney Payson Collection at the Portland Museum of Art, Maine, Gift of John Whitney Payson, 1991.62

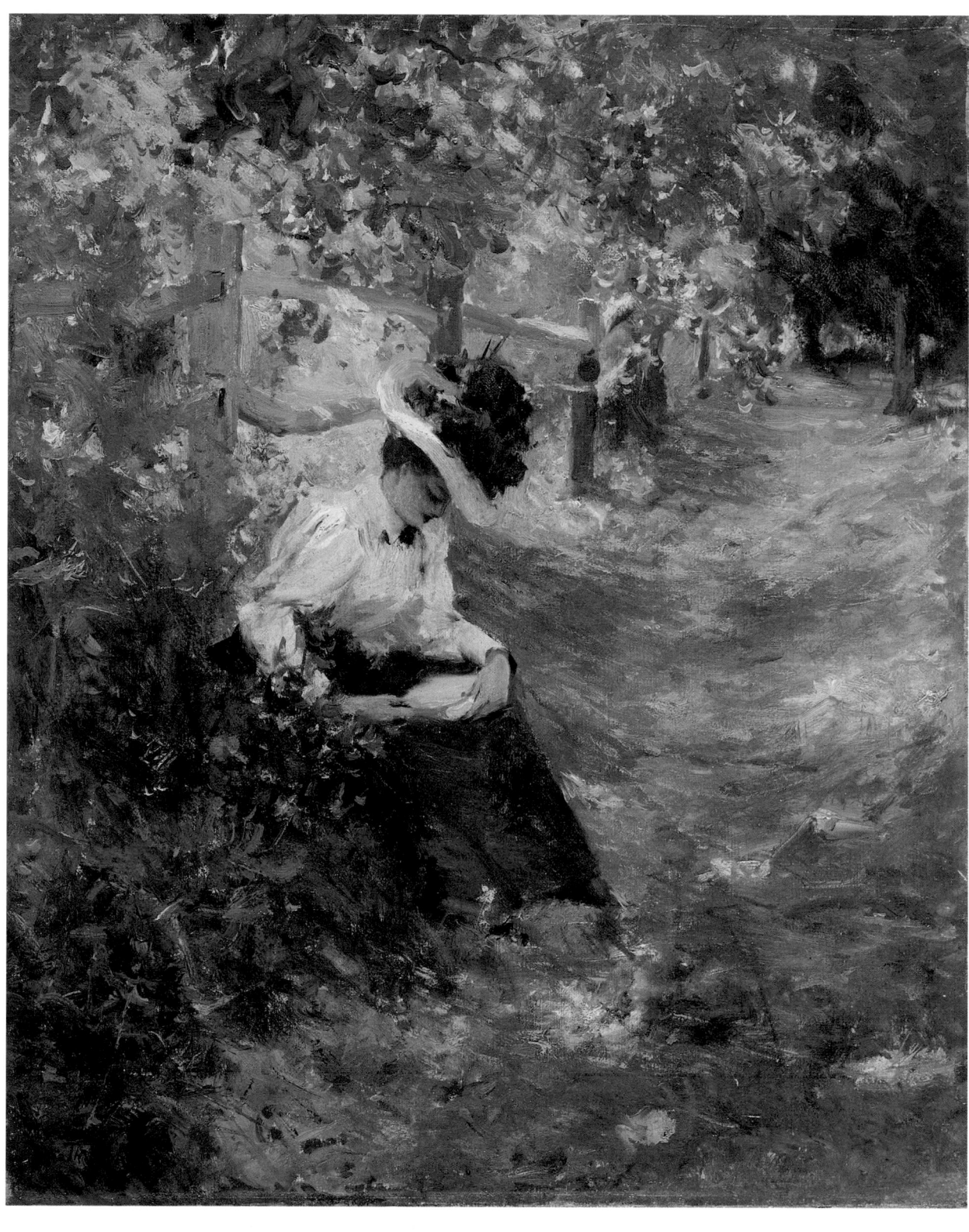

Theodore Robinson, *The Lane*, circa 1893, oil on canvas, 27 ³/₁₆ x 22 ¹/₁₆ inches. High Museum of Art, Atlanta, Georgia. Gift of Miss Mary E. Haverty for the J. J. Haverty Collection, 65.47

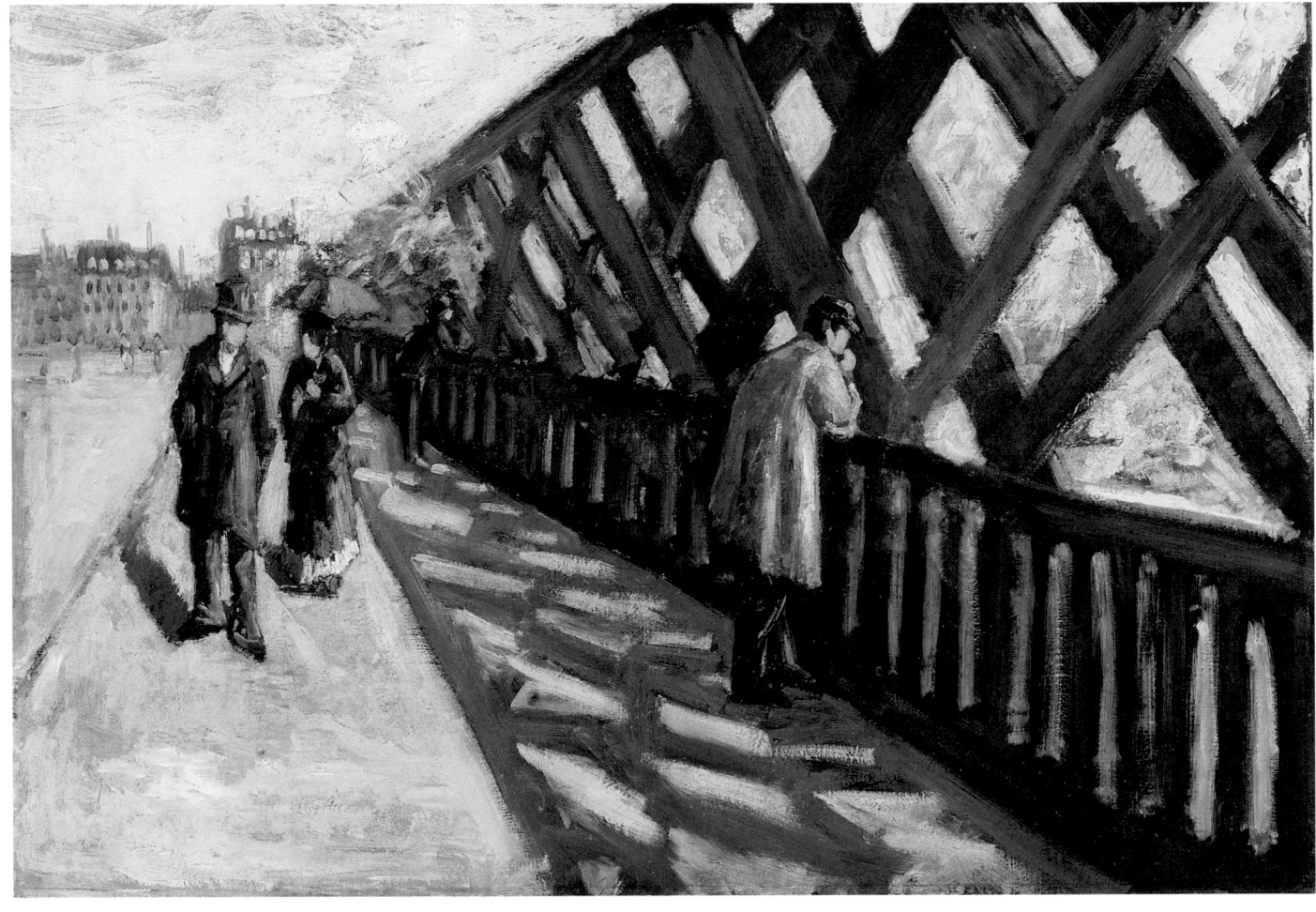

Gustave Caillebotte, *Étude pour "Le Pont de l'Europe" (Study for "Le Pont de l'Europe")*, 1876, oil on canvas, 32 ³/₄ x 48 ¹/₄ inches. Albright-Knox Art Gallery, Buffalo, New York, By exchange, Bequest of A. Conger Goodyear, 1974

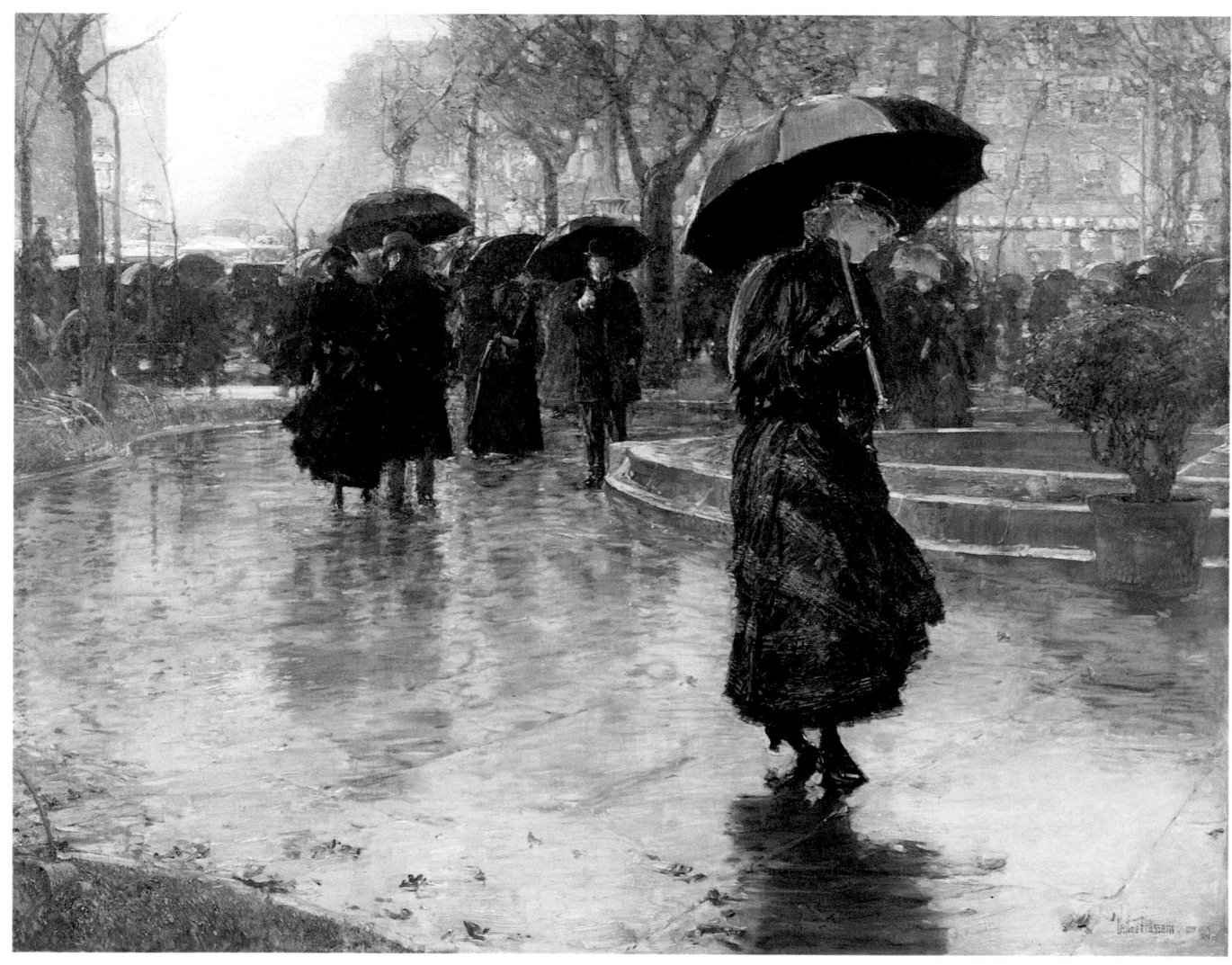

Frederick Childe Hassam, *Rainy Late Afternoon, Union Square*, 1890, oil on canvas, 35 1/2 x 43 1/2 inches. The Museum of the City of New York, Gift of Miss Mary Whitney Bangs, 69.121.1

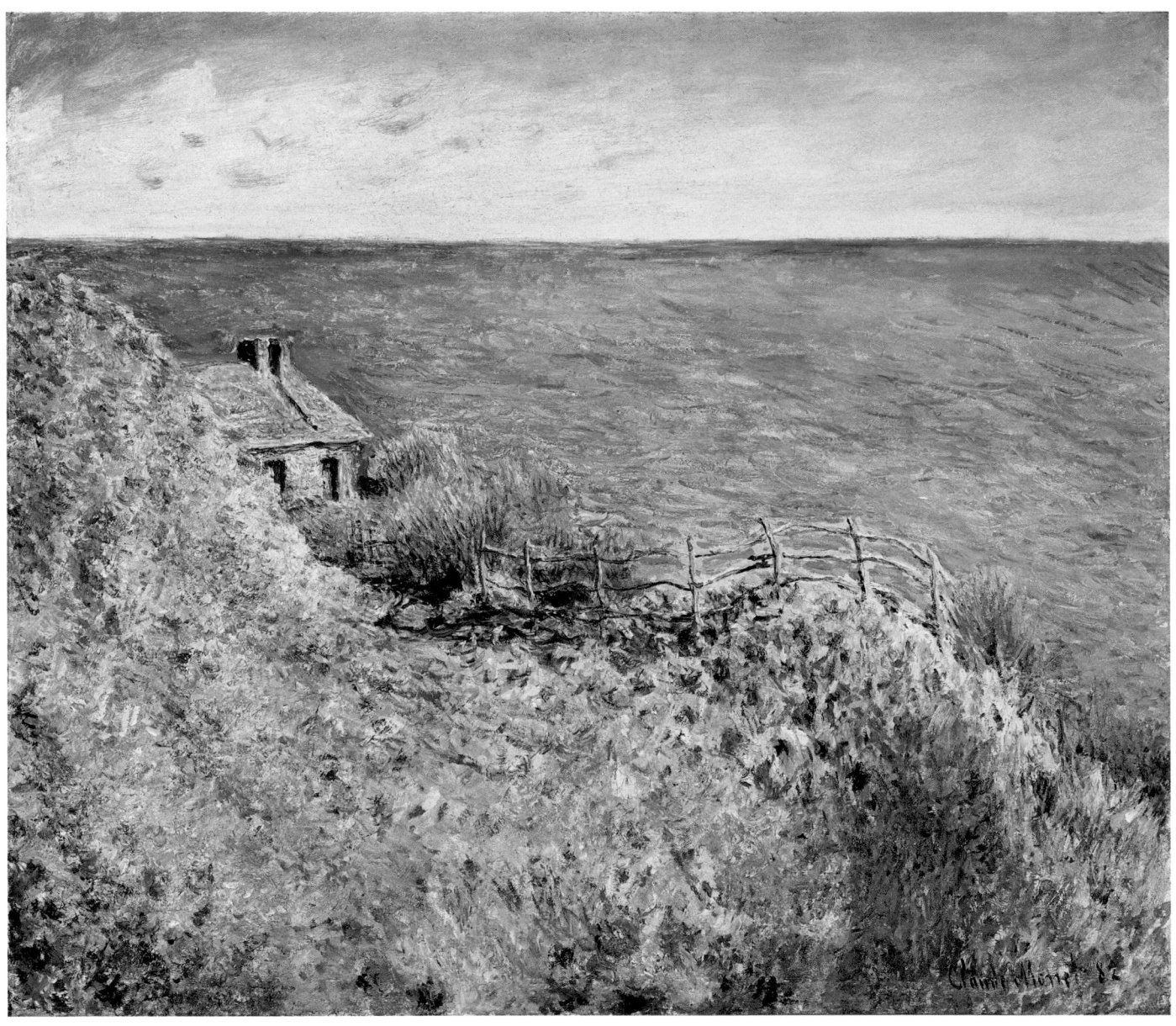

Claude Monet, *[Le] Cabane des douaniers (The Customs House)*, 1882, oil on canvas, 23 $^5/_8$ x 27 $^7/_8$ inches. Private collection, courtesy of Christie's

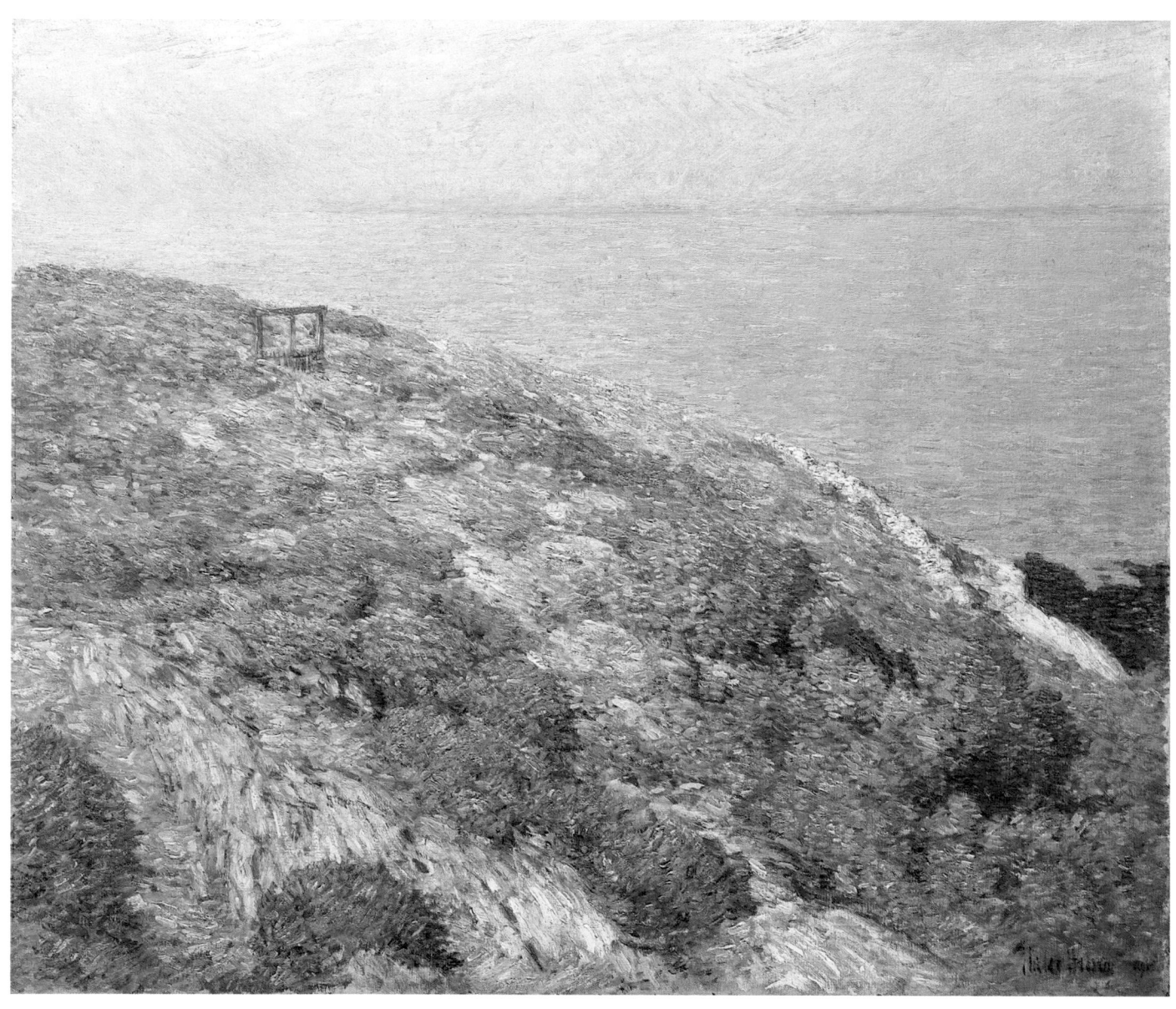

Frederick Childe Hassam, *Isles of Shoals*, 1915, oil on canvas, 25 x 30 inches. Portland Museum of Art, Maine, Bequest of Elizabeth B. Noyce, 1996.38.19

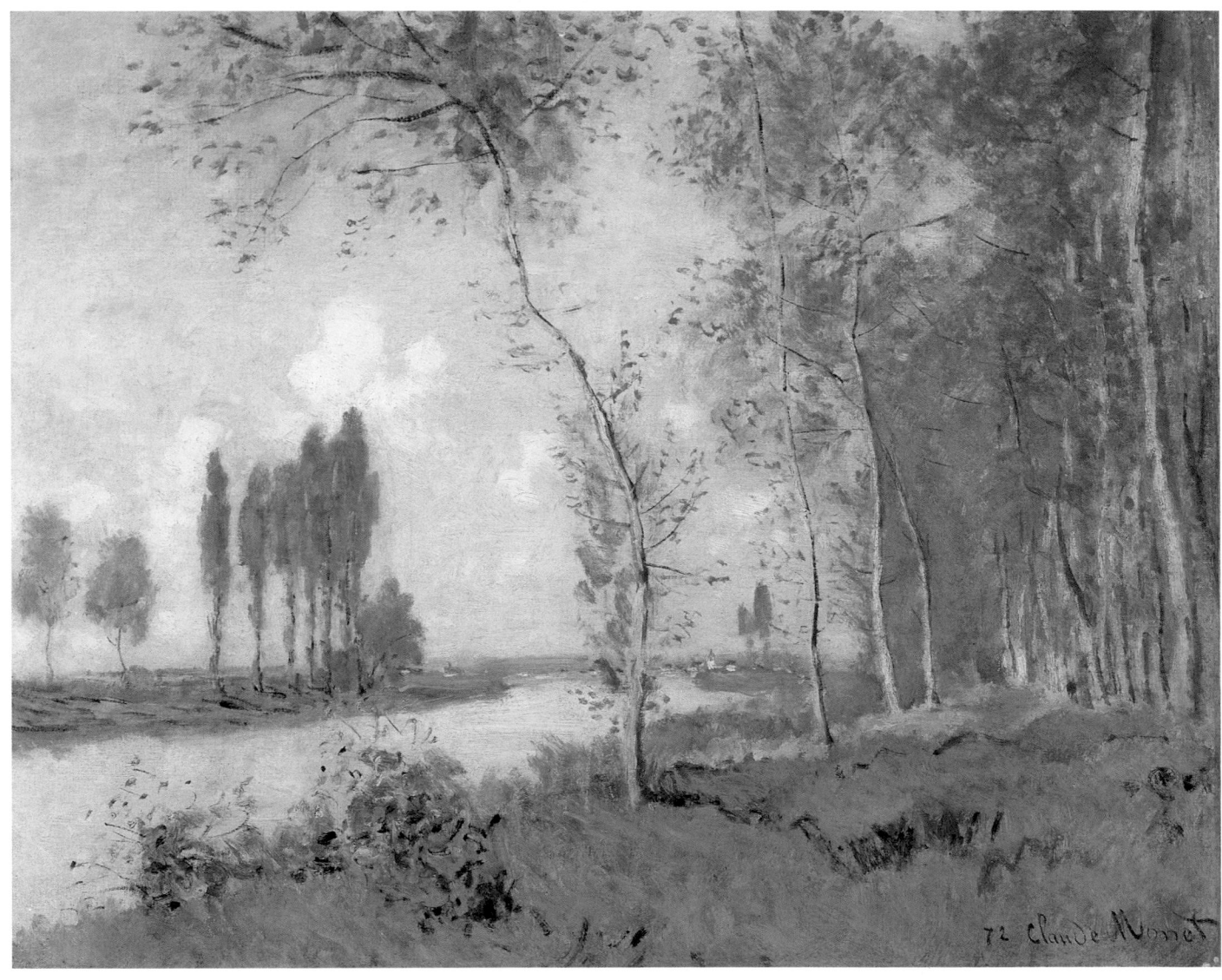

Claude Monet, *Le Printemps à Argenteuil (Springtime in Argenteuil)*, 1872, oil on canvas, 19 $\frac{1}{2}$ x 25 $\frac{1}{8}$ inches. The Joan Whitney Payson Collection at the Portland Museum of Art, Maine. Promised gift of John Whitney Payson, 15.1991.6

Mildred Burrage, *A November Day*, n.d., oil on canvas, 31 ⁷/₈ x 25 ¹/₂ inches. Portland Museum of Art, Maine, Gift of the artist, 1981.118

Pierre-Auguste Renoir, *Femme au corsage de Chantilly (Woman in a Chantilly Lace Blouse)*, 1869, oil on canvas, 32 x 25 ³/₄ inches.
Scott M. Black Collection

George Bellows, *Emma in the Black Print*, 1919, oil on canvas, 40 ¹/₈ x 32 ¹/₄ inches. Museum of Fine Arts, Boston, Bequest of John T. Spaulding, 48.518

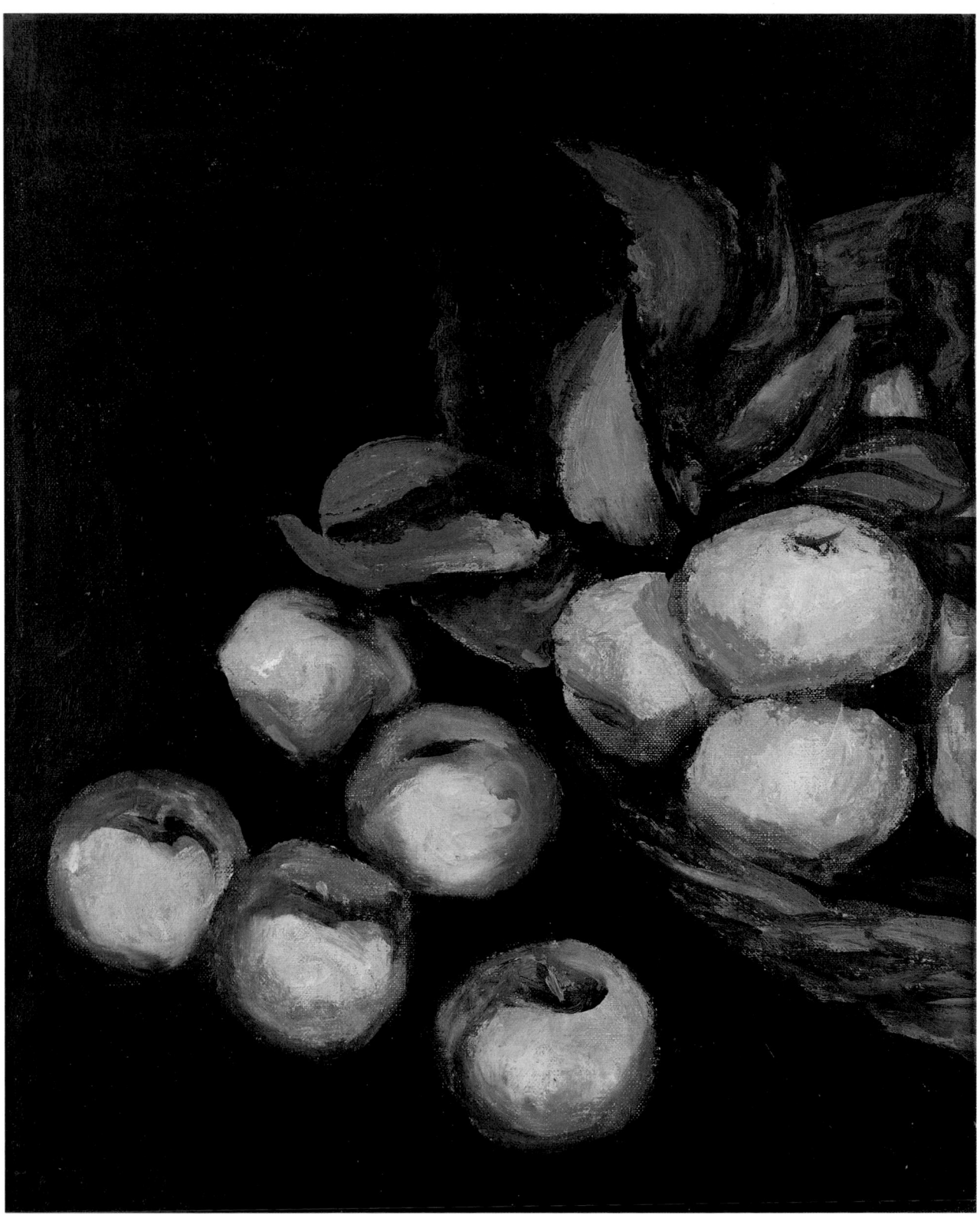

Walt Kuhn, *Green Apples and Leaves*, 1934, oil on canvas, 17 $\frac{1}{2}$ x 13 $\frac{1}{2}$ inches. From the collection of John and Joanne Payson; ex-collection, Joan Whitney Payson

Discovering America in Europe:

Marsden Hartley and the Modernists' Maine

Donna M. Cassidy

In 1928 the American painter Stuart Davis crossed the Atlantic to spend a year in Paris, later writing of this time, "There was so much of the past and of the immediate present, brought together on one plane, that nothing was left to be desired. . . . There was no feeling of being isolated from America."[1] In a painting produced after this trip, *New York–Paris, No. 2* (page 123), Davis visualizes this conflation of past and present, Europe and America, as he brings together on a single canvas emblems of Paris and New York, drawing from his many sketches and paintings of both cities. The two places are clearly identified: "Hotel de France" and "United States" mark adjacent buildings on the left. The curvilinear iron balustrades of the apartments and a kiosk advertising the aperitif Suze define the cityscape as French. Integrated with these things Parisian are signs of American culture, in particular the billboard with "United States" and hieroglyphs of small boats and the subway platform and steel girders seen in Davis's 1926 New York sketchbook.[2] Not only are the fragments of the two cities juxtaposed, but so are the styles and subjects associated with each—the empty street corners common in Surrealist literature like André Breton's *Nadja* (1928) and Eugène Atget's earlier photographs, whose imagery of desertion was admired by the Surrealists; the black outlines that resemble the wire sculptures of Alexander Calder (an American artist also in Paris at this time); and the bold, flat color areas found in both Synthetic Cubism and American advertisements.

In *New York–Paris, No. 2* the boundaries and borders between Paris and New York, France and the United States, have dissolved, as Davis thinks about his own country while absorbing the sights and new artistic styles in the French capital. This transatlantic encounter was essential to American modernism. Recent studies have shown how American artists in Paris during the 1920s—Davis, Calder, Gerald Murphy, for example—created a native art drawing from both European modernism and the products of modern culture that Europeans considered typically American—specifically, jazz, advertising, and the skyscraper.[3] But there are other ways of seeing this cross-cultural exchange. Just as Davis imagined Paris and New York as unbroken spaces, Marsden Hartley identified a continuity between European landscapes and those of his native region, writing at the end of the decade from Aix-en-Provence: "The curious thing about all this being over here is—that it has nothing to do with living in Europe—

I want to thank Duncan Dwyer and Robin O'Sullivan, my graduate assistants, for their help with the research for this essay.

1. Stuart Davis, quoted in epigraph to Elizabeth Hutton Turner, *Americans in Paris (1921–1931)* (Washington, D.C.: The Phillips Collection and Counterpoint, 1996).

2. Elizabeth Garrity Ellis, "The View from Paris," in Turner, 1996, pp. 67–68.

3. See, for example, Wanda M. Corn, *The Great American Thing: Modern Art and National Identity, 1915–1935* (Berkeley and Los Angeles: University of California Press, 1999).

there are days, weeks, even months when I'm not even conscious of it—I live in spaces that are so integral to my nature as to make geography seem trivial—whole days when I see nothing or feel nothing but New England."[4] As American artists encountered such landscapes and traditional folk communities on the other side of the Atlantic, they saw connections with American locales outside New York, places like Maine: they discovered America in Europe.

THE MODERNIST GEOGRAPHY OF MAINE

In 1866, when Winslow Homer traveled to Paris, he confronted one of the first bold experiments in modernist art, realism, advanced by the French painters Gustave Courbet and Édouard Manet and defined by a sketchy manner, seemingly spontaneous compositions, and contemporary subjects. Although we do not know what art Homer saw at this time, realism clearly shaped his genre paintings of the 1860s and 1870s and left a distinctive stamp on his Prout's Neck seascapes of the 1890s. In *Weatherbeaten* (page 87), Homer pictures an elemental battle of natural forces, the pounding waves against the rockbound Maine coast. The sea foam and spray, described in an impastoed paint, establish a powerful vicarious experience, as the owner of another Homer seascape stated: the picture "gave him the feeling that he might be washed out of his home at any moment."[5] Such paintings argue that Homer most likely studied Courbet's depictions of waves like *Stormy Weather at Étretat* (page 86) at some point in his career, since immediacy, directness, and crusty sea foam mark Courbet's painting just as they do Homer's.[6] This realist sea became the dominant mode of representing the Maine coast for modernists—in George Bellows's *Beating Out to Sea* (1913, Farnsworth Art Museum, Rockland, Me.) and Marsden Hartley's *Surf on Reef* (page 107), for example. The latter was painted when Hartley returned to Maine, his native state, after many years away and abroad— 1912–15 in Paris and Berlin; the 1920s in France, Germany, and Italy; and 1933–34 in Germany—and when he sought to promote himself as an American artist, as the "painter from Maine."[7] This homecoming and his late Maine paintings were possible because of his excursions to Europe, for it was there that he discovered Maine and saw it as a place where modernist art could be created.

Hartley identified Homer as a foremost New England artist and proclaimed his own ties to him: "I have always been proud as a yankee, that Homer's inspiration and his sense of dramatic nature were derived chiefly from my own native rocks, at Prout's Neck, Maine."[8] Hartley saw as a regionalist predecessor not only Homer but the French painter Paul Cézanne as well. In 1925 Hartley summered in Vence, a hilltop town in the maritime Alps, and the following June moved to Aix-en-Provence, where he painted on and off for the next three years. Provence was Cézanne's region, with Aix one of the major sources of subjects for his art, and Hartley went to this area seeking inspiration. While there, he closely studied the sites that had attracted Cézanne, especially Mont Sainte-Victoire, which he painted with the short brushstrokes, bright color patches, and even close-up view typical of his predecessor's land-

4. Marsden Hartley to Rebecca Strand, late summer 1929, Elizabeth McCausland Papers, reel X3, Archives of American Art, Smithsonian Institution, Washington, D.C. (hereafter AAA).

5. John Beatty, conversation with Dr. Frank Gunsaulus, owner of *On a Lee Shore* (1900, Museum of Art, Rhode Island School of Design), quoted in Sarah Burns, "Revitalizing the 'Painted-Out' North: Winslow Homer, Manly Health, and New England Regionalism in Turn-of-the-Century America," *American Art* 9, no. 2 (summer 1995): 26.

6. Bruce Robertson, *Reckoning with Winslow Homer: His Late Paintings and Their Influence* (Cleveland: Cleveland Museum of Art; Bloomington: Indiana University Press, 1990), p. 50.

7. On Hartley's late career in Maine, see Donna M. Cassidy, *Marsden Hartley: Race, Region, and Nation* (Lebanon, N.H.: University Press of New England, in press).

8. Marsden Hartley, "New England Painting and Painters," 1937, Marsden Hartley Papers, Yale Collection of American Literature, Beinecke Rare Book and Manuscript Library, Yale University (hereafter Yale) (Marsden Hartley Papers, reel 1369, frame 1822, AAA).

scapes, as can be seen in the pairing of Cézanne's *Mont Sainte-Victoire Seen from the Bibémus Quarry* (page 88) and Hartley's *Mont Sainte-Victoire, Aix-en-Provence* (1927, private collection).

In the late 1920s Hartley had seen numerous paintings by Cézanne at exhibitions in Paris and in the private collection of the American Charles Loeser in Florence. He considered the color sensations and clarity of light the paramount features of Cézanne's art but also admired Cézanne's intense absorption in his native locale.[9] For him, Cézanne possessed a "racial integrity and racial insight" and "arrived at his present interior or universal significance . . . directly and solely through the qualities of Provence."[10] During his time in Aix, he, too, felt the strong affinity to place that he detected in Cézanne's work: "There is something in the light and the natural aspects of Provence that 'belong' to me in that it offers to me a quality of 'air,' and by this I mean the inherent emanation from the land itself that gives my very feet a sense of home."[11] Discovering this "sense of home" led Hartley to think of his natal state, Maine. In a 1929 letter he compared the village of Head Tide, Maine, with Aix-en-Provence and commented that he would "have need once again for the spiritual succor that rises out of this area of the earth [Maine] for me. . . . For I never feel or have felt so downright New England as I do this very moment."[12] This revelation was crucial for Hartley who was in the late 1920s contemplating a return to the United States in response to increasing hostility among art critics and audiences to American artists working abroad. Seeing what Cézanne could do in his natal region assured him that he could do the same in Maine.

Yet coming between southern France and Maine was another trip that directed Hartley to his native state. In Germany in 1933–34 Hartley renewed his study of an important source for his early Maine mountain paintings—the Alpine landscapes of Giovanni Segantini. He viewed the Swiss painter's work in the Hamburger Kunsthalle, specifically mentioning *Consolation of Faith* (1896), and wrote about his desire to recover Segantini's influence on him.[13] His own paintings, drawings, and prints of the Bavarian Alps describe scenes of high mountains that dwarf the farm buildings at their base—compositions reminiscent of his own canvases of the Maine hills like *Carnival of Autumn* (1908, Museum of Fine Arts, Boston). Hartley's letters from Garmisch-Partenkirchen, where he stayed for much of his 1933–34 German trip, speak of how the Alps were awakening in him a desire to return to Maine and paint Mount Katahdin, as his time in Germany was "a grand preparation for recovery of the 'eye' for the native scene. . . . it is exactly alike here."[14] In another letter, he comments on the continuity between Maine and Germany: "After all it is nothing but the return to my own native land symbolically and mystically—and I see now I have only gone the other way round to get home. I hear the voices of Emerson, Thoreau, Emily Dickinson and they are true voices— they belong to my space. . . . So it is I hardly know I am in Germany."[15]

When Hartley finally returned to Maine and painted Mount Katahdin, his works were defined by his European exploits, from his study of Segantini and Cézanne to his time in the Alpine villages of southern Germany. Guided by the game warden Caleb Scribner, he took an eight-day trip to Katahdin in October 1939. Staying at the hunter's camp, Cobbs Camp, in

9. Marsden Hartley, "The MOUNTAIN and the RECONSTRUCTION" (1928), in *On Art by Marsden Hartley*, ed. Gail R. Scott (New York: Horizon Press, 1982), pp. 75–77. Hartley would later identify Cézanne as a regionalist in his essay "The Education of the American Artist," circa late 1930s, Yale (reel 1369, frame 1252, AAA).

10. Marsden Hartley, "Impressions of Provence: From an American's Point of View," circa 1920s, in Scott, 1982, pp. 145–46.

11. Scott, 1982, p. 146.

12. Hartley to Strand, November 19, 1929, reel X3, AAA.

13. Hartley to Adelaide Kuntz, July 12, 1933, McCausland Papers, reel X4, AAA.

14. Hartley to Kuntz, September 7, 1933, reel X4, AAA.

15. Hartley to Kuntz, July 12, 1933, reel X4, AAA.

a rough-hewn log cabin overlooking Katahdin Lake, Hartley made a series of drawings and oil sketches that formed the basis of the paintings that he worked on over the next three years. In these works, such as *Mount Katahdin, Autumn No. 2* (page 89), he used a simple composition of horizontally layered forms—lake, woods, mountain, sky and clouds, with a tall pine at the base—and presented the mountain from the vantage point of the southern shore of Katahdin Lake. This perspective, with its focus on the pyramidal granite cone, attracted Hartley because it offered a dramatic composition and was "a picture made to order for the painter."[16] It also resembled Cézanne's Mont Sainte-Victoire landscapes (page 88); Hartley seems to have seen the Maine mountain through the veil of the French artist's paintings.

Cézanne provided other models for representing the Maine landscape, which is evident in the art of John Marin. In Paris from 1905 to 1910, Marin saw the work of emerging modernists in the galleries and was particularly taken by the innovative watercolors on display in the French capital. A 1907 Cézanne exhibition at the Galerie Bernheim-Jeune and a retrospective at the Salon d'Automne featured a new type of watercolor—fragmentary natural forms floating on white paper—and Marin began to fashion a similar manner in his celebrated early cityscapes of New York and seascapes of Maine.[17] In these works, Marin was not seeking naturalistic description but rather wanted to create equivalents of his own feelings toward nature, as advocated by the Alfred Stieglitz circle and as he himself explained: "These works are meant as constructed expressions of the inner senses, responding to things seen and felt. One responds differently toward different things; one even responds differently toward the same thing."[18] Marin devised a shorthand language to visualize his responses. In *Lead Mountain, Beddington, Maine* (page 91), broken pencil lines and broad gray and green watercolor washes with red and yellow spots suggest the rocky topography and autumnal season; the sky too is not described but evoked in the blue shape topping the mountain. The forms are dematerialized, with lines and colors floating in a white field. The simplified lines, colors, and forms suspended on the white paper and the fluid washes resemble Cézanne's work in the same medium, such as *Mont Sainte-Victoire* (page 90).

Modernists working in Maine found diverse ways to transform Cézanne's style and subjects. A comparison of Cézanne's *Turn in the Road* and Marguerite Zorach's *Brunswick Mills* reveals this complex relation (pages 92, 93). The former painting typifies the artist's style of the early 1880s—the short, parallel brushstrokes, absence of spatial recession, and focus on the two-dimensional canvas surface which is emphasized by the band of trees; it marks Cézanne's movement toward the geometric construction that would distinguish his late style. The subject—the rural countryside—is also typically Cézannesque. The village pictured in *Turn of the Road* has been identified as Valhermeil, located along the Oise River between Auvers and Pontoise just an hour west of Paris, where Cézanne had lived and worked for many years alongside Camille Pissarro. Cézanne paints this rustic enclave as an unpeopled, abandoned town, reminiscent of the deserted villages of Charles-François Daubigny and Alfred Sisley.[19]

Brunswick Mills possesses striking similarities with the manner and mood in *Turn in the*

16. Marsden Hartley, "Be That as It May," 1941, Yale (reel 1369, frame 2200, AAA).

17. Carol Troyen, "A War Waged on Paper: Watercolor and Modern Art in America," in *Awash in Color: Homer, Sargent, and the Great American Watercolor* (Boston: Museum of Fine Arts and Bulfinch Press, 1993), p. xxxvi.

18. *The Forum Exhibition of Modern American Painters* (1916; reprint, New York: Arno Press, 1968), n.p.

19. Françoise Cachin et al., *Cézanne* (New York: Harry N. Abrams; Philadelphia: Philadelphia Museum of Art, 1996), p. 230.

Road. The collapse of three-dimensional space in Zorach's work clearly shows her study of Cézanne, while the long, parallel brushwork in the boulders and fall foliage in the background trees is another sign of the French painter's influence. Zorach is not interested in depicting the rustic villages of Maine but rather the architecture of the modern landscape; even here, she seems to take a lesson from Cézanne as the uninhabited cottages of Valhermeil, with their blackened windows, become the deserted mills of New England. We see glimpses of another kind of exchange between European and American artists, one between the rural and industrial, the premodern and the modern. Zorach presents a view of the Bowdoin Mills on Great Mill Island in the Androscoggin River on the Brunswick-Topsham line. Her perspective is from the Brunswick riverbank, although it is a rather close-up perspective in which much of the river and new iron bridge are eliminated and the focus is on the boulders and rock formations that mark the site. The darkened sky and unpeopled buildings suggest the troubled times that the mill experienced in the 1930s, specifically the halting of paper production in 1934, the increased international competition from Canadian mills, and the threats of labor strikes.[20]

The geometric construction and architectonic forms in Cézanne's paintings became fundamental to the language of European modernism. Often employing a structured approach to nature, Cézanne converted trees, mountains, and houses into geometric forms, with their open edges merging into other areas—an approach that influenced Cubism. In *La Maison. La Roche-Guyon* (page 94), Georges Braque abandoned deep spatial recession and a consistent light source and transformed a house, tree, and landscape into a densely packed surface of faceted volumes described by a limited palette, with forms blending with each other, a technique evident in the corner of the house that opens into the surrounding landscape. La Roche-Guyon is a picturesque site on the Seine River downstream from Mantes, where Cézanne had painted and where Braque found the isolation he needed to do his work. The American painter Max Weber discovered a similar locale in Westport, Connecticut, a retreat from New York City and a site that he painted with Arthur Dove, as can be seen in his 1911 *Connecticut Landscape* (page 95). Weber learned his first lessons in Cubism during his trip to Paris (1905–9), when he saw the works of Cézanne, Pablo Picasso, and Robert Delaunay. He was able to continue his study of this new style on his return to New York at the 1911 Picasso exhibition at Stieglitz's Little Galleries of the Photo-Secession (or 291) and in reading Gelett Burgess's "The Wild Men of Paris," a 1910 article in *Architectural Record* that reproduced Picasso's *Les Demoiselles d'Avignon* (1907, The Museum of Modern Art, New York).[21] Made in response to that exhibition and essay, *Connecticut Landscape* displays the hallmarks of Cubism and a striking resemblance to Braque's painting with its geometric brushwork, angular trees, and faceted sky, foliage, and earth. Like Dove's contemporary paintings such as *Abstraction No. 3* (1910/11, private collection), however, Weber produces a version of Cubism that is decorative, brilliantly colored, more Fauvist, and less sculptural than Braque's *La Roche-Guyon.*[22]

Hartley, too, transformed the regional landscape, in his case the northern New England woods, into a Cubist geography. The 1911 Picasso exhibition at 291 inspired Hartley's

20. See Bowdoin Mills file, Pejepscot Historical Society Archives.

21. Percy North, *Max Weber: The Cubist Decade, 1910–1920* (Atlanta: High Museum of Art, 1991), pp. 14, 21–23, 85–86.

22. On Dove and Weber, see Debra Bricker Balken, *Arthur Dove: A Retrospective* (Andover, Mass.: Addison Gallery of American Art; Cambridge, Mass.: MIT Press, in association with The Phillips Collection, 1997), pp. 20–22.

early Cubist essays like *Landscape No. 32* (1911, Weisman Art Museum, University of Minnesota, Minneapolis), just as it had for Weber. Like Weber, too, he extended his study of Cubism in Paris, where he saw Picasso's art at Gertrude Stein's apartment (where he even met the artist in 1912) and exhibitions at the Salon d'Automne, Section d'Or, and Daniel Henry Kahnweiler's gallery. The intersecting planes, spatial ambiguity, and linear grid typical of Picasso's Analytical Cubist works like *The Architect's Table* (1912, The Museum of Modern Art, New York) are most obvious in Hartley's self-named "cosmic cubist" abstractions of the early 1910s, yet the lessons of Cubism continued to affect his art throughout his career. The form and structure of Cubism are placed over the rocky, rugged New England landscape in *Kinsman Falls* (1930, Portland Museum of Art) and *Smelt Brook Falls* (1937, Saint Louis Art Museum, Mo.), which depicts a site near Georgetown, Maine, where Hartley stayed in the summer of 1937. In the latter, the autumnal landscape, waterfall, and surrounding trees are pushed into the foreground, replicating the interlocking surface facets of Cubism, while the black outlines of the waterfall and trees form a linear pattern reminiscent of the characteristic Cubist grid.

THE MODERNIST IDYLL: MAINE AS AN ANTIMODERN PARADISE

The modernist landscapes of Maine—the realist crashing waves, Cézannesque mountains, Cubist boulders—create a vision of a place isolated, primitive, elemental, and outside the over-civilized, regimented cities of modern America. An antimodern paradise, Maine offered escape for both early-twentieth-century artists and tourists to an isolated wilderness and to a locale where nature balanced culture, where a rural culture survived. The state was imagined as a pastoral idyll in paintings where humans were present but did not destroy nature and instead enjoyed its benefits, as in Gertrude Fiske's *Ogunquit Beach, Maine* (1924, Colby College Museum of Art, Waterville, Me.) and Leon Kroll's *Summer Days, Camden, Maine (The Bellows Family)* (1916, Mead Art Museum, Amherst College, Amherst, Mass.). Such idylls also figured prominently in European modernism. Henri Matisse's *Le Bonheur de Vivre* (1905–6, Barnes Foundation, Merion, Pa.), for instance, manufactures a fantasy world inhabited by mostly female nudes with sensual, curving bodies and shepherd-musicians who recall characters from classical mythology. With the pleasures of being, living, and working in nature as its subject, this painting, and other modernist idylls shaped the art of the American modernists and even representations of Maine in the early twentieth century, as seen in Marguerite Zorach's work.

Arriving in Paris in 1908, Zorach was enthralled with the avant-garde art that she saw at the Salon d'Automne and Salon of the Société des Artistes Indépendants. It was Matisse's art that most profoundly appealed to her, as she developed a cloissonist manner of dark outlines filled with the vibrant, unmixed colors typical of Fauvism.[23] Settling in New York on returning to the United States, Zorach and her husband, William, agreed early in their marriage that they would spend summers away from the city. Chappaqua, New York; Plainfield, New Hampshire; Provincetown, Massachusetts; and Stonington, Maine, all served as summer getaways for

23. Roberta K. Tarbell, "Life and Work," in *Marguerite and William Zorach: Harmonies and Contrasts* (Portland, Me.: Portland Museum of Art, 2001), p. 51.

the couple during the 1910s, and in 1922 they bought a house in Georgetown, Maine. For the Zorachs, such locales outside the modern city and close to nature possessed a recuperative, rejuvenating power. They were spaces in which the rules of middle-class respectability and manners could be abandoned, as Marguerite wrote about New Hampshire: "It certainly is an isolated spot if there ever was one and I fear we will all revert to the wild state if we stay here long."[24] Zorach found Matisse's idylls perfect visions for embodying her attitudes toward these uncivilized summer spaces.[25] In *The Garden* (1914, Portland Museum of Art), inspired by a summer in Chappaqua, she invokes Matisse's *Le Bonheur* and *Three Bathers* by painting male and female figures, some nude, embracing and cultivating the soil: the figures' rounded silhouettes create a relaxed mood similar to that of Matisse's works; the outlined figures and crouching female at right and gardener in the background of *The Garden* even parallel poses of the figures in *Three Bathers* (page 96).

Pastoral idylls became a staple in the art of both Zorachs, especially that associated with their retreats away from the city, including Maine, which is pictured in *Maine Islands* (page 97), an embroidered tapestry made collaboratively by Marguerite and William. This medium was common in the American folk art that the Zorachs became interested in through their association with Hamilton Easter Field and Edith Halpert, although the stitches also resemble Matisse's broken brushstroke and patterned, decorative surfaces. Other relations to Matisse are evident in this tapestry. Like Matisse's *Luxe, Calme, et Volupté* (1904–5, Musée d'Orsay, Paris), *Maine Islands* situates the nude in a specific locale—along the Maine coast, as it was inspired by a vacation in Stonington.[26] The contemporary and the mythic are juxtaposed as they were in Matisse's *Three Bathers* and *Luxe*: the father and son group refers to William Zorach and his young son Tessim, and the sailboats give the scene a modern tone, while the nude female and bull on the right evoke the myth of the Rape of Europa. Here, as in Matisse's paintings, the figures merge with the landscape to produce a harmony between humans and the natural world.

As the art historian Margaret Werth has argued, the pastoral idyll had multiple functions in modernist art and culture in France: it engaged dreams and fantasies; it was a site where social and cultural identity was contested; and it represented a desire for an imagined, unified culture of the past that had been lost.[27] The pastoral idyll also had a relation to early-twentieth-century culture in the United States: it served as a sign of antimodernity and antipuritanism for American modernists. The Stieglitz-circle critics Van Wyck Brooks and Waldo Frank adopted the term *Puritanism* to denote the emotional and sexual restrictions that typified American society. In *The Wine of the Puritans* (1908) Brooks presented the Puritan as the embodiment of the negative characteristics of American culture—materialism, intellectualism, efficiency, commercialism. For him, in order to mold a new culture and a vigorous creative life, American artists must spurn Puritanism and embrace emotion. This rejection of inhibition in favor of instinct formed the philosophical base of American modernism, and the female nude became an important vehicle for embodying the regenerative power of spontaneity,

24. Marguerite Zorach to John Weichsel, summer 1917, from Plainfield, N.H., John Weichsel Papers, reel N60-1, AAA. Also see Jessica Nicoll, "To Be Modern," in *Zorach: Harmonies and Contrasts*, 2001, pp. 25, 28.

25. Tarbell, 2001, pp. 51, 58.

26. Hazel Clark, "The Textile Art of Marguerite Zorach," *Woman's Art Journal* 16 (spring–summer 1995): 20.

27. Margaret Werth, *The Joy of Life: The Idyllic in French Art, circa 1900* (Berkeley and Los Angeles: University of California Press, 2003).

freedom, and sensuality in the work of many artists. Stieglitz, for instance, presented the female nude as a symbol of creation in his writings and in such photographs as *Portrait of R.* (1923, Museum of Fine Arts, Boston), while Gaston Lachaise molded sculptures of potent, procreative female nudes, with large breasts, round abdomens, and wide hips, as in *Standing Woman* (1912–29, Whitney Museum of American Art, New York).[28]

From 1931 to 1952 John Marin painted about seventy works with nude figures, mostly female, with the largest number from 1935 to 1942. In these paintings, he combined the nude with another of his favorite subjects, the Maine coast. Although he exhibited his distinctive dynamic, linear style in these paintings, Marin was responding to the many depictions of the female nude in Euro-American modernism—drawings and paintings by Matisse, Cézanne, Auguste Rodin, and Abraham Walkowitz that he would have seen in Stieglitz's galleries (291, the Intimate Gallery, and An American Place) and during his trip to Paris earlier in the century. In the 1930s and 1940s he studied and collected reproductions of bathers by Matisse, Picasso, and Cézanne, and his scrapbook includes clippings of Cézanne's *Bathers* (n.d., The Barnes Foundation) and *The Large Bathers* (page 98). Marin's figures in *Sea and Figures, Concept #1* (page 99) merge with nature as their bodies seemingly dissolve into the ocean, just as Cézanne's nudes appear to be part of the wooded landscape. They are posed within an implied triangle, suggesting the geometric structure that defined the figures in *The Large Bathers*, while their buoyant pink bodies recall the flesh tones of Matisse's nudes. In the titles of his bather paintings, Marin frequently identified the nudes as sea nymphs, the lesser sea divinities who frolicked by the shore and were wooed by the Tritons. His choice of this mythological subject suggests his intention to construct a paradise in his bather paintings, following the example of Matisse in *Le Bonheur de Vivre*. The setting was critical to creating this paradise. Maine, for Marin, was an Eden of sorts that contrasted with modern society, and he lamented having to leave the Maine coast (nature) to return New York (civilization), which he described as "streamlined—ironed out—flattened out—squeezed out—by the Hitlers of the Earth—they haint up here [in Maine]—no semblance of a Hitler was ever known to live by the Sea."[29]

In similar fashion, the male bather was used to critique modern culture, its restrictions and, particularly, emerging anxieties about masculinity, as can be seen in the work of northern European modernists. In Edvard Munch's *Bathing Men* (page 100), sunbathing is extolled as a source of health and regeneration as men strip off their clothes to enjoy nature. Two male nudes confront the viewer and exude a masculine power through their tensed muscles and striding legs. This work embodies the ideals of vitalism, a reform movement that drew inspiration from the philosophy of Friedrich Nietzsche, who criticized modern social repressions and preached the importance of reconnecting with nature. Vitalism and related movements like nudism also advocated the construction of a new masculinity at a time when gender roles were dramatically shifting and office jobs took men away from traditional physical labor. One nudist advocate claimed that being naked in nature offered the "experience of true manhood," and nakedness and exercise were important for crafting a new masculinity: "Wondrous swells

28. Donna M. Cassidy, "John Marin's Dancing Nudes by the Seashore: Images of the New Eve," *Smithsonian Studies in American Art* 4, no. 1 (winter 1990): 71–91. On anti-Puritanism and the Stieglitz circle, also see Marcia Brennan, *Painting Gender, Constructing Theory: The Alfred Stieglitz Circle and American Formalist Aesthetics* (Cambridge, Mass.: MIT Press, 2001), pp. 23–29.

29. John Marin to Herbert J. Seligmann, September 18, 1938; reprinted in *The Selected Writings of John Marin*, ed. Dorothy Norman (New York: Pellegrini and Company, 1949), p. 155.

the manly chest, reflecting the sunlight; fine are the hips and broad the shoulders; the arms tense to firm swells of muscle. Perfect in form do the bodies appear, in the movements of German gymnastics. Hours of consecration are these for healthy beauty and manhood."[30]

Given his admiration of Germany and his many trips there, it would be surprising if Hartley did not know about vitalism or nudism, or the northern European modernists' use of the male nude as a sign of virility and natural force. Cézanne's male bathers are often cited as a source for Hartley's late figures and, indeed, he would have seen examples of the French painter's figural work at 291 in New York and at the Salon d'Automne and the Stein apartment when he was in Paris.[31] It was in Berlin in the early 1920s, however, that Hartley engaged in his first sustained experiment with the subject of the male nude. He produced a series of oversize, full-bodied figures, modeled after the classicizing figures of avant-garde artists like Picasso and the bulging musclemen of Helmut Kölle, a gay artist active in the German Youth Movement, who worked in Berlin in the early 1920s and whose work Hartley knew.[32] These 1920s figures became the foundation for Hartley's male swimmers and beach bathers of Maine, done in the late 1930s and early 1940s.

Like his northern European counterparts, Hartley presents the male bather as an incarnation of manliness and sexual power by exaggerating the genitals and positioning the figure so that he directly confronts the viewer (page 101). This drawing was based on Hartley's excursions to Old Orchard Beach, a working-class beach and amusement park in southern Maine, the "Coney Island of New England."[33] While hardly the nudist beach of northern Europe, Old Orchard Beach (like Coney Island) similarly challenged middle-class mores and became a space where physical freedom, fast romance, and boisterous, openly sexual attitudes were common and where people reveled in nature. Seaside sensuality is the subject of Hartley's many drawings and paintings of Old Orchard Beach—the heterosexual physical intimacy in *On the Beach* (1940, private collection) and the display of the male body and genitals in *The Lifeguard* (circa 1940, private collection). In such works, Hartley transforms the vitalist male nude of northern European nudist resorts into the bronzed beachgoers of Old Orchard Beach. With this subject, moreover, he expressed his own sexuality and the eroticism of the male body with an acceptable subject—the bather.

FROM THE EUROPEAN FOLK TO THE MAINE FOLK

Just as European art and culture shaped the modernist landscapes and bathers of Maine, so, too, did it influence representations of the rural folk. Homer's paintings of fishermen and fishwives set the pattern for the modernists who followed him to Maine. In 1881 Homer had traveled to the small fishing village of Cullercoats, near Tynemouth on the northwest coast of England—a region that functioned as an artists' colony and summer resort for Londoners. For many, Cullercoats seemed untouched by modernization; for Homer, its appeal was the people, especially the robust fishwives, with their powerful physiques built by hard physical labor, as

30. Hans Surén, *Der Mensch und die Sonne*, translated by David Arthur Jones as *Man and Sunlight* (Slough, Eng.: Sollux Publishing Company, 1927), pp. 13, 60, 193. See Kirk Varnedoe, *Northern Light: Nordic Art at the Turn of the Century* (New Haven: Yale University Press, 1988), pp. 194–95, on vitalism.

31. Jill Kyle, "Paul Cézanne, 1911: Nature Recontructed," in Sarah Greenough, *Modern Art and America: Alfred Stieglitz and His New York Galleries* (Washington, D.C.: National Gallery of Art; Boston: Bulfinch Press, 2000), pp. 101–2.

32. Marsden Hartley, "Helmut Kölle," n.d., Yale (Hartley Papers, reel 1371, frame 3947, AAA). Also see *Helmut Kölle* (Cologne: Galerie Orangerie-Reinz; Düsseldorf: Galerie Vömel, 1998).

33. Jill C. Cournoyer, "Victorian Retreat to Amusement Capital: The Transformation of Old Orchard Beach, Maine, at the Turn of the Century" (master's thesis, University of Southern Maine, 1996), p. 1.

seen in *The Breakwaters, Cullercoats* (1882, Portland Museum of Art). Homer spent twenty months in this village, returning to the United States only in late 1882, when he settled in Prout's Neck, Maine, a promontory just ten miles south of Portland. Although the local fisherfolk reportedly posed for him, the Maine fishwives in paintings like *Light on the Sea* (1897, Corcoran Gallery of Art, Washington, D.C.) resemble the figures Homer painted in England. In these works and those by Homer's successors, the rural, working-class people of Maine are implicitly contrasted with the bourgeois, genteel ideals of turn-of-the-century culture. They are the Folk—a construct formulated by the middle class as the antithesis to all that it detested in urban industrial life. Anxious about the social upheavals associated with modernization, this group was nostalgic for a premodern way of life, a rural innocence, and an imagined organic community that was fixed, unchanging, and untainted by modernization. Rural people on the margins of society embodied this ideal along with distinctive characteristics of nation and race.[34]

In the late nineteenth and early twentieth centuries, art colonies proliferated in Europe and North America as visual artists sought out the Folk in remote peasant and fishing communities. One such colony was Pont-Aven in Brittany. Urban bourgeois artists and tourists regarded the province as backward and remote, quaint and picturesque. The Breton people, not French but Celtic, were considered exotic, with a separate language and folklore, traditional Roman Catholic rituals, and distinctive national costumes such as the female headdress, or *coiffe*. This Brittany was imagined not only in academic paintings like Pascal Dagnan-Bouveret's *The Pardon in Brittany* (1886, The Metropolitan Museum of Art, New York) but also in avant-garde examples like Paul Gauguin's *The Vision after the Sermon* (1889, National Gallery of Scotland, Edinburgh).[35]

Among the colonizers of Brittany were American artists—Arthur Wesley Dow, Robert Henri, and Hamilton Easter Field perhaps the most noteworthy. In the summer of 1901 Field painted in the Breton summer art colony of Concarneau, where he envisioned founding an American counterpart to this site. The next year he discovered the perfect location in Maine—the small fishing village of Ogunquit—and in 1910 organized the Ogunquit School of Painting and Sculpture, which opened the following year. Field's protégé, the sculptor Robert Laurent, noted the connection between Concarneau and Ogunquit: "When we reached Ogunquit we felt that we had found the perfect spot.... I at once fell in love with its attractive fishing village which reminded me of Brittany where I was born."[36] Field imagined other affinities between the rural provinces of France and Maine: "There's much right here in Maine as there is in Monet's Normandy. But to get it you must live in touch with the native Ogunquit life, just as Monet wears the sabots and peasant dress of Giverny."[37]

The "native Ogunquit life" attracted many American modernists. Accompanied by George Bellows, Robert Henri spent the summer of 1915 in Ogunquit, which became for him a substitute for Holland and Spain when transatlantic travel became dangerous because of World War I.[38] For Henri, who was critical of nationalism, all people shared an essential hu-

34. Ian McKay, *The Quest of the Folk: Antimodernism and Cultural Selection in Twentieth-Century Nova Scotia* (Montreal: McGill-Queen's University Press, 1994).

35. See Michael Jacobs, *The Good and Simple Life: Artist Colonies in Europe and America* (Oxford: Phaidon, 1985), and Gill Perry, "Primitivism and the 'Modern,'" in *Primitivism, Cubism, Abstraction: The Early Twentieth Century*, ed. Charles Harrison, Francis Frascina, and Gill Perry (New Haven: Yale University Press, 1993), pp. 8–46, for a discussion of Brittany and other rural art colonies.

36. Robert Laurent, quoted in Doreen Bolger, "Hamilton Easter Field and His Contribution to American Modernism," *American Art Journal* 20, no. 2 (1988): 87.

37. Hamilton Easter Field, *The Techniques of Oil Painting and Other Essays* (Brooklyn: Ardsley House, 1913), p. 58.

38. Robert Henri to Helen Niles, July 17, 1915, quoted in Valerie Ann Leeds, *My People: The Portraits of Robert Henri* (Orlando, Fla.: Orlando Museum of Art; Seattle: University of Washington Press, 1994), p. 34.

manity: "My devotion to humanity burns up as brightly for Europe as for America; it flares up as swiftly for Mexico if I am painting the peon there; it warms toward the bull-fighter in Spain . . . it intensifies before the Irish peasant whose love, poetry, simplicity and humor have enriched my existence, just as completely as though each of these people were my own country and my own hearthstone."[39] Given these ideas, Henri easily transferred his interest in the peasants of Holland and the Gypsies and flamenco dancers of Spain to a community of Gypsies camped outside Ogunquit, producing more than twenty portraits that summer, including *Village Girl (Lily Cow)* (page 103). Gypsies and children had figured in many portraits from his summer painting excursions to Spain and Holland—for example, *Gypsy with Guitar* (1906, The Chrysler Museum, Norfolk, Va.)—and such work drew from the art of Diego Velázquez, Rembrandt van Rijn, Francisco Goya, and Frans Hals that Henri had studied at the Louvre, the Prado, and museums in Belgium and Holland. Among these artists, Hals was perhaps most important, and his style, as seen in *Man with a Beer Keg* (page 102), resonates in *Village Girl*—in the vigorous brushstrokes, seemingly spontaneous paint application, and the close-up bust-length pose—even as the brilliant color and light palette betray Henri's interest in the newer expressionist manners.

Two summers later found Marsden Hartley in Ogunquit, which reminded him of his European experiences, just as it did for Henri. Hartley had seen Bavarian *Hinterglasmalerei* (glass painting) in the *Blaue Reiter Almanac* (1912) and collected it in Germany in the early 1910s, but his first experiments with this technique (for example, *Tinseled Flower* [1917, Museum of Fine Arts, Boston]) date to his summer in Ogunquit when Field and Laurent were collecting American folk paintings on glass and mirrors. Earlier in Berlin, Hartley had been inspired by the Blaue Reiter artists' passion for native folk art and followed suit by looking to both German folk art and an indigenous (Native American) folk art as sources for his *Amerika* series (1914–15).[40] German folk art thus led Hartley to American folk art.

Germany was key not only to Hartley's study of folk art but also his idea of the Folk. After arriving in May 1933, he spent time in Hamburg and then lived in the Bavarian Alps in Garmisch-Partenkirchen, returning to the United States in February 1934. He worked with the German peasant as subject matter in at least one drawing from this trip, and his letters reveal a passionate interest in the native people and their culture. Hartley encountered the northern German folk and their history preserved in the Altona Volksmuseum near Hamburg and imagined the inhabitants of the reconstructed peasant homes there and present-day farmers of the region as inspirations for the urban-weary: "O it's all too grand really—so good for the jaded soul. I've been glad even to get out of Hamburg as fine as it is—for there is in the end a makeshift life in all city ways—and watching the people here is like having too much butter on one's bread—for they are a solid diet for the eyes—so handsome and physically solemn as they are—bodies that are like hymns of praise to their maker."[41] The area around Garmisch-Partenkirchen provided an ideal setting for the display of the Bavarian folk, as the people held onto traditional attire, customs, and art. Hartley praised the violin making of

39. Robert Henri, "My People," *Craftsman* 27, no. 2 (February 1915): 459.

40. Gail Levin, "Marsden Hartley's 'Amerika': Between Native American and German Folk Art," *American Art Review* 5, no. 2 (winter 1993): 120–24.

41. Hartley to Kuntz, July 12, 1933, reel X4, AAA.

Mittenwald, admired the wooden religious shrines on the mountain walkways and the local folk pageants, and visited the Bauern Theater in Partenkirchen to see the plays written by the peasants and performed in traditional costume.[42] In Hartley's estimation, these rural people possessed the qualities commonly ascribed to the Folk: naturalness, spirituality, and authentic masculinity and femininity. They were "hundred percent men, and look every inch of it; Aside from here and there, the women don't come off so well, but so it is everywhere with Teutons, for a female here is a woman and not a toy, and that is a satisfaction, they can do a day's work whatever it is along with their men, and they look so powerful and not ornamental in the dull sense."[43] One young Alpine peasant sprawling on a bench and basking in the sun represented the height of masculinity and sexuality for Hartley:

> THIS YOUNG MAN IS OF MAGNIFICENT BUILD, . . . HE IS VERY WIDE AND THICK, . . . AND HE IS AS BROWN AS A GUERRERO INDIAN WHERE THE SUN HAS BURNED HIS CREAMY FLESH AND WHERE THE SUN HAS NOT PENETRATED, THE COLOUR IS ALMOST GIRLISHLY FAIR.
>
> BEING SPREAD OUT LIKE THIS ON THE BENCH, LEGS SPREAD WIDE APART IS OF COURSE NARCISSISTIC, AND HE WANTS THE WORLD TO KNOW OF HIS MASCULINITY WHICH IS OPULENT IN HIS ENTIRE POSTURE.[44]

This encounter with the German folk helped Hartley appraise his own native region and its inhabitants. While still in Germany, he began to compare the German and North Atlantic people: Canada had the "warmth of the Bavarian nature and character," and the "Hamburg type" with its "almost Anglo-Saxon style and look" was "quite like my own New England in its outer behaviour."[45] Germany was "much the same latitude as that in which I was born, and the racial life of the place here is so much second nature to me that I hardly sense it."[46] Here and elsewhere in his letters and writings, Hartley described a link between the European northerners (Germans) and American northerners (Canadians, Mainers), as all belonging to the northern race. In so doing, Hartley breaks down national and continental borders. His late paintings of the Maine folk crossed these borders as well, as the central figure in *Down East Young Blades* (page 104) wears an Alpine hat and Bavarian boiled-wool jacket along with typical Maine fishing attire (blue jeans, boots).[47]

The central figure in *Down East Young Blades* also resembles Luis Trenker, the famed German film actor and director, as pictured in a postcard that Hartley owned (page 105). Hartley knew Trenker's work in the popular postwar German mountain films, in particular, *Doomed Battalion* (1932).[48] Set in the Tyrol with Trenker as the main character, this movie chronicles a World War I battle between the Austrians and Italians for a strategic mountain pass and opens with a scene of the two military leaders climbing together in the snow-covered Alps just before the war. The representation of the Alpine landscape and people in *Doomed Battalion* overwhelmed Hartley: "I saw last night a magnificent movie taken in the Alps some-

42. Marsden Hartley, "The Sleeping Violins of Mittenwald," circa 1933–34, pp. 1–5, Yale (reel 1371, frames 3411–15, AAA); Hartley to Kuntz, September 7 and November 4, 1933, reel X4, AAA; and Marsden Hartley, "The Peasant Theatres of Bavaria," circa 1933–34, Yale (reel 1369, frames 1970–71, AAA).

43. Hartley to Kuntz, August 23, 1933, reel X4, AAA.

44. Marsden Hartley, "The Eight Capucines," circa 1933–34, p. 3, Yale (Hartley Papers, reel 1368, frame 89, AAA).

45. Hartley to Kuntz, July 19, 1933, reel X4, AAA, and Hartley to Edith Halpert, July 12, 1933, AAA, excerpted in Garnett McCoy, ed., "Letters from Germany 1933–38," *Archives of American Art Journal* 25, nos. 1–2 (1985): 7–8.

46. Hartley to Kuntz, July 22–23, 1933, reel X4, AAA.

47. I want to thank Carol Dean Krute (curator of Costumes and Textiles at the Wadsworth Atheneum Museum of Art) and Ingrid Loschek (costume historian) for their help in reading the attire in these paintings.

48. *Doomed Battalion* was an American remake of the German film *Berge im Flammen* (1931); see David Stewart Hull, *Film in the Third Reich: A Study of German Cinema, 1933–1945* (Berkeley and Los Angeles: University of California Press, 1969), p. 14, and Siegfried Kracauer, *From Caligari to Hitler: A Psychological History of German Film* (Princeton: Princeton University Press, 1947), pp. 260–61.

where . . . and all of it in the snow up among the peaks, and I have never seen anything more beautiful in my life—such superb honest to god men and none of that Hollywood trash being bloody male for so much a week, and the one woman was superb too—and such glorious scenes of peasant life just prior to the war being declared, the rest being up in the Alpine heights."[49] Hartley viewed other films of this genre, including one with the Alpinist Franz Schmidt called *Der Gipfel Sturmer* (The Summit Stormer, 1931) and another with Arnold Fanck, *Der Weisse Rausch* (The White Ecstasy, 1931). Such films helped him reconnect with Maine: "[They] brought about a conversion to nature and is the religion that I began my life with up in Maine, and I feel all aquiver with the new conversion as a result."[50]

When he painted the Maine folk in the late 1930s, Hartley created a bond between them and these Germans, endowing them with the vitality and masculinity that he perceived in these "summit stormers." Alluding to the warrior theme of *Doomed Battalion, Young Hunter Hearing Call to Arms* (page 106) pictures a hunter and soon-to-be soldier with a solid physique, sculpted features, and striking blond hair, kneeling with the spoils of his battle with nature, ready to respond to another type of call to arms. The figure is sexualized, with the buck's antlers, gun, and pipe as not-so-subtle substitutes for the male genitals. His sexuality and masculinity evoke the German warrior types that appealed to Hartley: in Berlin in the 1910s Hartley spoke of the Prussian military culture as having an "organized energy" and "sexual immensity,"[51] and painted the military uniform as a sign for manliness in the *War Motif* series (1914–15), which memorialized his friend and presumed lover, Karl von Freyburg, a lieutenant killed in World War I. The hunter-warrior in *Young Hunter* refers to German culture in other ways. His blond hair and blue eyes are features associated with the Germanic type, while his culottes, smocked shirt, and vest derive from nineteenth-century German folk attire. In addition, the figure's pose recalls that in a painting of St. Hubertus, which Hartley saw at the Schloss Schleissheim near Munich, in which the courtier and hunter rests on one knee and confronts the deer he had been pursuing while a vision of a cross appears between the deer's antlers.[52]

In the midst of all these German references is a sign of Maine culture: a red hunting cap on the ground next to the young man. Hunting was an activity as much associated with the sporting clubs of northern Maine and the clients of L. L. Bean as it was with early-twentieth-century Germany. *Young Hunter*, then, like Stuart Davis's *New York–Paris, No. 2*, is a painting in which emblems from both sides of the Atlantic dwell on one plane and in which the borders between Europe and America dissolve. While early-twentieth-century art critics demanded that American artists live within the physical borders of the United States—and believed a national art could only be produced by artists who stayed within these borders—they did not recognize how porous national boundaries were and how essential the European experience was for these artists: being in Europe brought many closer to understanding and picturing their own nation, its landscape, and its people. Just as today we see "America" more clearly through international lenses, so, too, was it the case for modernists in search of nation and region in the early decades of the twentieth century.

49. Hartley to Kuntz, circa February 1933, reel X4, AAA.

50. Hartley to Kuntz, July 22, 1933, reel X4, AAA.

51. Marsden Hartley, "Somehow a Past: Prologue to Imaginative Living," in Marsden Hartley, *Somehow a Past: The Autobiography of Marsden Hartley,* ed. Susan Elizabeth Ryan (Cambridge, Mass.: MIT Press, 1997), p. 87.

52. See Marsden Hartley, "Schloss Schleissheim bei Munich," circa 1933–34, p. 1, Yale (reel 1369, frame 1934, AAA). Hubertus was the patron saint of hunters and trappers, and his attribute was a stag.

Gustave Courbet, *Temps d'Orage à Étretat (Stormy Weather at Étretat)*, circa 1869, oil on canvas, 29 $^{13}/_{16}$ x 36 $^{3}/_{8}$ inches. The Joan Whitney Payson Collection at the Portland Museum of Art, Maine, Promised Gift of John Whitney Payson, 15.1991.2

Winslow Homer, *Weatherbeaten*, 1894, oil on canvas, 28 $\frac{1}{2}$ x 48 $\frac{3}{8}$ inches. Portland Museum of Art, Maine, Bequest of Charles Shipman Payson, 1988.55.1

Paul Cézanne, *Mont Sainte-Victoire Seen from the Bibémus Quarry*, circa 1897, oil on canvas, 25 $\frac{1}{8}$ x 31 $\frac{1}{2}$ inches. The Baltimore Museum of Art: The Cone Collection, formed by Dr. Claribel Cone and Miss Etta Cone of Baltimore, Maryland, BMA, 1950.196

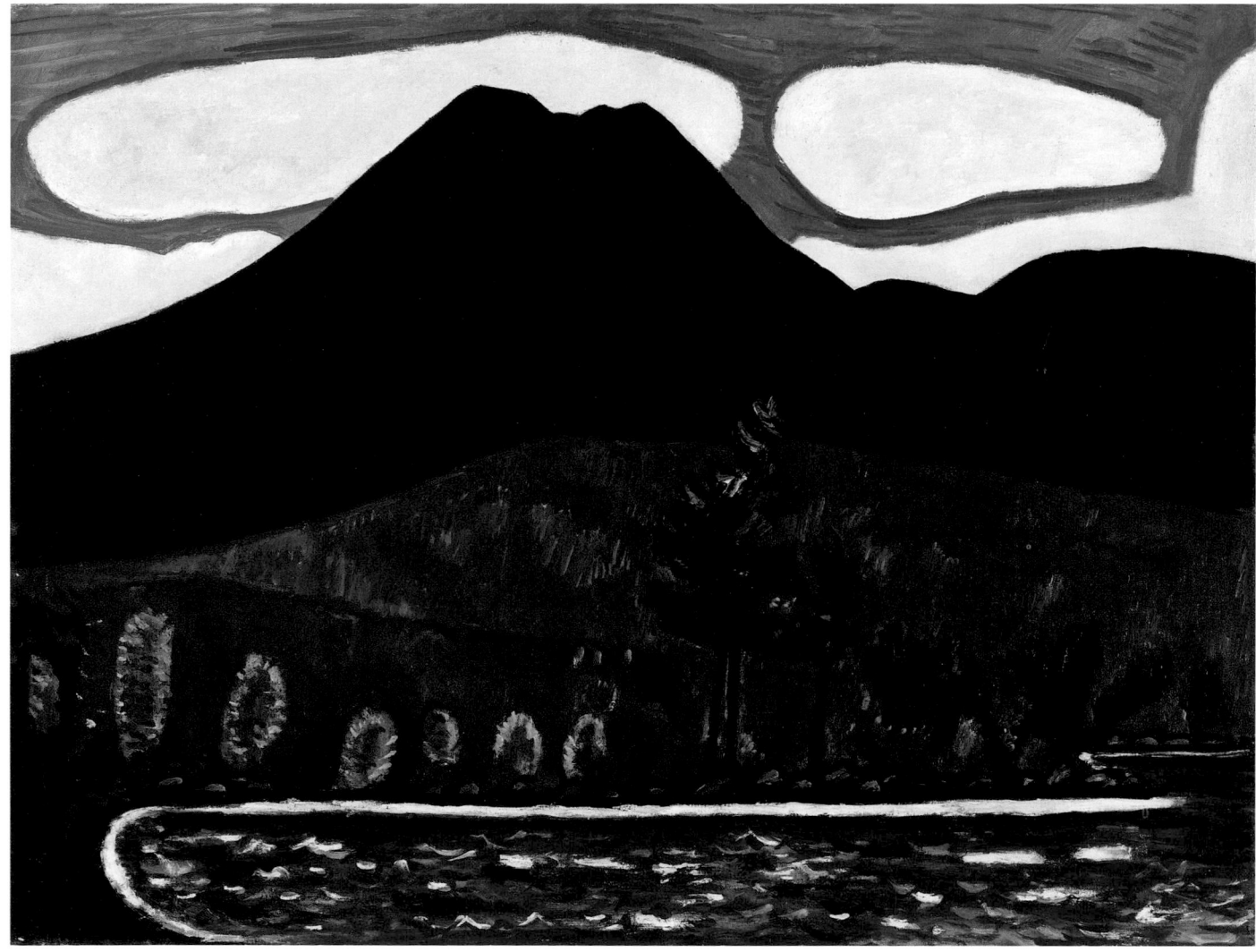

Marsden Hartley, *Mount Katahdin, Autumn No. 2*, 1939–40, oil on canvas, 30 ¼ x 40 ¼ inches. The Metropolitan Museum of Art, New York, Edith and Milton Lowenthal Collection, Bequest of Edith Abrahamson Lowenthal, 1991

Paul Cézanne, ***Mont Sainte-Victoire*** (recto)*; **Landscape Study*** (verso), circa 1890–1902, recto: watercolor and gouache over graphite on buff wove paper; verso: graphite, 12 ¹/₄ x 18 ⁵/₈ inches. Smith College Museum of Art, Northampton, Massachusetts, Bequest of Charles C. Cunningham in memory of Eleanor Lamont Cunningham, calss of 1932, through the kindness of Priscilla Cunningham, class of 1958

John Marin, *Lead Mountain, Beddington, Maine*, 1952, watercolor on paper, 14 ¹/₂ x 19 inches. Richard York Gallery, New York

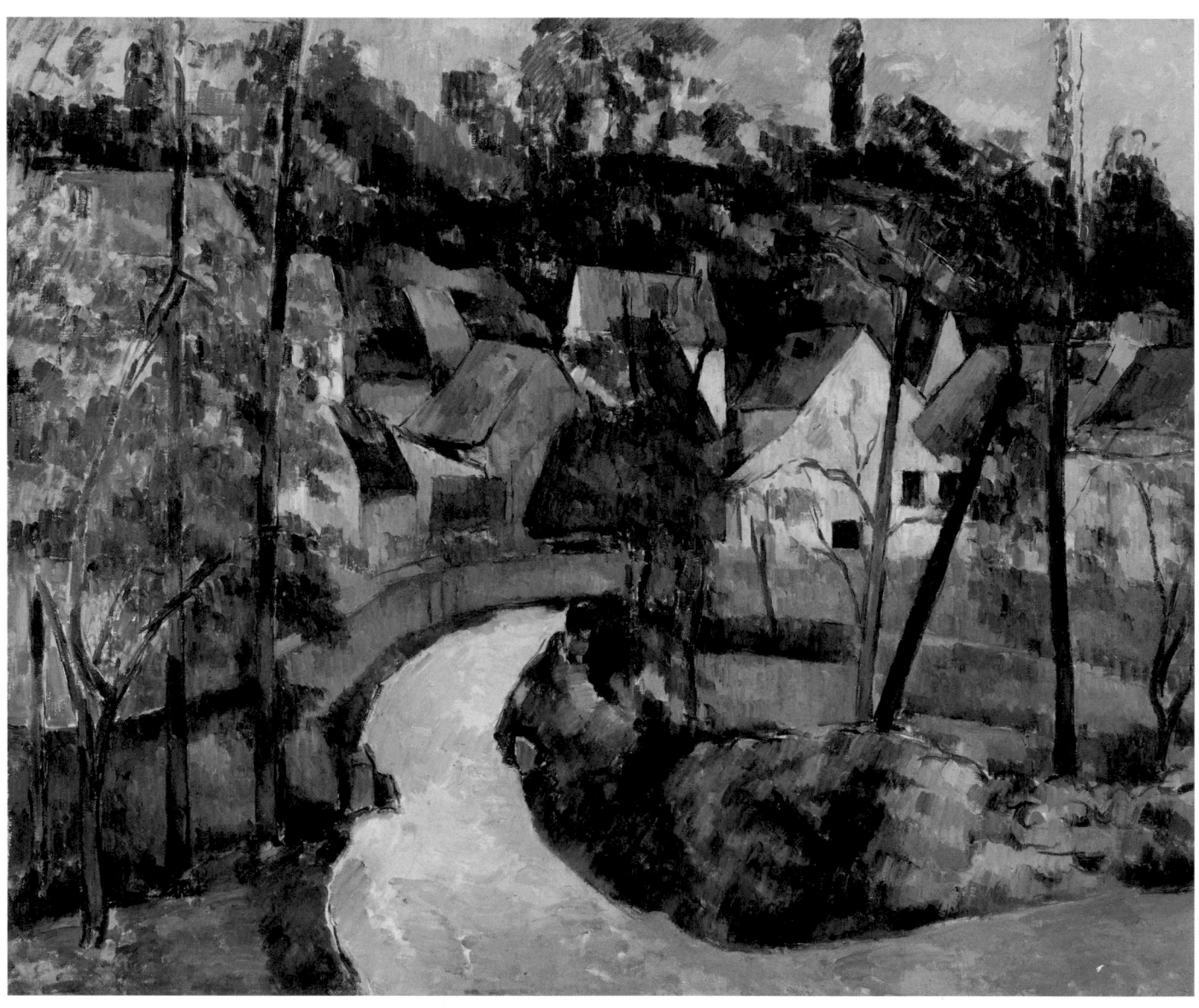

Paul Cézanne, *Turn in the Road*, circa 1881, oil on canvas, 23 ⁷/₈ x 28 ⁷/₈ inches. Museum of Fine Arts, Boston, Bequest of John T. Spaulding, 48.525

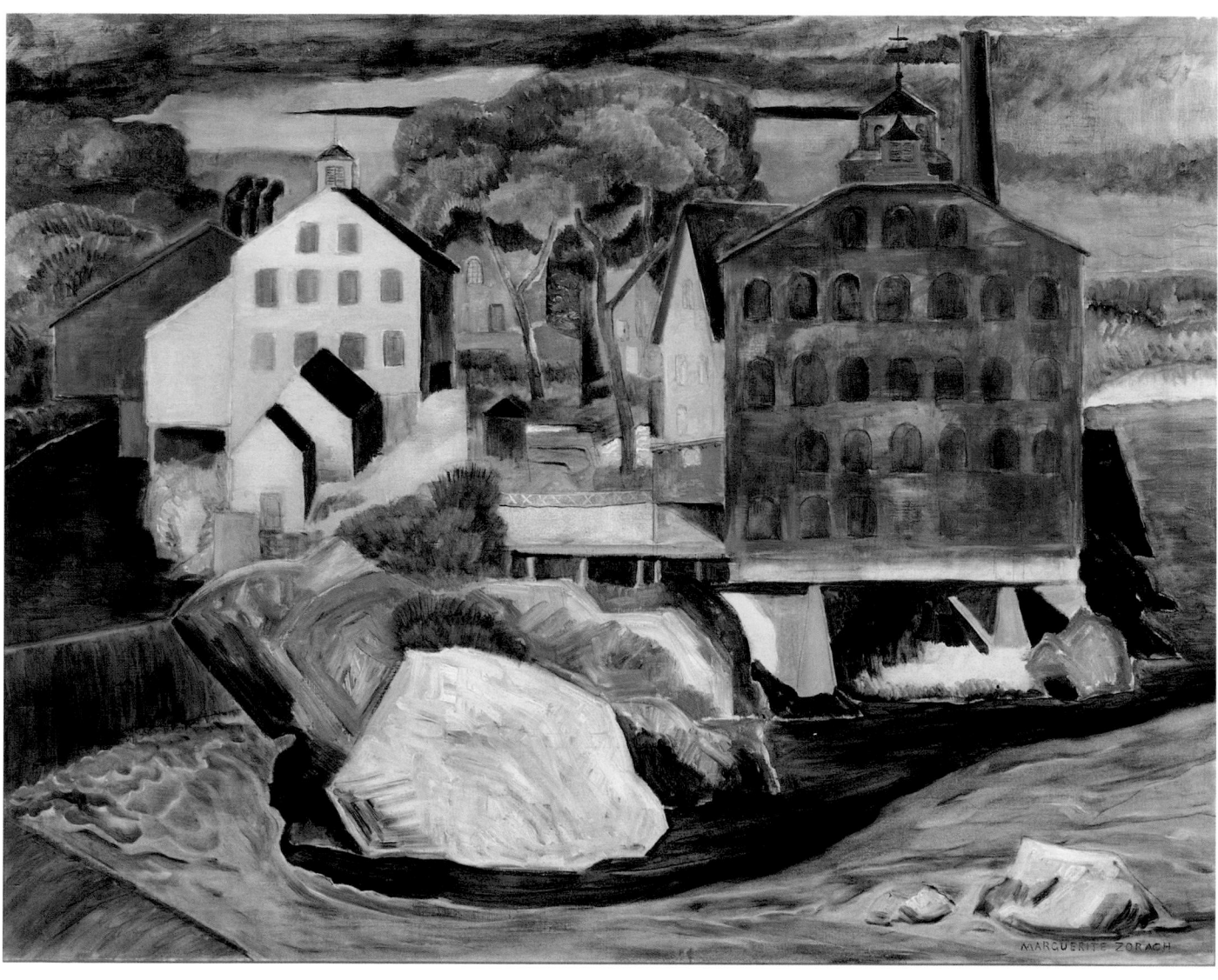

Marguerite Zorach, *Brunswick Mills*, 1930s, oil on canvas, 28 x 36 inches. Private collection

Georges Braque, *La Maison: La Roche-Guyon*, 1908, oil on canvas, 18 ¹/₈ x 15 ¹/₄ inches. Scott M. Black Collection

Max Weber, *Connecticut Landscape*, 1911, oil on panel, 28 x 22 ¼ inches. Margery and Maurice Katz

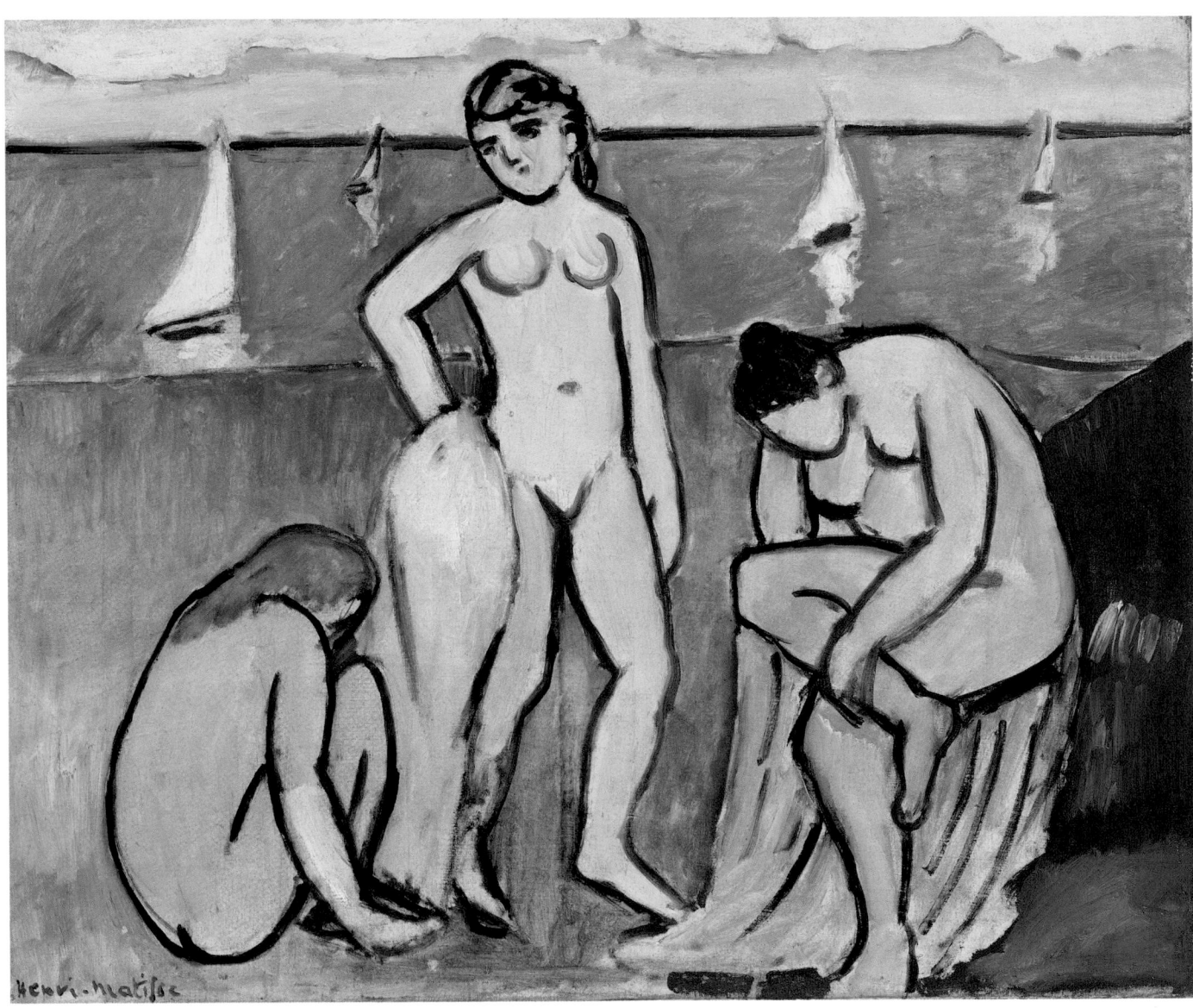

Henri Matisse, *Three Bathers*, 1907, oil on canvas, 24 x 29 inches. The Minneapolis Institute of Arts, Bequest of Putnam Dana McMillan

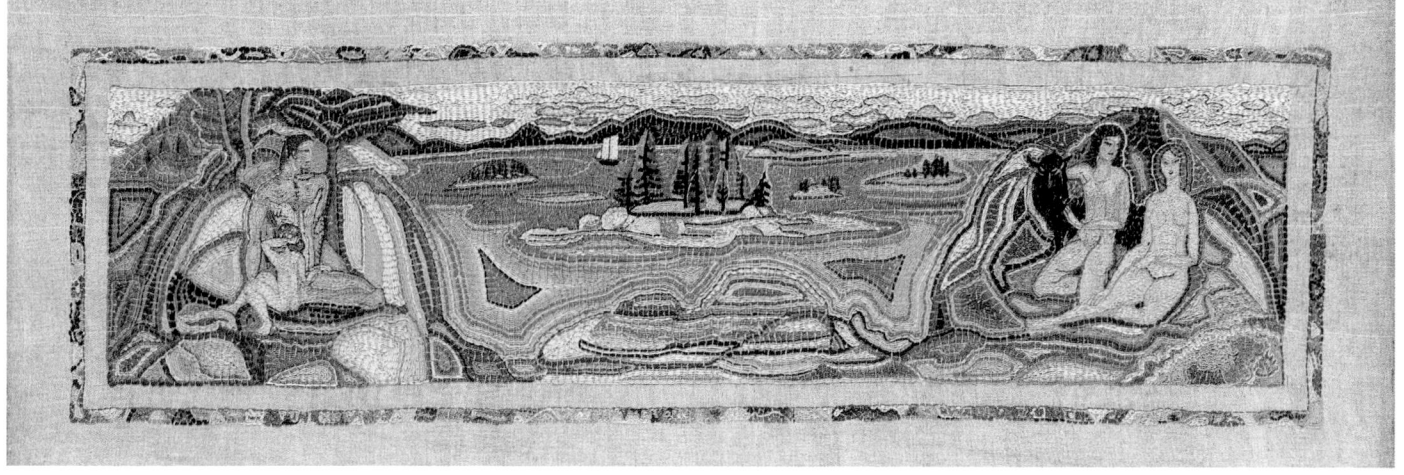

Marguerite and William Zorach, *Maine Islands*, 1919, needlework and pencil on canvas, 17 3/4 x 49 3/4 inches. Smithsonian American Art Museum, Gift of Dahlov Ipcar and Tessim Zorach

Paul Cézanne, *The Large Bathers*, 1906, oil on canvas, 6 feet 10 inches x 8 feet 3 inches. Philadelphia Museum of Art, purchased with the W. P. Wilstach Fund

John Marin, *Sea and Figures, Concept #1*, 1942, oil on canvas, 22 x 28 inches. Colby College Museum of Art. The John Marin Collection, Gift of John Marin, Jr. and Norma B. Marin, 1973.016

Edvard Munch, *Bathing Men*, 1907–8, oil on canvas, 81 $\frac{1}{8}$ x 89 $\frac{3}{8}$ inches. Ateneum Art Museum/The Antell Collection, Helsinki

Marsden Hartley, *Untitled (Three Male Figures)*, circa 1940, pencil on paper, 7 ¹⁄₄ x 4 ³⁄₄ inches. Marsden Hartley Memorial Collection, Bates College Museum of Art, Lewiston, Maine, 1955.1.64

Attributed to Frans Hals, *Man with a Beer Keg*, circa 1635, 33 ¹/₄ x 26 ¹/₂ inches. Portland Museum of Art, Maine, Gift of Ilse Breuer Reichhold, 1983.158

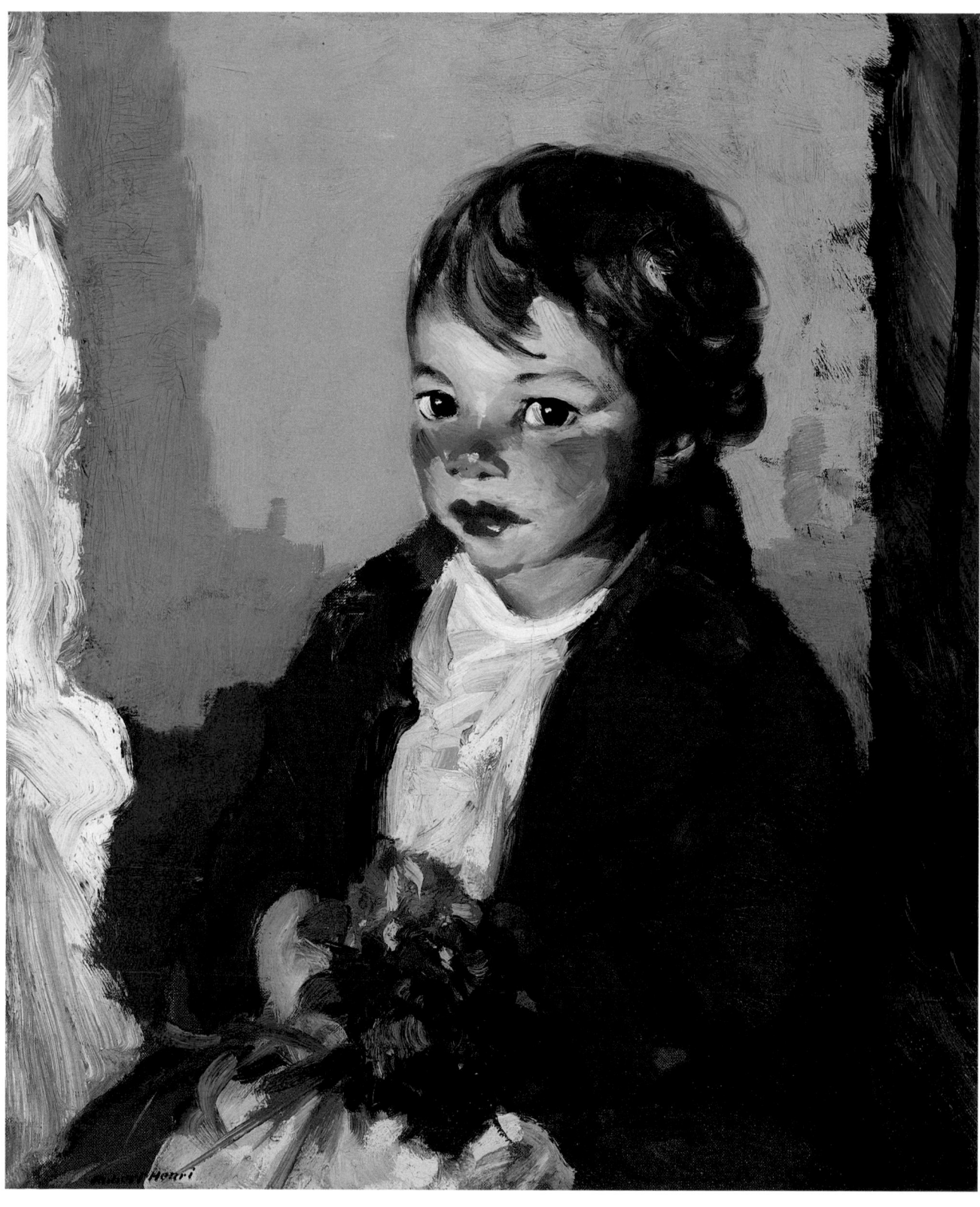

Robert Henri, *Village Girl (Lily Cow)*, 1915, oil on canvas, 24 x 30 inches. Museum of Fine Art, St Petersburg, Florida, Gift of the Stuart Society in honor of the Twenty-fifth anniversary of the Museum of Fine Arts, 90.20

104

Marsden Hartley, *Down East Young Blades*, circa 1940, oil on panel, 40 x 30 inches. Wadsworth Atheneum Museum of Art, Hartford, Conn. The Douglas Tracy Smith and Dorothy Potter Smith Fund; The Evelyn Bonar Storrs Trust Fund; The Krieble Family Fund for American Art; The Dorothy Clark Archibald and Thomas L. Archibald Fund

Luis Trenker

Postcard, Luis Trenker. Marsden Hartley Papers, Yale Collection of American Literature, Beinecke Rare Book and Manuscript Library

Marsden Hartley, *Young Hunter Hearing Call to Arms (The Hunter)*, 1939, oil on Masonite, 41 x 30 ¼ inches. Carnegie Museum of Art, Pittsburgh; Patrons Art Fund, 44.1.2

Marsden Hartley, *Surf on Reef*, 1937–38, oil on board, 9 7/8 x 14 1/8 inches. Portland Museum of Art, Maine. Bequest of Elizabeth B. Noyce, 1996.38.18

Charmion von Wiegand, *Night Environment*, 1947, oil on canvas, 30 x 25 inches. Courtesy of Michael Rosenfeld Gallery, New York

Reversing the Tide:

European Modernism Comes to America

Martica Sawin

Commenting on the American artist Charles Demuth, Marcel Duchamp said, "His work is a living illustration of the disappearance of a Monroe Doctrine applied to art."[1] He was referring to President James Monroe's 1823 warning against interference with hemispheric hegemony as if it had forbidden incursions of foreign art and artists as well as armed intervention. Duchamp's words acknowledged an increasing receptivity in the United States to European modernism as evidenced by its adoption by growing numbers of American artists. To be sure, since the late eighteenth century much American art had been closely tied to Europe, and it was not unusual for American artists to spend extended periods of time in London, Rome, and Paris to familiarize themselves with the work of European masters. The typical scenario, throughout the nineteenth century and up to World War I, had been for American artists to go abroad for study and immersion in the artistic traditions of Europe. By the 1920s, when modernism had made academic training irrelevant, and Paris, according to expatriate Gertrude Stein, was where the twentieth century was, Americans traveled to France to experience the shock of the new firsthand rather than to absorb the tradition of the old.[2] However, a number of factors slowed down travel abroad in the years between World War I and World War II, among them American isolationism following the U.S. Senate's refusal to join the League of Nations, the rise of regionalism in art and literature, and lack of funds during the Great Depression. But something else was happening: artistic Europe began to come to the United States.

The Armory Show of 1913 was an opening wedge, driven by a group of American painters who went to France, Germany, and England with the express purpose of assembling an exhibition of recent and contemporary European art, some of it fresh off the easels of the latest avant-garde artists, to bring American art into the twentieth century. Prior to the Armory Show the pioneering photographer and gallery owner Alfred Stieglitz had ventured to exhibit examples of European modernism in his small Photo-Secession Gallery at 291 Fifth Avenue. When the photographer Edward Steichen, who was studying art in Paris in the early 1900s, suggested that in addition to the art in photography, he might consider showing the nonphotographic in art, Stieglitz agreed to stage exhibitions of drawings by Henri Matisse and early Cubist work by Pablo Picasso. After 1910 he added a few American modernists—John Marin, Marsden Hartley, Arthur Dove, Max Weber, and, in 1916, Georgia O'Keeffe.

Those artists who had thought they were the vanguard in the United States, Robert Henri and the Eight (known later as the Ashcan School), suddenly appeared out of date when

1. Quoted in Andrew Carnduff Ritchie, *Charles Demuth* (New York: The Museum of Modern Art, 1950), p. 17.

2. Gertrude Stein, *Paris France* (New York: Liveright, 1970), p. 11.

confronted at the Armory Show by Marcel Duchamp's *Nude Descending the Staircase* or Francis Picabia's *Dances at the Spring* (page 118). In 1915 Duchamp himself arrived, along with Picabia, while Americans driven home by the war brought canvases reflecting Fauvism, Cubism, and Synchromism. Soon there were exhibitions of work by American adherents of these movements and a cluster of activities known as New York Dada. Joseph Stella, who immigrated to the United States from Italy in 1896, met Picabia and Duchamp in 1915 at Louise and Walter Arensberg's apartment, a gathering place for the artists and writers who constituted the New York version of the Swiss-born Dada movement. He would have already been familiar with their work from the Armory Show, and his painting *Der Rosenkavalier* of 1913–14 shows a definite affinity with their attempts to convey a sense of movement through the fragmentation and repetition of forms (page 119).

Although there was a retreat from modernism during the 1920s and 1930s, advanced European art continued to flow into American collections such as those of Albert Barnes, Katherine Dreier, and A. E. Gallatin.[3] During the decade of the 1930s New York galleries, especially those opened by Pierre Matisse and by German dealers fleeing the Nazis, J. B. Neuman, Otto Kallir, Karl Nierendorf, and Curt Valentin, made the work of European modernists known to the American public. American artists too poor to go abroad during the Depression had only to go to Fifty-seventh Street in New York to see the paintings of Picasso, Matisse, and Joan Miró or the sculpture of Constantin Brancusi. Arshile Gorky haunted the gallery that Julien Levy opened in 1931, which was largely dedicated to presenting the latest new movement from Paris, Surrealism. During the 1930s Levy staged four exhibitions of the work of Salvador Dalí and introduced Max Ernst, Giorgio de Chirico, René Magritte, and Yves Tanguy, as well as American artists who were already demonstrating an awareness of Surrealism—Joseph Cornell and Alexander Calder in 1932, Walter Quirt in 1936, Jared French in 1939, and Arshile Gorky in 1945, 1946, and 1948.

The most influential showcase for twentieth-century European art was, of course, the Museum of Modern Art, which opened in midtown Manhattan in 1929 and moved into its own dazzling International Style building in 1936. The existence of MoMA served as a goad and a challenge. Largely ignoring the predominant Regionalism and Social Realism of the day, MoMA geared its exhibitions and its acquisition policies toward an artistic ideology that favored abstract art, partly because it was compatible with the modern design that the museum also promoted.[4] And it favored Europe—the curators at the Modern in the mid-1940s were of the opinion that contemporary American art was not of a quality that could be exhibited alongside the European moderns, a view that led to occasional picket lines of disgruntled artists in front of the museum.

One American artist who gained early MoMA approval was Alexander Calder, who had spent the years between 1926 and 1938 largely in France and had grafted aspects of European modernism onto his own engineering skills. During those years Calder saw a good deal of Miró, whose fanciful images traced in wirelike line and biomorphic shapes in bright

3. The Gallatin Collection, now at the Philadelphia Museum of Art, was on public view at New York University on Washington Square from 1927 through the 1930s and offered artists and public an opportunity to see work by Klee, Mondrian, Kandinsky, and other pioneers of modernism.

4. The museum did mount the exhibition *American Realists and Magic Realists* in 1943, and in 1944 it staged *Art in Progress*, which included European Surrealists and a cross section of Americans that ran the gamut from Gorky to Hopper. However, until its 1951 exhibition *Abstract Painting and Sculpture in America*, the museum had hardly acknowledged that there was a modern movement in the United States.

primary colors were translated into three-dimensional form in Calder's mobiles and stabiles. Calder also made a crucial visit to Piet Mondrian's Paris studio in 1930, which he recollected as follows: "This one visit gave me a shock that started things. Though I had heard the word 'modern' before, I did not consciously know or feel the term 'abstract.' So now at 32 I wanted to paint and work in the abstract. And for two weeks or so I painted very modest abstractions. At the end of this time I reverted to plastic work which was still abstract."[5] Mondrian was a member of the recently formed Abstraction-Création group, and Calder was soon considered sufficiently abstract to be invited to join as well, although his cutout metal shapes suspended on wires tended to be closer to the organic shapes of Miró than to geometric abstraction; his work might be regarded as a fusion of modernism's abstract and surreal strains (pages 120, 121).

Like Calder, Stuart Davis managed to get to Paris in the 1920s and returned in 1929 having absorbed the Synthetic Cubism of Picasso and Braque and the city abstractions of Fernand Léger (pages 122, 123). Writing to his parents from Paris in September 1928, Davis described a visit to his studio from Léger. "He liked *Egg Beaters* very much and said they showed a concept of space similar to his latest developments . . . he said it was interesting that two people who do not know each other should arrive at similar ideas."[6] Davis used flat, synthesizing shapes and bright colors to make simplified compositions based on city street views and harborside seascapes. Later he would enlarge his canvases, introduce graphic elements, and quicken the tempo of shifting, broken-up forms in what became known as his billboard style, thus transforming a mode of abstraction that originated in Europe into something that had an American brashness and lively syncopation.

Retrospective exhibitions of the art of Matisse were held in New York in 1927 at the Valentine Dudensing Gallery and in 1931 at the Museum of Modern Art; Matisse himself stayed in New York in 1930, when he came to the United States to serve on the jury of the Carnegie International Exhibition in Pittsburgh. The 1927 Matisse exhibition was a seminal event for Milton Avery, inspiring him to abandon volumetric rendering and to condense the sensations of direct experience into flattened, simplified shapes (pages 124, 125). When Avery saw the work of Matisse he realized that a painting could be constructed through color relationships, and he henceforth eliminated modeling based on contrast in favor of interlocking color shapes holding the painting's surface. Although his subject matter was the American landscape and the human figure, his treatment differed radically from that of his realist contemporaries. The liberating inspiration of Matisse led Avery to develop a mode of painting that was compatible with modernism, yet spare enough to be the quintessential product of a reticent Yankee sensibility.

The name most closely identified with Surrealism in the United States in the 1930s was that of Salvador Dalí, whose flair for publicity during visits to New York, exhibitions at the Julien Levy Gallery, and short-lived Dream of Venus pavilion for the New York World's Fair in 1939 had gained him considerable notoriety. His brand of Surrealism penetrated the

5. *Calder: An Autobiography with Pictures* (New York: Pantheon, 1966), p. 113.

6. Quoted in Karen Wilkin, *Stuart Davis* (New York: Abbeville Press, 1987), p. 120.

worlds of fashion and advertising and paralleled a growing interest in the United States in Freudian theory and psychoanalysis. A scattering of American artists began to experiment with a Dalíesque pictorial Surrealism. Walter Quirt, executing a mural for a psychiatric lecture room at Bellevue Hospital, illustrated psychotic states in a Dalí-inspired manner. Louis Guglielmi practiced what has been categorized as "Social Surrealism," since he dealt with themes of urban poverty and social injustice using some of the dreamlike qualities of Surrealist painting.[7] The term has also been applied to the paintings of James Guy, who used enigmatic spaces and composite figures made up of oddly juxtaposed elements to portray themes of police violence and white-robed Ku Klux Klansmen. Guy had lived in Hartford, Connecticut, where the first United States exhibition of Surrealism opened in December 1931 at the Wadsworth Atheneum. He found Surrealism an effective way to express the more nightmarish aspects of human existence, although by the mid-1940s he had moved on to geometric abstraction. Painted at the onset of World War II, *Shipwrecked Poet* portrays his vision of a world about to be engulfed in flames (pages 126, 127).

 Julien Levy introduced the work of Magritte to New York in a solo exhibition in 1935 and included him in a number of group exhibitions. Jared French, whose Works Progress Administration (WPA) murals Levy showed in 1939, would certainly have been familiar with Magritte through Levy and also through the Museum of Modern Art's *Fantastic Art, Dada and Surrealism* exhibition of 1936. Although early Renaissance and classical art were powerful influences on French's figure proportions and treatment of space, his interest, as he put it, in "representing aspects of the psyche" led him to adopt a Magritte-like stillness and enigmatic quality in the frozen positions of his figures and ambiguity of his spaces (pages 128, 129).[8]

 In 1936 the Museum of Modern Art also staged a historical survey of the leading modern movements, *Cubist and Abstract Art*, and failed to include any American artists, even though there was already a group of abstract painters holding informal meetings. Out of these meetings grew an official organization, American Abstract Artists, which held annual members' exhibitions between 1936 and 1956, sponsored lectures, and staged protests; by the 1950s its membership had grown to fifty-five. When Léger and Mondrian arrived in New York as refugees in 1941, the group staged a welcoming reception and sponsored a lecture by Mondrian attended by an overflow crowd.

 Another faction of European abstraction was represented at the Museum of Non-Objective Art, which opened in New York in 1939 and was devoted largely to Wassily Kandinsky and his followers, among them the museum's director, Baroness Hilla Rebay, and her friends. Rebay handed out stipends to non-objective artists and gave part-time jobs to some of them, including Jackson Pollock. For many artists living in or around Greenwich Village, the Museum of Living Art, as the Gallatin collection at New York University was known, offered an opportunity to become familiar with the work of Paul Klee, the German Expressionists, and other European moderns right in the heart of their downtown territory. So during the Depression years of the 1930s, even though few artists could afford a trip abroad,

7. For a discussion of Social Surrealism, see Jeffrey Wechsler, *Surrealism and American Art, 1931–1947* (New Brunswick, N.J.: Rutgers University Art Gallery, 1977), pp. 39–43.

8. Nancy Grimes, *Jared French's Myths* (San Francisco: Pomegranate Artbooks, 1993), p. xiii.

there was a steady flow of European modern art into American galleries, museums, and private collections, and its echoes could be seen on American canvases despite the prevailing Regional and Social Realist styles favored by the public and the Works Progress Administration. While these latter styles held sway among artists on the WPA, some, such as Stuart Davis, Burgoyne Diller, and Arshile Gorky, were dedicated modernists. Increasingly, modernism appeared to be a lingua franca, an international language that transcended national borders. Oddly enough, the preferences of MoMA, an institution financed by the Rockefeller family and others of New York's wealthy establishment, coincided with those of an influential faction in left-wing politics. Many artists resigned in the later 1930s from the left-dominated American Artists Congress and embraced the political line of the Trotskyists who, after the Moscow trials, had split with the old Stalinist left. To separate themselves from Social Realism, which was identified with the Old Left, the Trotskyist intellectuals, among them several prominent art critics, embraced Trotsky's advocacy of total artistic freedom and the fidelity of the artist to his interior self.[9] In effect, this meant favoring one or another liberating aspect of modernism as it had developed among European artists and promoting it to the detriment of most realist art.

By the end of the 1930s, then, there was a receptiveness to change in the air. Soon not only the artworks but the artists themselves were streaming across the Atlantic, fleeing a Europe threatened by war. As the rise of fascism became more ominous, the westward flow of artists and other cultural refugees increased. The years immediately preceding Hitler's invasion of Poland in September 1939 saw the most momentous intellectual emigration in history, as scientists, psychologists, scholars in all fields, musicians, writers, artists, and architects arrived in the Western Hemisphere. Their flight assured that the atom bomb would be in Allied rather than fascist hands, and it deeply affected American culture, from Hollywood films to urban architecture, from the symphony orchestra to the Broadway stage, and from advertising to prestige publishing. Hans Hofmann arrived from Munich to teach at the Art Students League and opened his own influential school in New York in 1934. After Hitler shut down the Bauhaus in 1932, many members of its faculty and its former students, including Josef Albers, László Moholy-Nagy, and a contingent of architects and designers, found teaching positions in American universities. As they learned from and mixed with the émigrés, American artists began to have a stronger sense of status as participants in a wave of artistic internationalism.

A second wave of emigration began when France and England entered the war after Hitler invaded Poland. It swelled following the fall of France in June 1940 as refugees availed themselves of the southern escape route still open through the unoccupied portion of southern France to the seaport of Marseilles or through Spain to Lisbon. An Emergency Rescue Committee (ERC) was set up to help with visas and the costs of passage for endangered European intellectuals whose names were on a list drawn up by Alfred Barr, Jr., and Thomas Mann. As a result of the efforts of the ERC's emissary in France, Varian Fry, and those of a variety of collectors and art dealers, the artists Fernand Léger, Marc Chagall, André Masson, Piet Mondrian, Marcel Duchamp, Kurt Seligmann, and the spokesman for Surrealism, André

9. Arturo Schwartz, *Breton/Trotsky* (Paris: UGE, 1977), p. 60.

Breton, spent the war years in or near New York. The Surrealist artists Roberto Matta, Max Ernst, and Yves Tanguy had taken refuge in the United States in the company of their American wives or future wives. Breton's presence in New York ensured that the collective activities of the prewar Paris-based Surrealist group would continue in the form of exhibitions and publications. Stanley William Hayter whose Paris workshop, Atelier 17, had printed editions of prints for some of the Surrealist artists during the 1930s, transferred the whole operation to the premises of New York's New School for Social Research, where many artists were introduced to Hayter's experimental printmaking techniques. At Atelier 17 European and American artists worked side by side, and after work they carried on discussions in a coffee shop on nearby MacDougal Street.

Because of their international reputations, which had been furthered by the Museum of Modern Art and the publicity generated by their gallery exhibitions, these émigré artists made a considerable impact on younger American artists who were looking for an alternative to the representational art of the Depression years. The American art collector Peggy Guggenheim became a catalyst for social and artistic exchange when she returned from Europe in 1941, bringing with her Max Ernst, who had escaped from an internment camp. Her combination gallery and museum, Art of This Century, became a showcase not only for the émigrés but also for young American artists. In 1943 and 1944 Guggenheim presented the first solo exhibitions of Jackson Pollock, Robert Motherwell, William Baziotes, and Mark Rothko, four artists who would be at the core of what in 1950 was designated Abstract Expressionism. The work of these artists, together with that of a number of other young Americans, was usually referred to at the time as Abstract Surrealism; some of them actually participated in the *First Papers of Surrealism* exhibition in 1942, which became notorious because of the web of string that Marcel Duchamp strung through the improvised gallery in a Madison Avenue mansion. Among these "proto–Abstract Expressionists" there are many specific examples of a direct impact made by imported styles, but even more significant was the liberating example of some of the Surrealist techniques such as "psychic automatism" and the various ways they used blind chance to start an artwork.

Baziotes, Motherwell, and briefly Pollock were among the artists who attended sessions in the studio of the charismatic Chilean Matta to experiment with Surrealist automatism. "If you ask me who is the most important young artist in New York, I would say it is Matta," John Myers noted in his journal.[10] (Myers was a young poet working at *View*, a periodical that featured Surrealist art and literature.) "It was really Matta who swung the thing," recalled artist Gerome Kamrowski who had attended his studio sessions.[11] Matta had arrived in Paris in 1934 to work as a draftsman in the atelier of Le Corbusier and had joined the Surrealists as their youngest member in 1938. He reached the United States in November 1939 and, fluent in English, French, and Spanish, soon was serving as a point of contact between the émigrés and younger New York artists. In the summer of 1941 he traveled to Mexico in the company of Robert Motherwell, who was just starting to paint. "I was as close

10. John Meyers, *Tracking the Marvelous* (New York: Random House, 1983), p. 67.

11. Interview with the author, November 1986.

to Matta then as anybody can be," Motherwell recalled, characterizing him as "an intellectual Don Juan who seduces and moves on."[12] The Motherwell drawing in the collection of the Portland Museum of Art was done in Mexico and given to Ann Matta with the inscription, "for Pajarito," meaning "little bird," the name by which she was known among the Surrealists. The drawing is an attempt at using the free automatist style that Matta had been demonstrating for Motherwell during that summer in Cuernavaca. It represents a breakthrough for Motherwell, who henceforth started his paintings with a certain amount of unpremeditated gestural freedom, although he would use the term *plastic* rather than *psychic automatism*, indicating that for him it was a way to generate new forms rather than a means of accessing the unconscious (pages 130, 131).

In 1951, after the new American style had been christened Abstract Expressionism and had been featured prominently at the Museum of Modern Art, its strong advocate, the critic Clement Greenberg made the following statement regarding the French refugee artist André Masson: "He more than anyone else anticipated the new abstract painting and I don't believe he has received enough credit for it."[13] Masson, the first visual artist to join the Surrealist group in 1924, had arrived in the United States in 1941, thanks to the Emergency Rescue Committee. Although he and his family lived in a rural section of Connecticut and he seldom went to New York, his work received a good deal of exposure through his dealer, Curt Valentin, as well as in group shows such as Pierre Matisse's *Artists in Exile* exhibition in the spring of 1942 and the attention-getting *First Papers of Surrealism*. An anarchist who was profoundly intellectual and supremely gifted as a painter, Masson refused to adopt a signature style and constantly pushed at stylistic boundaries. During his American years (1941–45) he was searching for ways to express his view of nature as an unending process of metamorphosis, placing himself within nature as part of the perpetual flux. Eliminating any suggestion of illusionism, he laid his canvases on a flat surface and applied dark or black grounds, over which he painted with calligraphic brushwork in brilliant color, a way of working that produced a synthesis that paved the way to a whole new mode of painting.

Masson's content as much as his style also inspired Arshile Gorky, who visited him in Connecticut and saw exhibitions of his freely brushed works that were based on a personal mythology of nature and on direct observation of the woodland setting in which he was living. In 1943 Gorky also began to look closely at nature and to enlarge and improvise on botanical forms. The directness and freedom with which Masson worked may have helped to liberate Gorky from the tight shapes and heavy paint of his earlier canvases (pages 132, 133).[14] The young American William Baziotes, invited to exhibit in *First Papers of Surrealism*, submitted a painting titled *The Butterflies of Leonardo da Vinci*. Its curious title was apparently referring to the Masson painting *Leonardo da Vinci and Isabella d'Este* in which several butterfly shapes are formed between the profiled heads of the double portrait (pages 134, 135). Much has been said about the influence of the paintings Masson exhibited in New York on Jackson Pollock, in particular a hypothetical connection between the former's *Pasiphae* of 1943 and a painting by

12. Interview with the author, April 1985.

13. Clement Greenberg, *Art and Culture: Critical Essays* (Boston: Beacon Press, 1961), p. 126.

14. William Rubin, "Arshile Gorky, Surrealism and the New American Painting," *Art International* (Zurich), February 1963, pp. 27–38; "Notes on Masson and Pollock," *Arts*, November 1959, pp. 36–43.

Pollock of the same title of 1944, with Pollock reportedly saying after seeing the Masson, "I'm going to paint me a Pasiphae." While the story may well be apocryphal, the example of Masson's flattened space, direct linear brushwork, the momentum of his paint application, and abstract symbolism may have had an empowering effect on Pollock as he worked toward an increased automatism (pages 136, 137).[15]

Pollock's move toward allover linear abstraction appeared first on a small scale in a group of nine etchings executed at Atelier 17 in 1944. Pollock's old friend Reuben Kadish had been an assistant to Hayter and had a key to the workshop, which was across from Pollock's apartment on Eighth Street. Kadish persuaded Pollock, who had been in a funk, unable to work, to join him and try etching. Although the experimental plates were not editioned until long after Pollock's death and, according to Kadish, Pollock did not think much of the whole experience,[16] there are several ways in which working at Atelier 17 might have contributed to the direction in which Pollock was moving.[17] One is Hayter's emphasis on line and the way his teaching stressed the allover use of the plate and the creation of allover texture by pressing fabric into a soft ground. Hayter described his concept of "space-line" as a means of registering "imaginary space," unlimited in direction and not confined to "one order of time." He discussed the "trace" as an elementary human process, involving motion and the exercise of force, but not "primarily associated with the exact reproduction of the immediate visual experience because the trace resembles astonishingly few phenomena in external nature."[18] In the Pollock prints there remain fragments of images that have been absorbed into and obliterated by the linear flow that covers the plate, a forecast of what was to happen in Pollock's painting in the next few years (pages 138, 139).

With so many opportunities for contact with both artworks and their creators, there were naturally many and varied repercussions in American painting. The way had already been prepared for a hero worship of Mondrian among the members of American Abstract Artists. One of its members, Harry Holzman, had brought Mondrian across the Atlantic in 1941 and housed him at his own expense. Charmion von Wiegand met Mondrian in April 1941 when she went to interview him for an article in his studio on First Avenue. Through talking with him, seeing his paintings, and helping with the translation of some of his writings, she became committed to pure abstraction. Although von Wiegand's paintings of 1945, the year after Mondrian's death, are made up of intersecting curvilinear shapes—quite different from Mondrian's horizontal-vertical compositions—she held to principles derived from Mondrian, particularly from the freedom and complexity of his last great *Boogie Woogie* paintings (page 108).

Other artists, of diverse outlook and approach, avoided the strict geometry of Mondrian but looked to him to draw lessons about clarity and structure for their own art. Along with such seasoned artists as Burgoyne Diller, who followed in Mondrian's Neo-Plastic footsteps, there were younger Mondrian acolytes who made respectful visits to his New York studio, such as Leland Bell and Nell Blaine. These two painters were strongly imbued with the

15. Pollock was clearly interested in Surrealist automatism in 1942–43. Pollock, Baziotes, and Gerome Kamrowski collaborated on paintings in which all three experimented with dripping quick-drying lacquer. Their interest in automatism extended to poetry; Pollock, Lee Krasner, William and Ethel Baziotes, and Robert and Maria Motherwell spent evenings together writing automatic poetry.

16. Letter to the author, February 15, 1986.

17. Reuben Kadish, letter to the author, February 18, 1986.

18. S. W. Hayter, "Line and Space of the Image," *View*, no. 4 (December 1944).

principles of Mondrian's Neo-Plasticism to the extent that when they turned to figurative painting about 1950 they continued to base their work on a fundamentally abstract structure. Bell's shift to painting the figure was a result of the influence of Jean Hélion, who was in New York from 1943 to 1946, following his dramatic escape from a prisoner of war camp in eastern Germany. Hélion, who had been a founding member of Abstraction-Création and a prominent abstract artist during the 1930s, began to reintroduce figures in his art in 1939, and his wartime experience strengthened his resolve to omit humanity from his painting no longer (pages 140, 141).

Following her initial devotion to Mondrian (even at the end of her life she said, "It all goes back to Mondrian"[19]), Blaine became interested in Fernand Léger, who had been a colorful presence in New York during the war years. (He had also come on an earlier trip in 1936.) Impressed by his ability to combine a strong sense of abstract form with images of bicyclists, construction workers, and highly simplified still-life objects, Blaine began in the late 1940s to work her way back from abstraction to images, using broad, black outlines, primary colors, and simple, flat shapes to denote figures and objects, delineated with a decisiveness and clarity worthy of Léger. She even adopted some of the proletarian subject matter of Léger's series of workers on scaffoldings in her paintings of motorcycle riders and window washers (pages 142, 143).

The end result of the wartime influx of artists from Europe was not so much the adoption of any particular style, but a change in the way American artists viewed themselves and the possibilities of art. *Possibilities* was actually the title of the single-issue journal published by Robert Motherwell and critic Harold Rosenberg in 1947 after most of the European refugees had gone home and the New York School was gathering momentum. American artists began to feel a new empowerment, based on a sense that they were no longer the stepchildren of European art but part of a new postwar internationalism as well as part of a nation that had emerged as the dominant economic and military world power. In the postwar years, exhibitions of the new American art would be sent abroad; American artists would become internationally famous figures whose works were sought after by European museums and collectors; and New York would become the major showcase and marketplace for contemporary art. And in this reversal of the tide, artistic influences began to flow in a different direction across the Atlantic.

19. Conversations with the author.

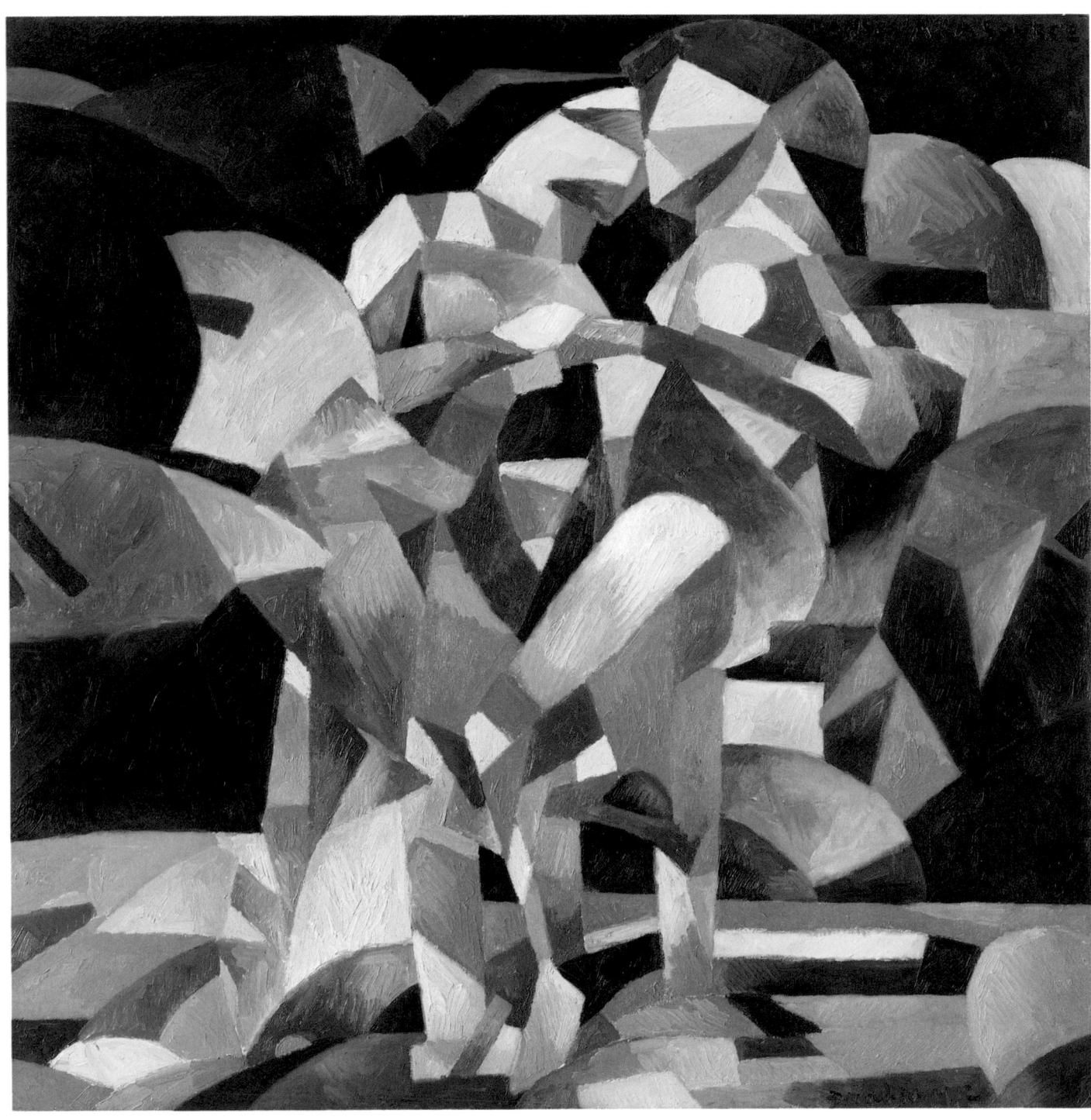

Francis Picabia, *Dances at the Spring*, 1912, oil on canvas, 47 $^{7}/_{16}$ x 47 $^{1}/_{2}$ inches. Philadelphia Museum of Art: The Louise and Walter Arensberg Collection, 1950

Joseph Stella, *Der Rosenkavalier*, 1913–14, oil on canvas, 24 x 30 inches. Whitney Museum of American Art, New York; Gift of George F. Of, 52.39

Joan Miró, *Graphisme Concret (Concrete Graphics)*, n.d., watercolor, chalk, and ink on paper, 28 $^7/_8$ x 39 inches. Lent by Leslie B. Otten

Alexander Calder, *Snow Flurry III*, 1948, painted metal and wire, 53 x 90 inches. Portland Museum of Art, Maine, Anonymous gift, 1990.31

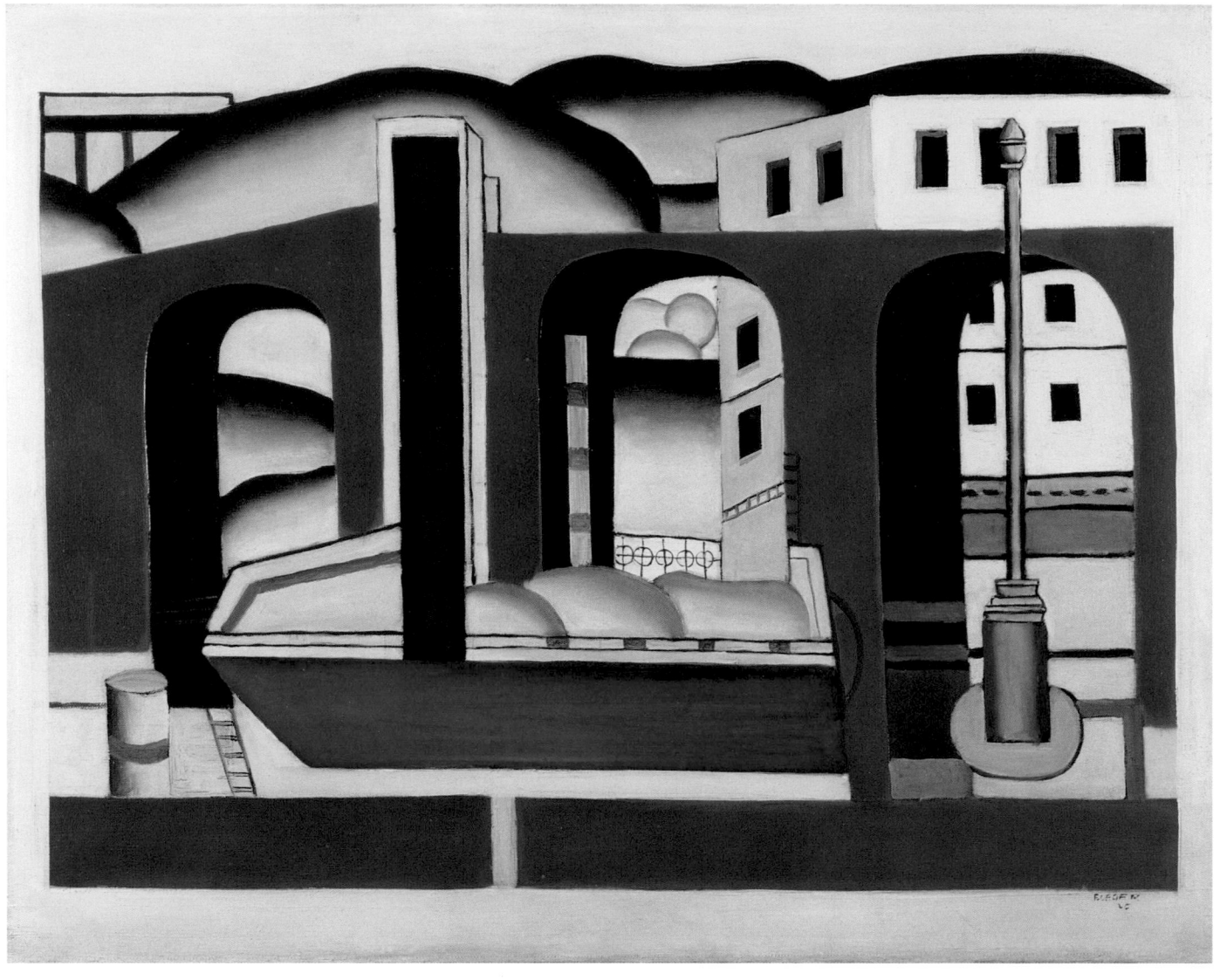

Fernand Léger, *Le Viaduc (The Viaduct)*, 1925, oil on canvas, 19 ³/₄ x 25 ¹/₂ inches. Norton Museum of Art, West Palm Beach, Florida, Bequest of R. H. Norton, 53.107

Stuart Davis, *New York–Paris, No. 2*, February 1931, oil on canvas, 30 $\frac{1}{4}$ x 40 $\frac{1}{4}$ inches. Portland Museum of Art, Maine, Hamilton Easter Field Art Foundation Collection, Gift of Barn Gallery Associates, Inc., Ogunquit, Maine, 1979.13.10

Henri Matisse, *La Séance de Trois Heures (The Three O'Clock Sitting)*, 1924, oil on canvas, 36 ¼ x 28 ¾ inches. Private collection

Milton Avery, *Pitcher Painter*, 1945, oil on canvas, 48 x 33 ¹/₂ inches. Palmer Museum of Art, The Pennsylvania State University, Gift of Roy R. Neuberger, 57.1

Salvador Dalí, *Landscape of Port Lligat with Approaching Storm*, 1956, oil on canvas, 25 ¼ x 34 inches. Private collection

James Guy, ***Shipwrecked Poet***, 1941, oil on canvas, 16 ¹/₁₆ x 20 ¹/₈ inches. Portland Museum of Art, Maine, Gift of Charles J. de Sieyes, M.D., 1983.333

René Magritte, *Le Coeur Dévoilé (The Heart Revealed), Portrait of Tita Thirifays*, 1936, oil on canvas, 31 $\frac{1}{2}$ x 25 $\frac{1}{4}$ inches. Scott M. Black Collection

Jared French, *Woman*, 1947, egg tempera on gesso panel, 17 $\frac{1}{2}$ x 15 inches. Private collection, courtesy DC Moore Gallery, New York

Roberto Matta, *Untitled*, 1941, oil on paper on Masonite, 13 $^{1}/_{4}$ x 16 $^{1}/_{2}$ inches. Courtesy of Latin American Masters, Los Angeles

Robert Motherwell, *For Pajarito*, 1941, oil wash and ink on paper board, 8 x 10 inches. Portland Museum of Art, Maine, Museum purchase with matching grants from the National Endowment for the Arts and the Casco Bank and Trust Company, 1981.100

André Masson, *Meditation on an Oak Leaf*, 1942, tempera, pastel, and sand on canvas, 40 x 33 inches. The Museum of Modern Art, New York, Given anonymously, 84.1950

Arshile Gorky, *Virginia Landscape*, circa 1943, pencil and colored crayons on paper, 17 x 22 inches. The Metropolitan Museum of Art, Promised Gift of Muriel Kallis Newman, The Muriel Kallis Steinberg Newman Collection, RL.1992.37.1

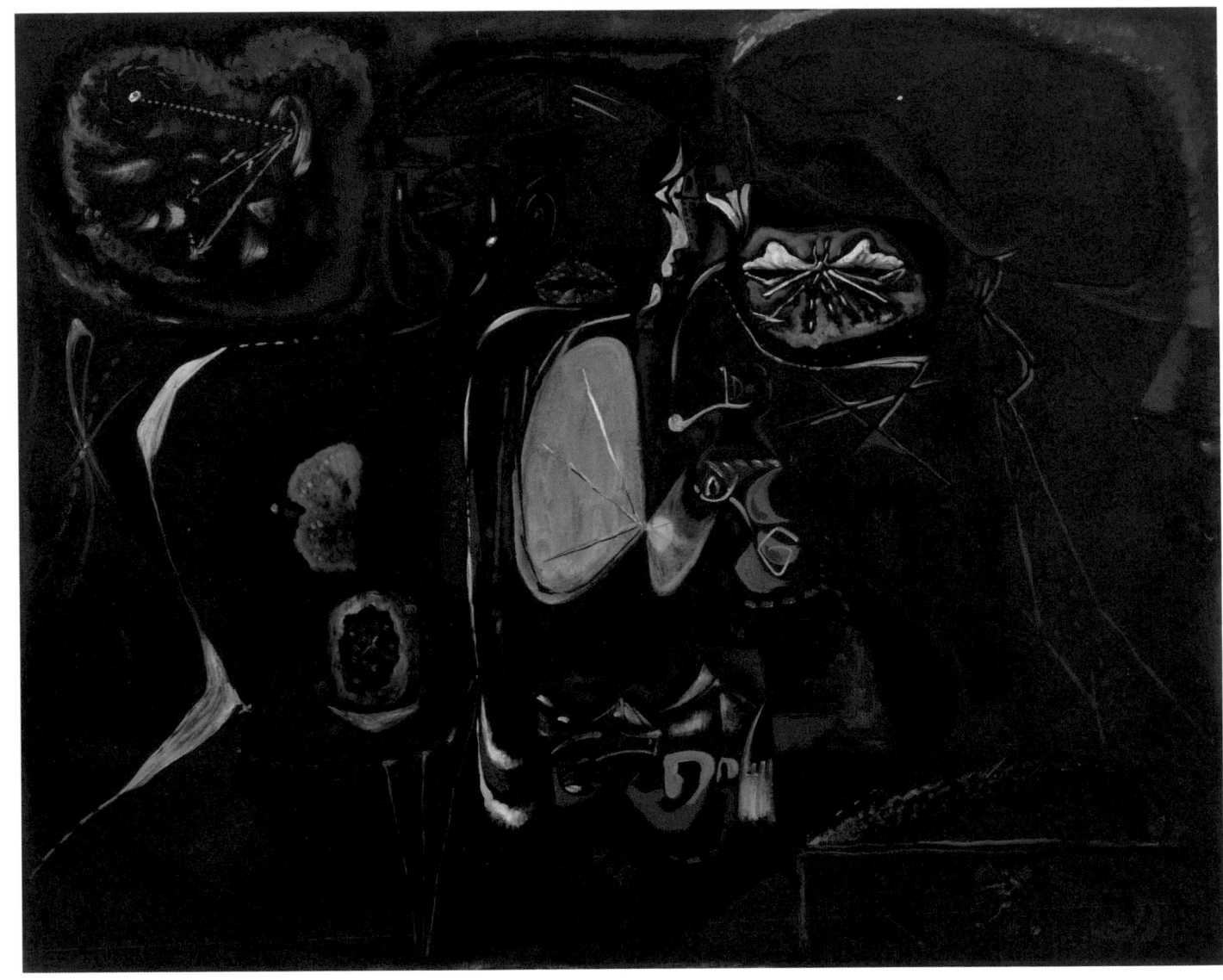

André Masson, *Leonardo da Vinci and Isabella d'Este*, 1942, oil on canvas, 39 $\frac{3}{8}$ x 50 inches. The Museum of Modern Art, New York, Given anonymously

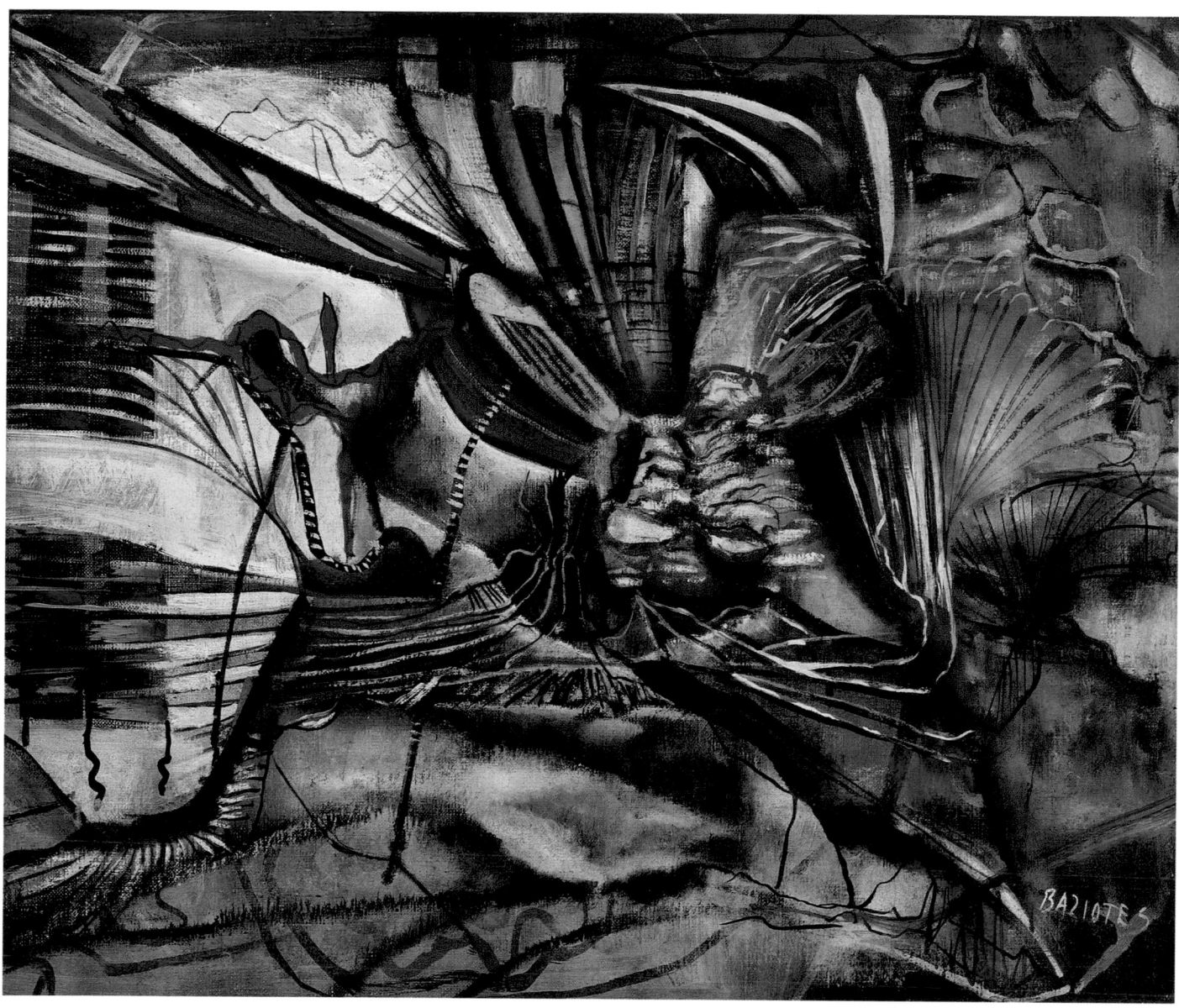

William Baziotes, *The Butterflies of Leonardo da Vinci*, 1941–42, oil on canvas, 19 ¹/₄ x 23 inches. Private collection

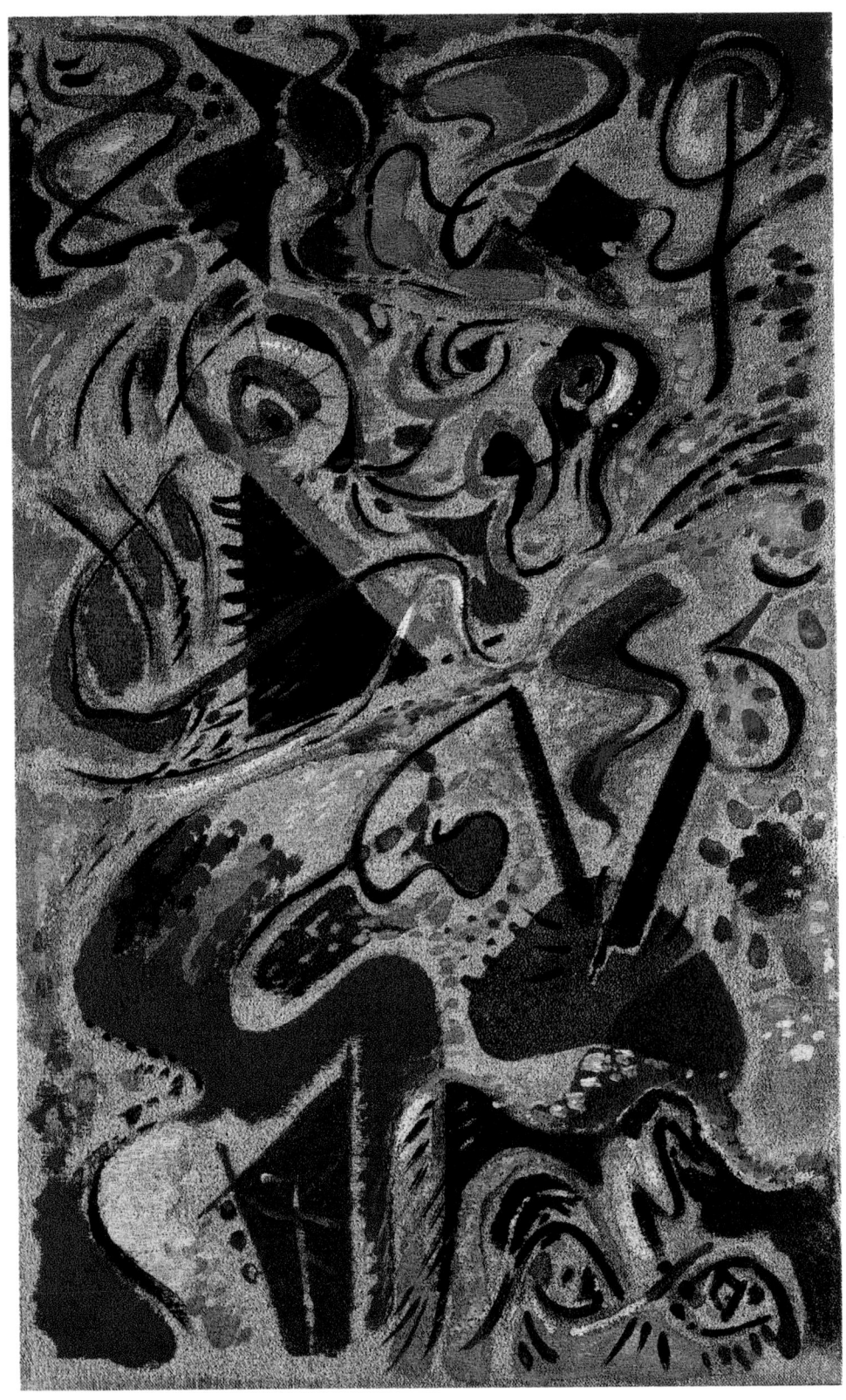

André Masson, *In the Forest*, 1944, tempera, oil, and sand on canvas, 25 x 15 inches. Albright-Knox Art Gallery, Buffalo, New York, Room of Contemporary Art Fund, 1944

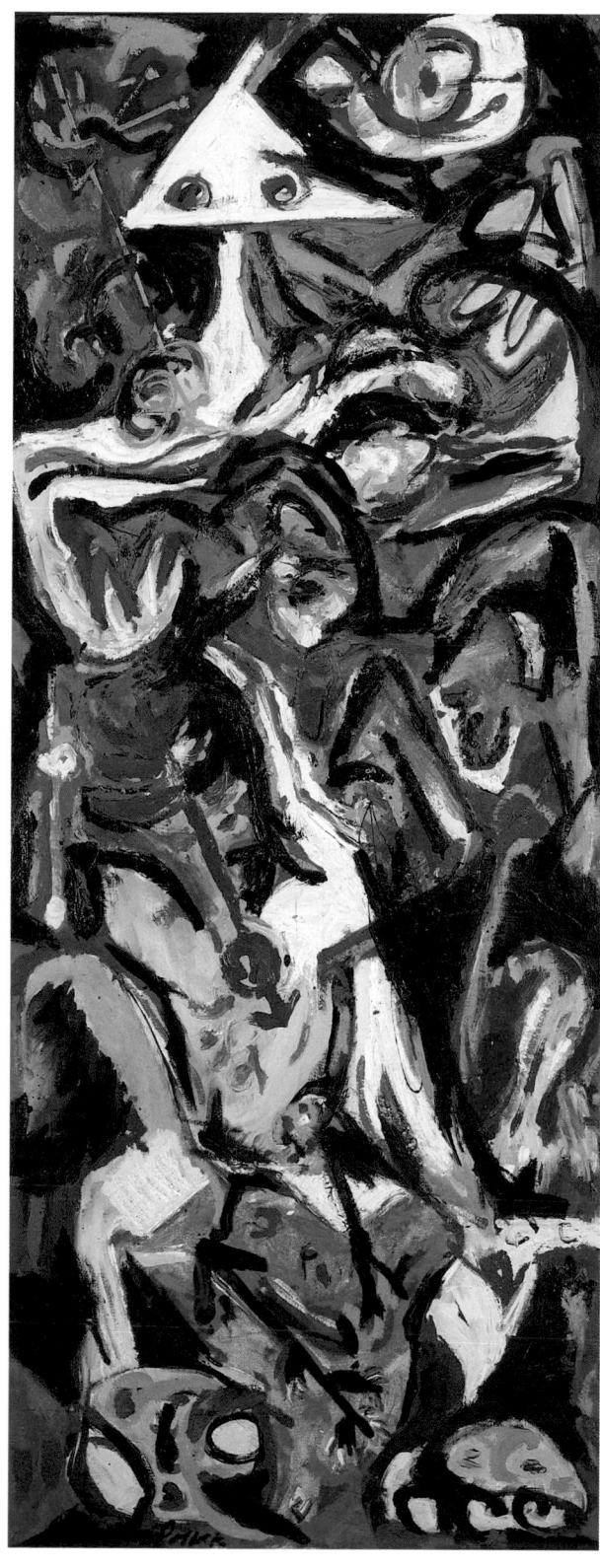

Jackson Pollock, *Water Figure*, 1945, oil on canvas, 72 x 29 inches. Hirshhorn Museum and Sculpture Garden, Smithsonian Institution, Gift of Joseph H. Hirshhorn, 1966

Stanley William Hayter, *Laocoon*, 1943, engraving and soft-ground etching, printed in black, plate 12 ¼ x 21 ¾ inches. The Museum of Modern Art, New York, Purchase

Jackson Pollock, *Untitled (7)*, 1945, printed 1967, engraving and drypoint, 15 ³/₄ x 23 ³/₄ inches. The Museum of Modern Art, New York, Gift of Lee Krasner Pollock

Jean Hélion, *L'Homme au Journal*, 1948, watercolor and pencil on paper, 9 x 6 ¹/₂ inches. Nancy Schwartz Fine Art Ltd.

Leland Bell, *Temma, Ulla, Frank and Mishka*, 1978, oil on canvas, 20 x 24 inches. Courtesy Salander-O'Reilly Galleries

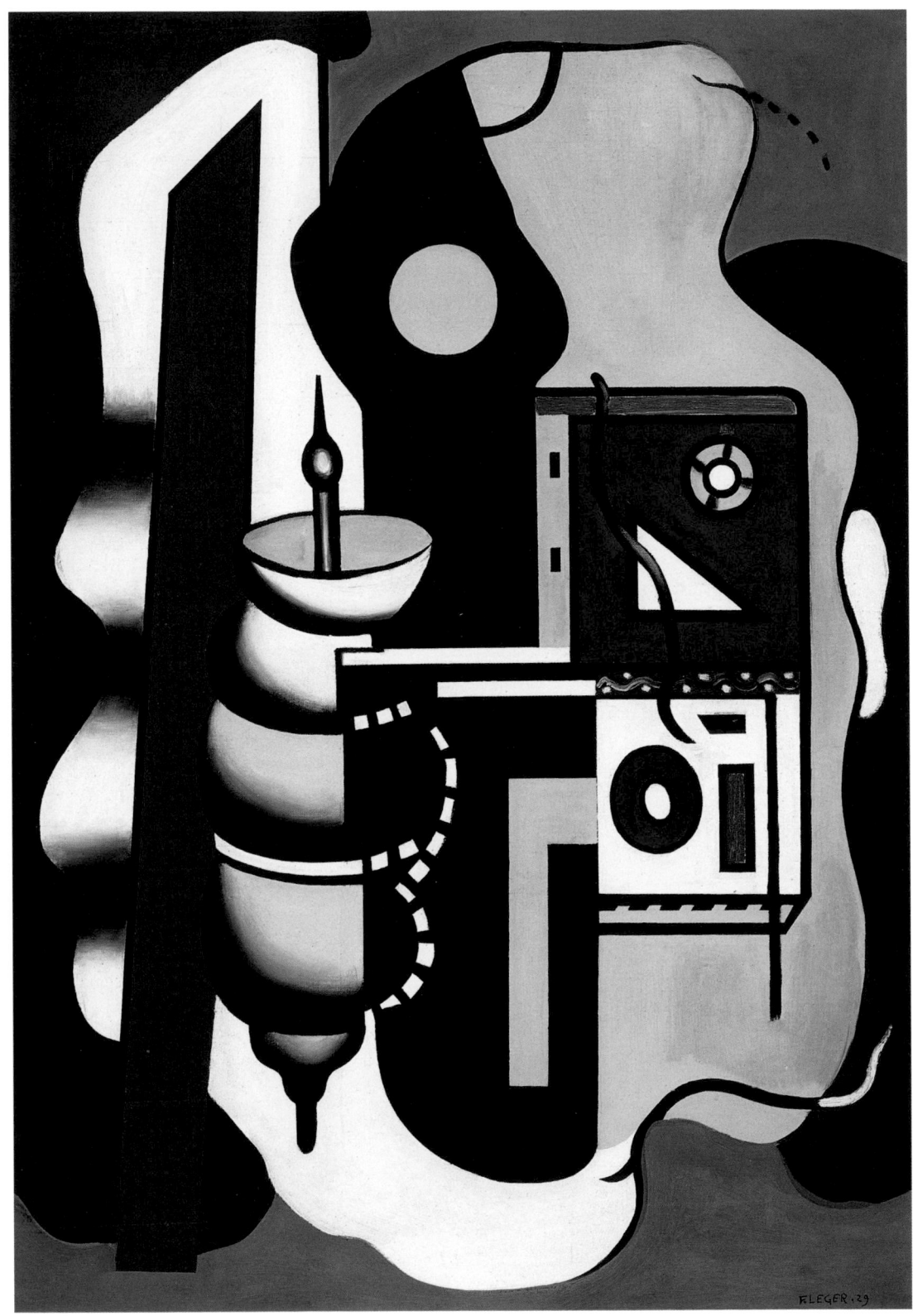

Fernand Léger, *Nature Morte (Still Life)*, 1929, oil on canvas, 36 x 25 ³/₄ inches. Scott M. Black Collection

Nell Blaine, *Tilted Forms*, 1947, oil on canvas, 41 x 50 inches. Collection of Drs. Michael and Colleen Silva

Marsden Hartley, *Still Life*, 1926–27, oil on cedar panel, 14 ⁵/₈ x 18 ¹/₈ inches. Margery and Maurice Katz

Checklist

Works are listed alphabetically by artist. Dimensions are in inches, height preceding width.

George Ault
United States, 1891–1948
Sculpture on a Roof, 1945
oil on board
16 x 12
The Butler Institute of American Art, Youngstown, Ohio,
Gift of Mrs. George Ault, 961-0-131

Milton Avery
United States, 1893–1965
Pitcher Painter, 1945 (p. 125)
oil on canvas
48 x 33 $^1/_2$
Palmer Museum of Art, The Pennsylvania State University,
Gift of Roy R. Neuberger, 57.1

Will Barnet
United States, born 1911
Awakening, 1949 (p. 21)
oil on canvas
42 x 52
Currier Museum of Art, Manchester, New Hampshire,
Gift of Will and Elena Barnet, 1986.43

Frédéric Bazille
France, 1841–1870
Summer Scene, 1869 (p. 38)
oil on canvas
62 x 62 $^3/_8$
The Fogg Art Museum, Harvard University Art Museums,
Gift of Mr. and Mrs. F. Meynier des Salinelles

George Bellows
United States, 1882–1925
Emma in the Black Print, 1919 (p. 71)
oil on canvas
40 $^1/_8$ x 32 $^1/_4$
Museum of Fine Arts, Boston, Bequest of John T. Spaulding,
48.518

Nell Blaine
United States, 1922–1996
Tilted Forms, 1947 (p. 143)
oil on canvas
41 x 50
Collection of Drs. Michael and Colleen Silva

Elizabeth Jane Gardner Bouguereau
United States, 1837–1922
He Careth, circa 1883 (p. 23)
oil on canvas
48 x 32
The Philbrook Museum of Art, Tulsa, Oklahoma, Gift of
Laura A. Clubb, 1947.8.84

William Bouguereau
France, 1825–1905
The Elder Sister, 1869 (p. 22)
oil on canvas
51 $^1/_4$ x 38 $^1/_4$
The Museum of Fine Arts, Houston, Gift of an Anonymous
Lady in memory of her Father, 1992

Georges Braque
France, 1882–1963
La Maison. La Roche-Guyon (House at La Roche-Guyon),
late 1908 (p. 94)
oil on canvas
18 $^1/_8$ x 15 $^1/_4$
Scott M. Black Collection

Georges Braque
France, 1882–1963
*Nature Morte aux Poires, Citrons et Amandes (Still Life with
Pears, Lemons, and Almonds)*, 1927 (p. 4)
oil on canvas
19 $^7/_8$ x 24
Scott M. Black Collection

Mildred Burrage
United States, 1890–1983
A November Day, n.d. (p. 69)
oil on canvas
31 $^7/_8$ x 25 $^1/_2$
Portland Museum of Art, Maine, Gift of the artist, 1981.118

Gustave Caillebotte
France, 1848–1894
*Étude pour "Le Pont de l'Europe" (Study for "Le Pont de
l'Europe")*, 1876 (p. 64)
oil on canvas
32 $^3/_4$ x 48 $^1/_4$
Albright-Knox Art Gallery, Buffalo, New York, By
exchange, Bequest of A. Conger Goodyear, 1974

Alexander Calder
United States, 1898–1976
Snow Flurry III, 1948 (p. 121)
painted metal and wire
53 x 90
Portland Museum of Art, Maine, Anonymous gift, 1990.31

Charles-Émile-Auguste Carolus-Duran
France, 1838–1917
Portrait of a Woman, n.d. (p. 60)
oil on canvas
28 $^3/_4$ x 23 $^3/_4$
Lent by The Metropolitan Museum of Art, Gift of Mr. and
Mrs. Oscar Kolin, 1981 (1981.366)

Eugène Carrière
France, 1849–1906
Le Contemplateur (The Contemplator), 1901 (p. 8)
oil on fabric
13 $^1/_4$ x 16 $^1/_8$
The Cleveland Museum of Art, In memory of Ralph King,
gift of Mrs. Ralph King, Ralph T. Woods, Charles G. King,
and Frances King Schafer, 1946.283

Mary Cassatt
United States, 1844–1926
Simone in a Plumed Hat, circa 1903 (p. 59)
pastel over counterproof
24 $^1/_8$ x 19 $^5/_8$
Scott M. Black Collection

Paul Cézanne
France, 1839–1906
Pears and Knife, 1879–82
oil on canvas
8 x 12
Private collection

Paul Cézanne
France, 1839–1906
Turn in the Road, circa 1881 (p. 92)
oil on canvas
23 $^7/_8$ x 28 $^7/_8$
Museum of Fine Arts, Boston, Bequest of John T. Spaulding,
48.525

Paul Cézanne
France, 1839–1906
Mont Sainte-Victoire (recto); *Landscape Study* (verso), circa
1890–1902 (p. 90)
recto: watercolor and gouache over graphite on buff wove
paper; verso: graphite
12 $^1/_4$ x 18 $^5/_8$
Smith College Museum of Art, Northampton, Massachu-
setts, Bequest of Charles C. Cunningham in memory of
Eleanor Lamont Cunningham, class of 1932, through the
kindness of Priscilla Cunningham, class of 1958

Paul Cézanne
France, 1839–1906
Les Baigneurs (The Bathers), circa 1898
lithograph on paper
16 $^3/_4$ x 20 $^1/_2$
Bates College Museum of Art, Lewiston, Maine, Gift of
Caroline P. Ehrenfest, '39, 1989.9.63

William Merritt Chase
United States, 1849–1916
The Leader, circa 1875
oil on canvas
26 $^1/_4$ x 15 $^7/_8$
Addison Gallery of American Art, Phillips Academy,
Andover, Massachusetts, Gift of an anonymous donor

William Merritt Chase
United States, 1849–1916
Lady with a Parasol, 1890
oil on canvas
72 x 36
Frye Art Museum, Seattle, Washington, Museum Purchase,
1969

Giorgio de Chirico
Italy (born Greece), 1888–1978
Piazza d'Italia, 1915
oil on burlap
23 $^3/_8$ x 19 $^3/_8$
Fine Arts Museums of San Francisco, Gift of Nathan
Cummings

Jean-Baptiste-Camille Corot
France, 1796–1875
Untitled Landscape, circa 1865–70
oil on canvas
12 $^3/_8$ x 18 $^1/_4$
Portland Museum of Art, Maine, Bequest of Mary King
Longfellow, 1942.2

Gustave Courbet
France, 1819–1877
Temps d'Orage à Étretat (Stormy Weather at Étretat),
circa 1869 (p. 86)
oil on canvas
29 $^{13}/_{16}$ x 36 $^3/_8$
The Joan Whitney Payson Collection at the Portland
Museum of Art, Maine, Promised and partial gift of John
Whitney Payson, 15.1991.2

Salvador Dalí
Spain, 1904–1989
Landscape of Port Lligat with Approaching Storm, 1956 (p. 126)
oil on canvas
25 $^1/_4$ x 34
Private collection

Arthur B. Davies
United States, 1862–1928
Bacchante Spring, n.d.
oil on canvas
21 x 29 $^1/_8$
Portland Museum of Art, Maine, Gift of James Augustine
Healy, 1947.3

Stuart Davis
United States, 1892–1964
New York–Paris, No. 2, February 1931 (p. 123)
oil on canvas
30 $^1/_4$ x 40 $^1/_4$
Portland Museum of Art, Maine, Hamilton Easter Field Art
Foundation Collection, Gift of Barn Gallery Associates, Inc.,
Ogunquit, Maine, 1979.13.10

Edgar Degas
France, 1834–1917
Danseuse Assise (Seated Dancer), 1894 (p. 58)
pastel on joined paper mounted on board
22 $^3/_4$ x 17 $^3/_4$
Scott M. Black Collection

Thomas Eakins
United States, 1844–1916
Swimming, 1885 (p. 39)
oil on canvas
27 $^5/_{16}$ x 36 $^5/_{16}$
Amon Carter Museum, Fort Worth, Texas, Purchased by the
Friends of Art, Fort Worth Art Association, 1925; acquired
by the Amon Carter Museum, 1990, from the Modern Art
Museum of Fort Worth through grants and donations from
the Amon G. Carter Foundation, the Sid W. Richardson
Foundation, the Anne Burnett and Charles Tandy Founda-
tion, Capital Cities/ABC Foundation, Fort Worth Star-
Telegram, the R. D. and Joan Dale Hubbard Foundation
and the people of Fort Worth

Jared French
United States, 1905–1988
Woman, 1947 (p. 129)
egg tempera on gesso panel
17 $^1/_2$ x 15
Private collection, courtesy DC Moore Gallery, New York

Jean-Léon Gérôme
France, 1824–1904
The Carpet Merchant, circa 1887
oil on canvas
33 $^7/_8$ x 27 $^1/_{16}$
Lent by The Minneapolis Institute of Arts, The William
Hood Dunwoody Fund

William Glackens
United States, 1870–1938
The Headlands, Rockport, 1936 (p. 48)
oil on canvas
23 $^1/_2$ x 32
Kraushaar Galleries

Dwinell Grant
United States, 1912–1991
Watercolor No. 67: Yellow Circle, 1938
watercolor on paper
19 $^3/_4$ x 15 $^3/_8$
The Dayton Art Institute, Ohio, Gift of the artist, 1939.41

James Guy
United States, 1910–1983
Shipwrecked Poet, 1941 (p. 127)
oil on canvas
16 $^1/_{16}$ x 20 $^1/_8$
Portland Museum of Art, Maine, Gift of Charles J. de Sieyes,
M.D., 1983.333

Attributed to Frans Hals
The Netherlands, 1585–1666
Man with a Beer Keg, circa 1635 (p. 102)
oil on canvas
33 1/$_4$ x 26 1/$_2$
Portland Museum of Art, Maine, Gift of Ilse Breuer
Reichhold, 1983.158

Marsden Hartley
United States, 1877–1943
Still Life, 1926–27 (p. 144)
oil on cedar panel
14 5/$_8$ x 18 1/$_8$
Margery and Maurice Katz

Marsden Hartley
United States, 1877–1943
Franconia Notch, 1930
oil on canvas
30 x 36
Curtis Galleries, Minneapolis, Minnesota

Marsden Hartley
United States, 1877–1943
Untitled: Three Male Figures, circa 1940 (p. 101)
pencil on paper
7 1/$_4$ x 4 3/$_1$
Marsden Hartley Memorial Collection, Bates College
Museum of Art, Lewiston, Maine, 1955.1.64

Frederick Childe Hassam
United States, 1859–1935
Rainy Late Afternoon, Union Square, 1890 (p. 65)
oil on canvas
35 1/$_2$ x 43 1/$_2$
The Museum of the City of New York, Gift of Miss Mary
Whitney Bangs, 69.121.1

Frederick Childe Hassam
United States, 1859–1935
Isles of Shoals, 1915 (p. 67)
oil on canvas
25 x 30
Portland Museum of Art, Maine, Bequest of Elizabeth B.
Noyce, 1996.38.19

Stanley William Hayter
England, 1901–1988
Cirque, 1933
engraving on Barcham green paper
5 x 3 1/$_2$ (plate)
15 5/$_8$ x 11 9/$_{16}$ (paper)
Portland Museum of Art, Maine, Gift of Yamile and Frank
Sledzinski, 2000.26.3

Robert Henri
United States, 1865–1929
Village Girl (Lily Cow), 1915 (p. 103)
oil on canvas
24 x 20
Museum of Fine Arts, St. Petersburg, Florida, Gift of the
Stuart Society in honor of the Twenty-fifth anniversary of
the Museum of Fine Arts, 90.20

Winslow Homer
United States, 1836–1910
Weatherbeaten, 1894 (p. 87)
oil on canvas
28 1/$_2$ x 48 3/$_8$
Portland Museum of Art, Maine, Bequest of Charles
Shipman Payson, 1988.55.1

Reuben Kadish
United States, 1913–1992
Lilith, 1945
etching and aquatint on paper
13 $^3/_4$ x 9 $^3/_4$
Print Collection, Miriam and Ira D. Wallach Division of
Art, Prints and Photographs, The New York Public Library,
Astor, Lenox, and Tilden Foundations

Wassily Kandinsky
Russia, 1866–1964
Stramm (Strong), 1929
oil on board
26 x 15 $^1/_2$
Lent by Leslie B. Otten

Walt Kuhn
United States, 1877–1949
Green Apples and Leaves, 1934 (p. 72)
oil on canvas
17 $^1/_2$ x 13 $^1/_2$
From the collection of John and Joanne Payson;
ex-collection, Joan Whitney Payson

Fernand Léger
France, 1881–1955
Le Viaduc (The Viaduct), 1925 (p. 122)
oil on canvas
19 $^3/_4$ x 25 $^1/_2$
Norton Museum of Art, West Palm Beach, Florida, Bequest
of R. H. Norton, 53.107

Fernand Léger
France, 1881–1955
Nature Morte (Still Life), 1929 (p. 142)
oil on canvas
36 x 25 $^3/_4$
Scott M. Black Collection

René Magritte
Belgium, 1898–1967
*Le Coeur Dévoilé (The Heart Revealed), Portrait of Tita
Thirifays*, 1936 (p. 128)
oil on canvas
31 $^1/_2$ x 25 $^1/_4$
Scott M. Black Collection

John Marin
United States, 1870–1953
Lead Mountain, Beddington, Maine, 1952 (p. 91)
watercolor on paper
14 $^1/_2$ x 19
Richard York Gallery, New York

Homer Dodge Martin
United States, 1836–1897
Autumn–Lake George, 1868
oil on canvas
17 $^7/_8$ x 31 $^7/_8$
Private collection

Henri Matisse
France, 1869–1954
La Séance de Trois Heures (The Three O'Clock Sitting),
1924 (p. 124)
oil on canvas
36 $^1/_4$ x 28 $^3/_4$
Private collection

Roberto Matta
Chile, 1911–2002
The Invasion of the Night, December 22, 1940
graphite and colored pencil on paper
16 $^5/_8$ x 20 $^7/_8$
Lucid Art Foundation Collection

Jean Metzinger
France, 1883–1956
Dancer in a Café, 1912 (p. 18)
oil on canvas
57 $^1/_2$ x 45
Albright-Knox Art Gallery, Buffalo, New York, General
Purchase Funds, 1957

Joan Miró
Spain, 1893–1983
Graphisme Concret (Concrete Graphics), n.d. (p. 120)
watercolor, chalk, and ink on paper
28 $^7/_8$ x 39
Lent by Leslie B. Otten

Claude Monet
France, 1840–1926
Le Printemps à Argenteuil (Springtime in Argenteuil),
1872 (p. 68)
oil on canvas
19 $^1/_2$ x 25 $^1/_8$
The Joan Whitney Payson Collection at the Portland
Museum of Art, Maine, Promised gift of John Whitney
Payson, 15.1991.6

Claude Monet
France, 1840–1926
[Le] Cabane des douaniers (The Customs House), 1882 (p. 66)
oil on canvas
23 $^5/_8$ x 27 $^7/_8$
Private collection, courtesy of Christie's

Robert Motherwell
United States, 1915–1991
For Pajarito, 1941 (p. 131)
oil wash and ink on paper board
8 x 10
Portland Museum of Art, Maine, Museum purchase with
matching grants from the National Endowment for the Arts
and the Casco Bank and Trust Company, 1981.100

Edward Penfield
United States, 1866–1925
Cover image for Harper's Magazine, *March 1894*, 1894
lithograph on paper
19 $^5/_{16}$ x 13 $^7/_8$
Fine Arts Museums of San Francisco, Achenbach Founda-
tion for Graphic Arts, Bequest of Arthur W. Barney

Edward Penfield
United States, 1866–1925
Cover image for Harper's Magazine, *February 1897*, 1897
lithograph on paper
19 $^5/_{16}$ x 14 $^3/_{16}$
Prints and Photographs Division, Library of Congress,
Washington, D.C.

Francis Picabia
France, 1879–1953
Dances at the Spring, 1912 (p. 118)
oil on canvas
47 $^7/_{16}$ x 47 $^1/_2$
Philadelphia Museum of Art: The Louise and Walter
Arensberg Collection, 1950

Pablo Picasso
Spain, 1881–1973
Man with a Pipe, 1911
oil on canvas
35 $^3/_4$ x 27 $^7/_8$ (oval)
Kimbell Art Museum, Fort Worth, Texas

Pablo Picasso
Spain, 1881–1973
Head of a Woman (Portrait of Marie-Thérèse Walter), 1934
oil on canvas
21 $^5/_8$ x 15
Scott M. Black Collection

Jackson Pollock
United States, 1912–1956
Untitled, circa 1944
etching and engraving on paper
20 x 25
Fine Arts Museums of San Francisco, Museum Purchase,
Achenbach Foundation for Graphic Arts Endowment Fund

Pierre-Auguste Renoir
France, 1841–1919
*Femme au Corsage de Chantilly (Woman in a Chantilly Lace
Blouse)*, 1869 (p. 70)
oil on canvas
32 x 25 $^3/_4$
Scott M. Black Collection

Pierre-Auguste Renoir
France, 1841–1919
Confidences, circa 1873 (p. 62)
oil on canvas
32 x 23 $^3/_4$
The Joan Whitney Payson Collection at the Portland
Museum of Art, Maine, Gift of John Whitney Payson,
1991.62

Pierre-Auguste Renoir
France, 1841–1919
L'Estaque, circa 1882
oil on canvas
18 $^3/_8$ x 21 $^7/_8$
Portland Museum of Art, Maine, Gift of Mr. and Mrs. A.
Varick Stout in memory of Mr. and Mrs. Phineas W.
Sprague, 1975.451

Theodore Robinson
United States, 1852–1896
The Lane, circa 1893 (p. 63)
oil on canvas
27 $^3/_{16}$ x 22 $^1/_{16}$
High Museum of Art, Atlanta, Georgia, Gift of Miss Mary
E. Haverty for the J. J. Haverty Collection, 65.47

John Singer Sargent
United States, 1856–1925
*Portrait of Ellen Archer Eveleth Smith (1856–1925) (Mrs. Henry
St. John Smith)*, 1883 (p. 61)
oil on canvas
25 $^5/_{16}$ x 20 $^7/_{16}$
Portland Museum of Art, Maine, Gift of Dr. and Mrs. Henry
St. John Smith and their children, 1986.65

Alfred Sisley
England (born France), 1839–1899
Moret-sur-le-Loing, 1888
oil on canvas
15 $^1/_8$ x 22 $^1/_8$
The Joan Whitney Payson Collection at the Portland
Museum of Art, Maine, Promised and partial gift of John
Whitney Payson, 15.1991.9

Edward Steichen
United States, 1879–1973
Moonlight Dance, Voulangis, 1909
oil on canvas
24 $^1/_4$ x 25
Portland Museum of Art, Maine, Gift of James Augustine
Healy, 1948.9

Joseph Stella
United States, 1877–1946
Der Rosenkavalier, 1913–14 (p. 119)
oil on canvas
24 x 30
Whitney Museum of American Art, New York; Gift of
George F. Of, 52.39

Henri de Toulouse-Lautrec
France, 1864–1901
Troupe de Mlle Églantine, circa 1890
lithograph on paper
24 x 31 $^{1}/_{4}$
Scott M. Black Collection

Frederick Vinton
United States, 1846–1911
Canal at Montcour, France, circa 1890
oil on canvas
15 x 22
Colby College Museum of Art American, Impressionist
Collection, Gift of Mr. and Mrs. Ellerton M. Jetté

Max Weber
United States, born Russia, 1881–1961
Connecticut Landscape, 1911 (p. 95)
oil on canvas laid on panel
28 x 22 $^{1}/_{4}$
Margery and Maurice Katz

Edwin Lord Weeks
United States, 1849–1903
The Soldier of the Rajah Coming to the Sword Sharpener of Ahmedabad, n.d.
oil on canvas
32 x 25 $^{3}/_{4}$
Portland Museum of Art, Maine, Gift of Marion R. Weeks
in memory of her father, Dr. Stephen Holmes Weeks,
1918.2

James McNeill Whistler
United States, 1835–1903
Miss Florence Leyland, circa 1873
oil on canvas
75 $^{1}/_{2}$ x 36 $^{1}/_{8}$
Portland Museum of Art, Maine, Gift of Mr. and Mrs.
Benjamin Strouse, 1968.1

Marguerite Zorach
United States, 1887–1968
Brunswick Mills, 1930s (p. 93)
oil on canvas
28 x 36
Private collection

William Zorach
United States, 1887–1966
Leo Ornstein–Piano Concert, 1918 (p. 19)
oil on canvas
30 x 24
Collection of Mr. and Mrs. William Bloom

Lenders to the Exhibition

Addison Gallery of American Art, Phillips Academy, Andover, Massachusetts
Albright-Knox Art Gallery, Buffalo, New York
Amon Carter Museum, Fort Worth, Texas
Bates College Museum of Art, Lewiston, Maine
Scott M. Black Collection
Mr. and Mrs. William Bloom
The Butler Institute of American Art, Youngstown, Ohio
The Cleveland Museum of Art
Colby College Museum of Art, Waterville, Maine
Currier Museum of Art, Manchester, New Hampshire
Curtis Galleries, Minneapolis, Minnesota
The Dayton Art Institute, Ohio
Fine Arts Museums of San Francisco
The Fogg Art Museum, Harvard University Art Museums
Frye Art Museum, Seattle, Washington
High Museum of Art, Atlanta, Georgia

Margery and Maurice Katz
Kimbell Art Museum, Fort Worth, Texas
Kraushaar Galleries
Library of Congress, Prints and Photographs Division
Lucid Art Foundation Collection
The Metropolitan Museum of Art, New York
The Minneapolis Institute of Arts
The Museum of the City of New York
Museum of Fine Arts, Boston
The Museum of Fine Arts, Houston
Museum of Fine Arts, St. Petersburg, Florida
The New York Public Library, Print Collection
Norton Museum of Art, West Palm Beach, Florida
Leslie B. Otten
Palmer Museum of Art, The Pennsylvania State University
John and Joanne Payson
Philadelphia Museum of Art
The Philbrook Museum of Art, Tulsa, Oklahoma
Private Collections
Richard York Gallery, New York
Collection of Drs. Michael and Colleen Silva
Smith College Museum of Art, Northampton, Massachusetts
Whitney Museum of American Art, New York

Photography Credits